THE TECHNICAL PEN

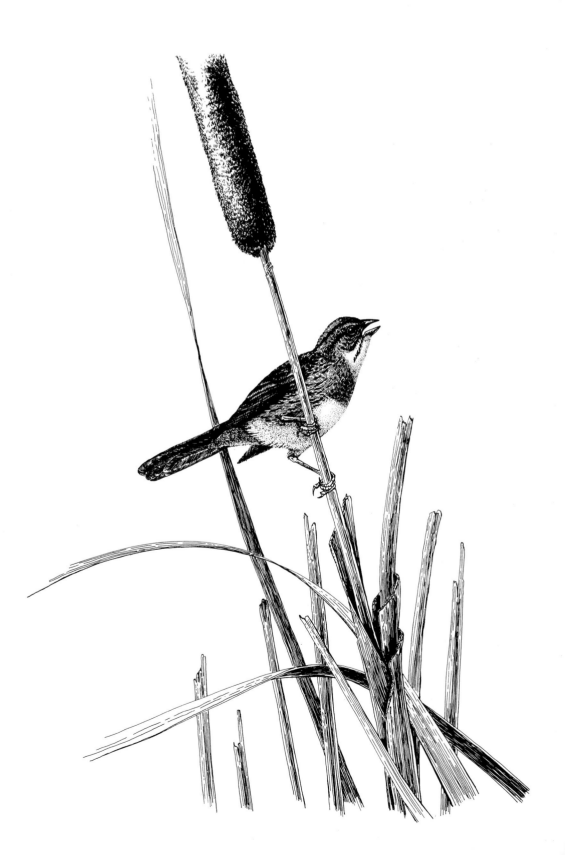

THE
TECHNICAL
PEN

GARY SIMMONS

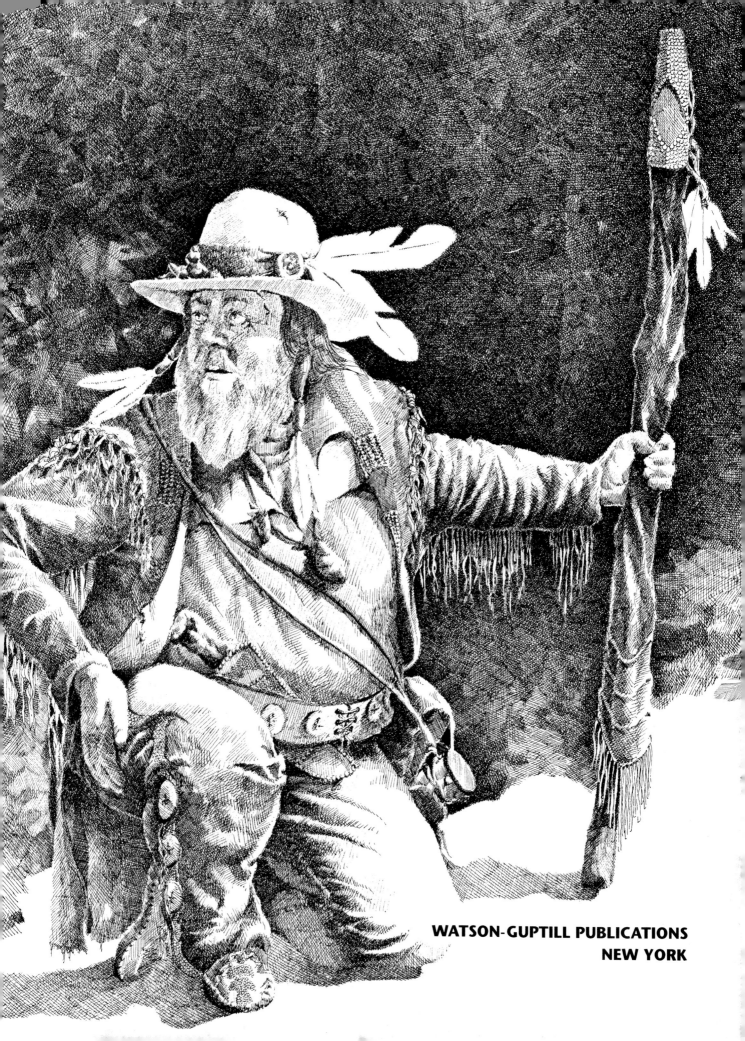

WATSON-GUPTILL PUBLICATIONS
NEW YORK

Half-title page: Drawing by Ralph Scott.

Frontispiece: *The Presence.* 28" x 35". Obscuring images within images is a form of camouflage. The indistinct edges of layered lines can appear haphazard, however, so images should be carefully constructed before the figure-ground relationship is confused. This figure contains the camouflaged face of an Indian over a mountain man's right shoulder. The face, the foliage, and the mountain man were all set up with precise edges, which were then obscured by patterns of contrast. The details of the Indian's features and the leaves were developed until they blended, leaving it unclear whether shapes are features, leaves, shadows, or sunspots. Using just layered parallel lines would have prematurely blurred the Indian's face. Collection of Mike and Sue Simmons, Benton, Arkansas.

The name Rapidograph® is a registered trademark of Koh-I-Noor Inc., Bloomsbury, New Jersey. Throughout this book use of the registered symbol ® with this name is implicit.

Photographs on pages 9–22 by Mike Kelley.

Senior Editor: Marian Appellof
Associate Editor: Carl Rosen
Designer: Bob Fillie, Graphiti Graphics
Production Manager: Ellen Greene

First published in 1992 by Watson-Guptill Publications, a division of BPI Communications, Inc., 770 Broadway, New York, NY 10003

Library of Congress Cataloging-in-Publication Data
Simmons, Gary.
 The technical pen / Gary Simmons.
 p. cm.
 Includes index.
 ISBN 0-8230-5227-3
 1. Pens. 2. Pen drawing. I. Title.
TS1262.S56 1992
741.2'6—dc20 92-14338
 CIP

Manufactured in the United States of America.
Color section manufactured in Singapore

First printing, 1992

9 10 11 12/03 02 01

ACKNOWLEDGMENTS

In the early 1980s Koh-I-Noor Rapidograph began running a series of ads featuring the works of artists that exemplified the potential of the technical pen. The series was the brainchild of Koh-I-Noor's Vince Trippy. It received so much attention that it was surely a major contributor to the growing popularity of this medium. As one of the contributing artists, I was perhaps most interested and pleased to discover how well the pens could be used for virtually all kinds of techniques and subjects. I think that these ads set the standards for many aspiring pen artists. Some of the artists who contributed to the Koh-I-Noor series have graciously granted permission to include their works in this book. Their work represents the broad potential of the technical pen when used by artists willing to bend talent to experimentation and imagination.

I wish to acknowledge a host of individuals who circled the wagons to keep the distractions out and to keep me in. Bob Coe, Vince Trippy, Ed Brickler, and the rest of the Koh-I-Noor staff have been generous with encouragement, materials, and assistance and in holding workshops in which much of this book's content was developed. Nora, Lynn, and Jack of Artists and Display in Milwaukee sponsored my first workshop and became a second family. My wife, June, and daughters, Jamie and Rebecca, patiently endured my diatribes about "the book." Fellow artist Richard Stephens has been a spiritual and business partner in most of the endeavors reflected in the book's artwork. Ed Martin, my chairman, and the administration of Henderson State University gave me encouragement and logistical support in the final stages of this effort. And finally, Candace Raney, Marian Appellof, and Carl Rosen of Watson-Guptill showed great patience with me throughout the publication process. To these individuals and to the many unidentified friends in the wagons, I say thanks.

Wolf Robe's Dream. 28" x 36". The uniform tonality in the eagle's outer feathers is created with individual curvilinear strokes. The inside feathers were created with the same kind of individual lines but were crosshatched to add value and texture. The cast shadows on Wolf Robe's face were crosshatched evenly to keep the texture smooth. Collection of Dr. George and Mimi Ryan, Memphis, Tennessee.

CONTENTS

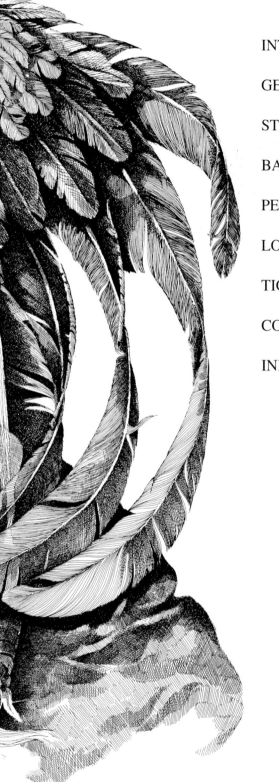

INTRODUCTION 8

GETTING ALONG WITH TECHNICAL PENS 10

STRATEGIES FOR PEN AND INK 24

BASIC PEN STROKES AND THEIR USES 40

PEN STROKES IN DESIGN AND COMPOSITION 68

LOOSE PEN-AND-INK DRAWING TECHNIQUES 86

TIGHT PEN-AND-INK DRAWING TECHNIQUES 104

COLOR AND THE TECHNICAL PEN 130

INDEX 144

INTRODUCTION

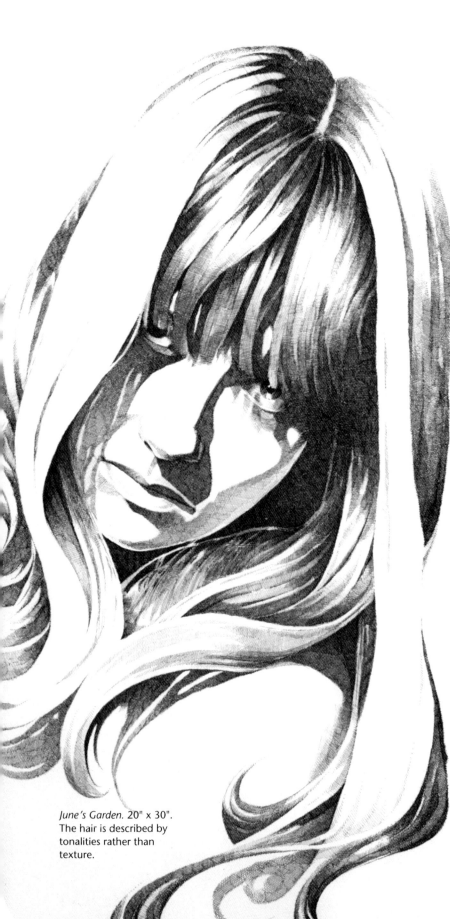

June's Garden. 20" x 30".
The hair is described by
tonalities rather than
texture.

The technical pen is a tubular-nib ink pen
designed specifically for India ink. Its point
is different from the traditional India ink
penpoint, which has a flexible nib like a
quill pen. Unlike the flexible-nib pen,
which can produce varying line widths
with a change of the artist's hand pressure,
the technical pen's constant ink flow from
its cartridge and its inflexible point
produces a constant line width. Its small
tubular metal point moves over the drawing
surface with a general disregard for the
direction of the paper grain, making it
much easier to use than the traditionally
temperamental nib pens. It was originally
designed for technical and architectural
drafting, so its points make precise line
sizes that are reflected in the pen's point-
size designations.

I work chiefly with the Rapidograph, a
trade name for a technical pen made by
Koh-I-Noor. The Rapidograph was first
produced in 1954 by Koh-I-Noor and its
German parent company, Rotring.

There are several different brands of
technical pens (Staedtler, Castell, Alvin,
Letraset, etc.), but Rapidograph is
responsible for about 80 percent of the
world's technical pens, and among artists,
it has become almost synonymous with the
technical pen. For this reason, and because
the majority of my own pen experience is
with Rapidograph, I have chosen to address
the technical part of this book to
Rapidographs. I am not discouraging the
reader from trying or using other types of
pens; in fact, that is the best way to find the
most personally suitable instrument. The
techniques discussed in this book are
appropriate to any technical pen, and even
to the traditional nib pen, particularly in
terms of pen-and-ink theory.

I have used my own drawings as the
main resource for this book (works
appearing without an artist credit are my
own). My work represents a combination
of large, very seriously constructed
drawings and loose, very personal
sketchbook materials evolved over the
years in a rather constant practicing with
the pen. I realize the limitations of some of
the sketches, but they are at the core of
most pen-and-ink processes and adequately
demonstrate many of the techniques and
strategies that are often overlooked.

APPROACHING THE MEDIUM OF PEN AND INK

Quite often, pen and ink is feared because it is monochromatic and noncorrective. More specifically, the technical pen is viewed as too temperamental to be very useful or worth the effort of mastering. There is just enough truth in both these fears to prevent some artists from learning the medium. Pen and ink is probably no more unforgiving than watercolor. Pen and ink looks difficult because it is a blizzard of small marks that works cumulatively, obscuring the principles of its construction. But it's quite manageable when you understand the nature of its limitations, when you know what the pen is supposed to be doing for you, and when you do some planning in order to avoid the medium's pitfalls.

Technical pens can indeed be temperamental, but it's more from their misuse than from poor mechanical design. The technical pen is a relatively new medium (invented in the 1950s), and it has had to evolve. Many of the charges leveled at it stem from artists' experiences with earlier pen designs. I want to correct some of the misconceptions by helping artists understand how the pen works, what it's supposed to do, and how to keep it working.

LEARNING FUNDAMENTALS, NOT FORMULAS

Pen and ink is not a matter of knowing the right formulas for specific subjects, such as strokes that produce trees and others that produce clouds. These kinds of rote applications are limiting, because they solve very narrow problems.

Most beginners assume that the most challenging problem with the pen is drawing an accurate shape, when in fact, the most critical problem is controlling the cumulative effects of the strokes. Once you understand the nature of those effects, you can master the techniques that let you control the process as you wish. I have tried to present the fundamentals of the medium so that you can build a technique that suits your particular interests.

The following list of basic points represents the logic you need to bear in mind as you apply pen strokes. This logic is based on the fact that you are doing a lot of things with one instrument, usually with one color, and sometimes with one set of strokes. Once you recognize the limitations of the medium, you can discover your own

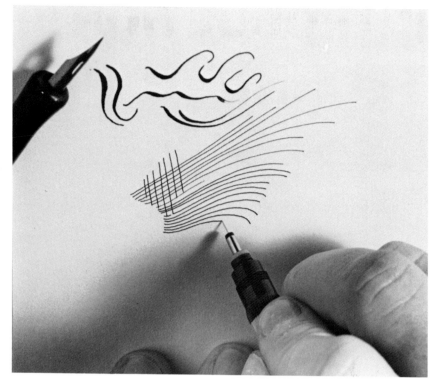

Both technical pens and flexible-nib (quill) pens are shown here with examples of the lines they produce. Technical pens are designed to make a consistent line every time they touch the page. Pens with flexible nibs produce lines of varying thicknesses depending on how much pressure is applied to the point.

methods for circumventing those limitations:

1. Pen technique is not a series of isolated pen strokes but a patchwork of cumulative applications developed one shape at a time. Each series of pen strokes works with all the others to comprise the subject's overall impressions of volume, value, texture, and color.

2. Any pen stroke can create impressions of volume, value, texture, and "color" (color here means the overall value of a shape. In black and white, this translates to an overall shade of gray that is separate from the shapes that indicate texture or shadows), particularly when it's used to form a pattern.

3. As pen strokes describe one attribute of a shape, such as its volume, it is simultaneously creating impressions of other attributes, such as value, texture, and color. Understanding this simultaneous function of pen strokes enables the artist to avoid the snare of creating unintentional effects.

4. The nature of the pen limits what any of its strokes can do. Regardless of the pen technique, all pen strokes are either lines or

dots, monochromatic (usually black), extremely narrow, and consistent in width during any one stroke.

5. The limited nature of strokes from a technical pen must achieve all effects in one of two ways. They either stand alone as a single shape or together as a single shape. A pen stroke stands alone as a shape when it outlines a shape's edges (as in a coloring book) or symbolizes a shape (such as a wavy line for a hair). When working together, however, strokes accumulate as patterns and represent values (shadows on a tress of hair), texture (curls or waves), and local color (brunette or blonde) for any one shape.

Given these basic parameters, you are ready to learn how versatile the technical pen can be when properly handled. Before any principles of pen and ink can be successfully applied, you have to be comfortable with the pen itself. Like any other art instrument, the technical pen works best when you are comfortable with it, when you know the pitfalls to avoid with it, and when you know whether your problem with a drawing is the pen or your own technique.

GETTING ALONG WITH TECHNICAL PENS

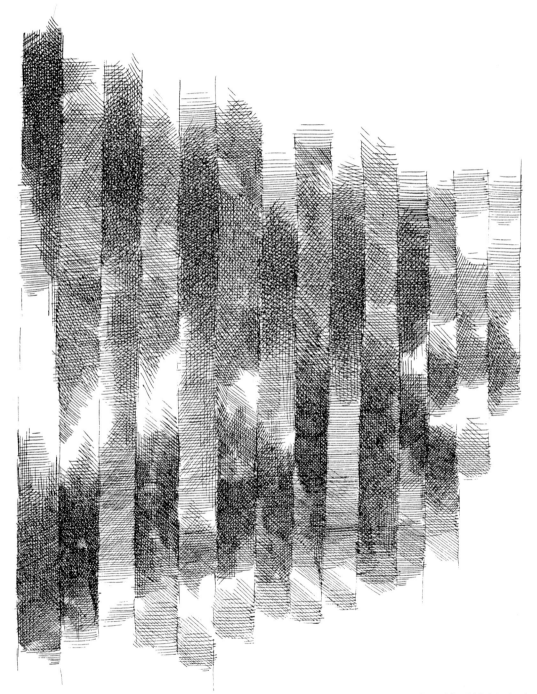

Bars. 8" x 10". Much of a pen stroke's appeal comes from the inherent texture of a mark on a page. Applied abstractly, these strokes form a nonfigurative composition with pleasing textures and values.

Understanding the technical pen inside and out lets you work confidently. When you choose among the various technical pens available from different manufacturers, you should be aware of the range of point sizes and how these sizes are designated, the variations in the point materials, and the variations in cartridge design.

It is equally important to know how to fill and refill the technical pen, how to clean and maintain it, how to spot and stop trouble if it occurs, and what inks and surfaces are available.

HOW THE TECHNICAL PEN WORKS

The pen's ink flows from its cartridge as a result of air pressure and gravity. The air supply into the ink cartridge comes from the penpoint during the stroke.

Tiny air bubbles float up through the point into the cartridge and push down on the ink. A vent channel on the point assembly allows air outside the pen to equalize the pressure inside the pen, thus maintaining an even flow of ink. When the channel is clogged, vapor locked occurs and the ink can't flow. Clogging results from shaking the pen, which causes air to expand, forcing ink into the channel.

Within the point's tubular nib is a tiny wire attached to a weight, the pen's only moving part. As the pen is tilted or shaken, the weight moves the wire up and down, controlling ink flow and removing any debris in the point.

Point Sizes

The Rapidograph technical pen comes in thirteen different point sizes, which are designated in four different ways:

The *North American Standards* designation identifies the points in fractions of an inch, beginning with .005 inch and ranging up to .079 inch. These widths are compatible with the standard American sizes and calculated with a geometric progression of the square root of 2 (1.414). The decimal sizes are not indicated on the pen parts.

The *metric designations* range from .13mm to 2.00 mm. These sizes are indicated on the cap's plug and on the base of the point.

The *numerical designations* are an arbitrary scale of numbers assigned to the pens in their early development. They range from 6x0 (*six-aught*), the smallest, to #7, the largest. This size designation is indicated on the cap plug as well as the base of the point.

The *color code* assigns a different color

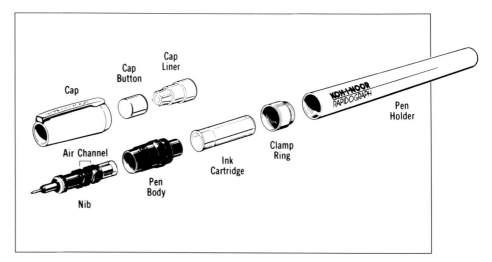

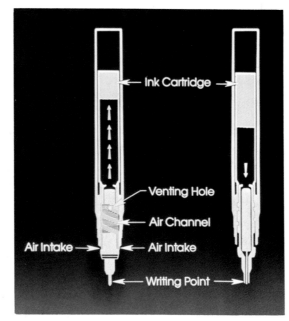

Exploded diagram of pen parts (above). Rapidographs disassemble into six basic parts. Note that the cap button and cap liner remain in one piece. Likewise, the cleansing wire and weight remain in the pen nib at all times. Courtesy of Koh-I-Noor.

Cross-section of air-flow channels (left). The pen's ink flow occurs from gravity and from air pressure above the ink in the cartridge. Dried ink in the air-flow channels is the most common cause of malfunction. Courtesy of Koh-I-Noor.

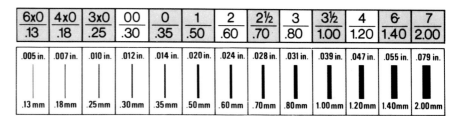

6x0	4x0	3x0	00	0	1	2	2½	3	3½	4	6	7
.13	.18	.25	.30	.35	.50	.60	.70	.80	1.00	1.20	1.40	2.00
.005 in.	.007 in.	.010 in.	.012 in.	.014 in.	.020 in.	.024 in.	.028 in.	.031 in.	.039 in.	.047 in.	.055 in.	.079 in.
.13mm	.18mm	.25mm	.30mm	.35mm	.50mm	.60mm	.70mm	.80mm	1.00mm	1.20mm	1.40mm	2.00mm

Width chart and metric pen nib sizes. Rapidograph penpoints are available in thirteen nib widths. There is a separate penpoint for each width. The most useful to the artist are sizes 4x0, 3x0, #0, and #2. Courtesy of Koh-I-Noor.

to each pen size. Any one pen will have the same color on the cap plug, the penpoint, and the clamp ring. This is serviceable for quick identification of a pen, whether capped or not, and for identification of a pen's parts when it is disassembled.

Choosing the Appropriate Size

Thirteen pen sizes were originally designed for architects, engineers, and draftspersons who needed a considerable range of very predictable line sizes for their blueprints, charts, and lettering devices.

Artists generally use only the smaller point sizes. Points that exceed #2 are difficult to draw with, requiring a fairly

vertical position and failing to flow very well with quick pen strokes. The larger points are serviceable for outlining, for lettering, for ruling, and for very controlled line work such as borders.

The most useful pen sizes for artists tend to be 4x0, 3x0, #0, and #2. One of the original point sizes (5x0) has been omitted from the Rapidograph line.

The 3x0 Rapidograph is fine enough to achieve very delicate results, but not so fine that it is temperamental. When sketching, a #0 or #1 is favorable, because the points are not so fine that they snag the paper during quick, gestural strokes.

When using color inks, it is impractical

to clean one or two pens every time you want to change colors. I would recommend a series of 3x0, #0, and #2 for about five different colors. This is obviously the kind of situation you need to work out to fit your personal working style.

Generally, choose pens that are consistent with the kind of drawing you intend to create. Your choice determines the potential success of the technique you have chosen. The size of the point affects the precision and texture you can achieve in the drawing. Pen strokes remain obvious on the page, even after lots of other strokes have been made over them. The smallest point sizes enable you to create light grays

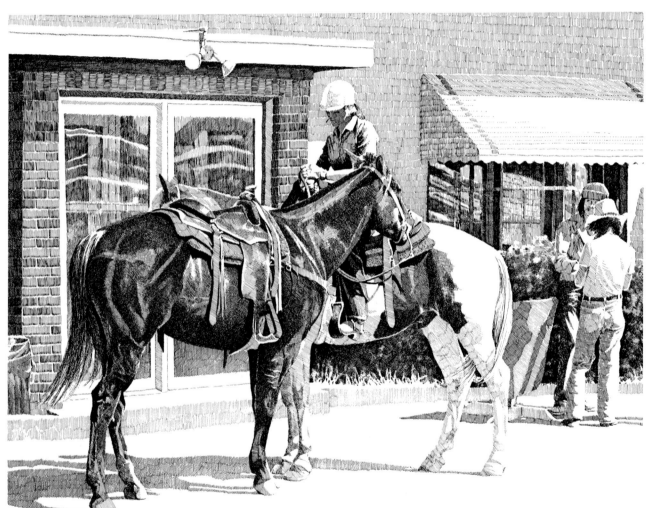

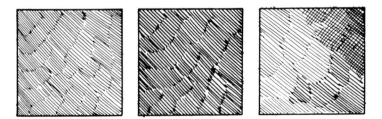

Point size makes a major difference in how subtle a drawing is. The pen strokes (bottom left) with a 3x0 point at far left represent a basic hatched pattern. The strokes in the center are the same pattern done with a #1 pen, and at right are 3x0 strokes covered with #1 strokes. Note that the #1 line continues to dominate the pattern even when it is covered with 3x0 lines. Because of this effect, begin your drawings with smaller point sizes and use the larger ones only when you are willing to accept coarser textures.

with very little texture. Larger point sizes give you strokes that are dynamic and black. One of the central virtues of technical pens is that they can produce an incredibly refined pattern of lines, enabling you to create very small, specific shapes and to blend patterns of line into very subtle values.

The delicacy I achieve in the tonalities of a drawing is partly owed to working large shapes with small pens. Working with bigger pens simply reduces subtlety. The smaller the pen and the larger the drawing, the more refined the overall effect. If the shape is very small and the pen is large, every stroke becomes a shape. Large shapes and small pens, however, give you the opportunity to make several strokes per shape, so the strokes become less critical, and the resulting pattern is much more subtle.

If you work with a point size that is too large, the shapes become clumsy, and the blending is inhibited by the obvious presence of earlier pen strokes. In this case, your eye sees the individual lines much more than it sees the blend or patterns. This is no problem if you're viewing the drawing from fifteen feet, but that's not how people look at pen-and-ink drawings.

When choosing the appropriate size penpoint to work with, keep in mind that artwork is most often reproduced in one of two ways. The most common method of reproduction is the *line negative*. Each stroke (or line) is reproduced in one color only, typically black. In order to produce a value other than black or white, space must be used between strokes. The more distance between strokes, the lighter the value looks, producing gray values between the extremes of black and white. This method is fine unless the original art is extremely reduced in the final printed version. In reductions, the space between the strokes can disappear, making the pattern look black instead of gray. Color, if added to a drawing, also tends to come out black in a line negative.

A solution to the problems associated with extreme reduction and color use is the *halftone negative*. In this method, printing can still be in just one color because every mark in the drawing is broken up into dots. The denser areas of the drawing have a lot of dots, and the lighter areas have fewer. To the eye, the printed art looks like it is made up of black, gray, and white values. This method, however, is not recommended unless the drawing is reduced to some extreme percentage such as 35 percent or less of the original size. Anything larger makes the drawing look as though it were done in gray ink.

Very refined shapes and tonalities can be created in a large pen drawing by working with small pens. In *The Old Oaklawn Kitchen*, 20" x 30" (opposite page top), each shape is comprised of many strokes, enabling the artist to build the shape and to correct it as it progresses. Working on smaller drawings with larger pens, such as the small facial studies (right), produces a coarser but more dramatic effect than working with the smaller pens.

If drawings are to be reduced for reproduction more than about 40 percent, the pen strokes and their texture remain most visible when the original is done with #0 and larger pens.

The large drawing of Lincoln, 24" x 30" (left), was done entirely with a #2 pen. Crosshatched work reduced more than 30 or 40 percent should be reproduced as 150- or 200-line halftones. Print collection of Arkansas Governor Bill Clinton, Little Rock, Arkansas.

Point Materials

The most common point material is hard-chrome stainless steel. Rapidograph also offers its thirteen pen sizes in jewel points (7-J) of synthetic sapphire and Tungsten Carbide points (7-T). These points are for artists who work on such abrasive materials as polyester, acetate, or Mylar. Jewel points have a "self-wetting characteristic" that makes it very smooth, but the tip is more fragile than metal and can shatter if dropped. Jewel and Tungsten Carbide points are about twice as expensive as stainless steel ones, but are reputed to last thirty times longer if properly maintained.

Variations in Cartridge Design

The Koh-I-Noor 3165 Rapidograph technical pen uses a refillable cartridge that will accommodate India ink, dyes, or liquid acrylics. The breathing mechanism for this system is built into the penpoint.

The Rotring Rapidograph pen uses a system of prefilled cartridges that are discarded when empty. This system has the breathing mechanism built into the cartridge itself. The intention is to avoid clogging by installing a clean breathing system with each new cartridge. The cartridges are sealed and contain a double rotating helix designed to control the flow of expanding ink when it gets warmer, preventing the ink from leaking to the outside of the cartridge.

This pen comes in ten sizes (.13mm to 2.0mm). The prefilled cartridges are available in six colors (including black). One criticism of this pen is that the ink, which contains a chemical additive to prevent its drying in the system, is not as waterproof as the traditional India ink. The limited color selection can also be a problem.

The Rotring Rapidoliner technical pen has a sketching point with a larger radius on the point, making it a little more rounded than the #3165 and more responsive when sketching. It uses a disposable point and prefilled cartridge, all in one unit. Point sizes come in four widths (.25mm, .35mm, .50mm, and .70mm). Black ink is the only color available in the cartridges.

OTHER PEN MANUFACTURERS

All technical pens operate on similar principles. Other popular brands, such as Staedtler, Castell, and Alvin, have their own recommendations for care and their own systems for size designations, assembly, etc. The best recommendation is

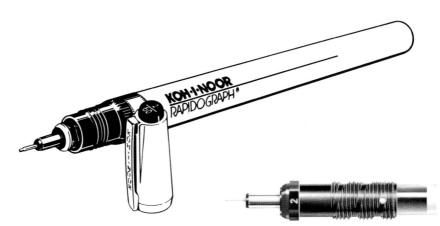

Koh-I-Noor Rapidograph pen, replacement point, and point capsule. The Koh-I-Noor Rapidograph technical pen uses refillable cartridges and has the breathing system in the pen nib.

Replacement point. A close up of the point shows the spiral air channels and the breathing hole that send the air into the ink cartridge.

Rotring Rapidograph pen and cartridge.

The Rotring Rapidograph pen uses prefilled disposable cartridges that contain the pen's breathing system. The rationale for this construction is to avoid dirty penpoints and to start each cartridge with a whole new breathing system, which is based on a helix arrangement that confines the flow of any extra ink to the cartridge instead of the point. This pen is available in 10 line widths, and cartridges are available with ink in 6 colors. All figures on this and facing page are courtesy of Koh-I-Noor.

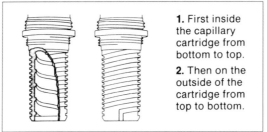

1. First inside the capillary cartridge from bottom to top.

2. Then on the outside of the cartridge from top to bottom.

Cutaway of Rotring cartridge design.

Line thickness mm	Color code
0.13	violet
0.18	red
0.25	white
0.30	olive
0.35	yellow
0.5	brown
0.7	blue
1.0	orange
1.4	green
2.0	light gray

Rotring line width chart.

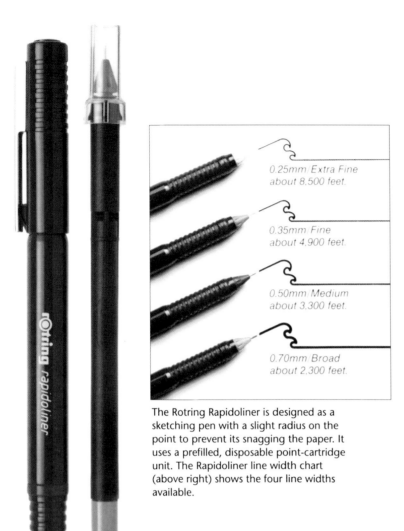

The Rotring Rapidoliner is designed as a sketching pen with a slight radius on the point to prevent its snagging the paper. It uses a prefilled, disposable point-cartridge unit. The Rapidoliner line width chart (above right) shows the four line widths available.

0.25mm/Extra Fine
about 8,500 feet.

0.35mm/Fine
about 4,900 feet.

0.50mm/Medium
about 3,300 feet.

0.70mm/Broad
about 2,300 feet.

to familiarize yourself with different pens and make a choice based on your own needs.

FILLING THE PEN

Be sure to save the packaging, which includes printed instructions that tell you about loading, disassembling, and cleaning the pens. Also, don't throw away the plastic cap on the package. It is a nib-wrench for twisting the point out of the pen holder if it is too tight or is stuck. Be warned that the point should be hand tightened and the nib wrench should be used only for loosening the point, not for tightening it.

To fill the pen, first take it apart: Remove the cap from the barrel, the barrel from the clamp ring, the clamp ring from the pen holder, and pull the cartridge from the pen holder. The clamp ring sometimes unscrews with the barrel, but this is no problem. When filling the pen, do not remove the penpoint from the pen holder.

Tip the cartridge and fill it with ink to the embossed fill line about a quarter inch from the opening. Overfilling will cause the extra ink to leak around the cartridge clamp ring and sometimes down into the point. It is not necessary to fill the cartridge to capacity, but doing so limits the amount of air that is likely to get into the pen's system and cause the pen to skip. The cartridge has a chemical coating that prevents the ink from adhering to the sides, enabling you see how much ink is in the cartridge. Eventually this coating will wear off, but it won't affect the cartridge's function.

To reassemble the pen, push the filled cartridge back onto the pen holder and secure it with the clamp ring. Screw the barrel onto the clamp ring.

Starting the Ink Flow

Hold the pen vertically with the point down for about 30 seconds and tap the top of the pen a few times with your finger to start the gravity flow of ink down into the penpoint. If that doesn't work, give the pen a gentle horizontal shake to start the ink flow. Vigorous or vertical shaking forces excess ink into the point and down into the air channels.

Try drawing a line, and if the ink flow hasn't started, turn the penpoint up and tap the butt of the barrel on a hard surface two or three times in the same manner that people sometimes tap cigarettes against a table. This action pushes the air out of the pen assembly and up to the top of the ink cartridge. This particular action is by far

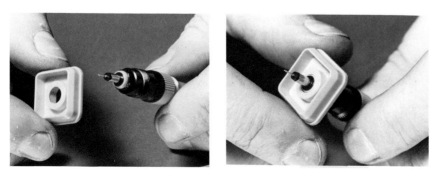

Nib wrench and package (left) and hand unscrewing point with nib wrench (right). The plastic cap on the pen package is a nib wrench for loosening penpoints that are stuck.

the most reliable way I have found of starting and restarting the pens.

Once the ink flow has started, you should be able to draw a continuous line about two feet long without any skips. If the pen does skip, tap it point up again and retry it. Repeat this until it quits skipping. Occasionally, the pen skips because you have not really filled the cartridge with ink. An air bubble over the mouth of the cartridge can make it appear full of ink, particularly when refilling the cartridge.

Hold the pen at an angle comfortably in the same way you would hold a pencil. The only time it is necessary to hold the pen vertically is to achieve absolute accuracy of line width for borders or other ruled lines. Even then you can get away with a vertical tilt of 12 to 15 degrees.

Because the pen is gravity fed, working with the penpoint higher than the cartridge will usually lead to difficulty with ink flow.

Refilling the Pen

This is the most likely time you will shake ink onto your drawing.

If the pen starts skipping or must be restarted every few strokes, it is probably dry. It is not unusual to nurse a skipping pen through several minutes of frustration before realizing that you perhaps should check the cartridge for ink.

When you refill the pen, watch out for the ink remaining in the point. As you push the refilled cartridge back onto the pen body, the air in the cartridge may force some of that residual ink out of the point or out around the sides of the point assembly. You will not necessarily see the extra ink, but it is lurking at the opening, right where the penpoint screws into the pen holder. When you shake the pen to restart it, you will shake this ink out onto your drawing and/or your clothes.

There are two ways to avoid shaking ink onto your drawing. The most obvious solution is to break yourself of the tendency to shake any pen over your artwork. The second solution is to take a paper towel and, with your thumbnail, wipe the penpoint and the shoulder of the pen assembly where it is screwed into the pen holder, just in case there is some extra ink there.

Ink sometimes spills over the clamp ring, and the shellac in the ink will freeze the ring into place. Try to keep this area clean, or rinse it if you know that there is ink on the ring.

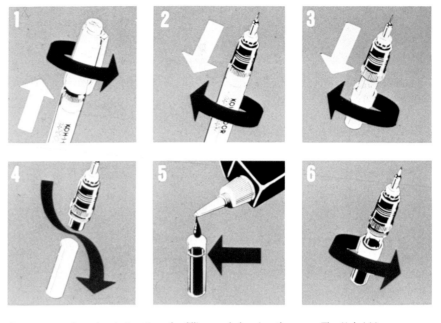

Every pen package has instructions for filling and cleaning the pens. The Koh-I-Noor instructions begin with filling the pen: Unscrew the cap (1), holder (2), and clamp ring (3) from pen body. Pull cartridge from pen body using a slight twist (4). Fill cartridge only to a line 1/4" from top (5). Slowly press pen body down into filled cartridge using a slight twist. Replace clamp ring to secure cartridge (6) and thread holder onto pen body.

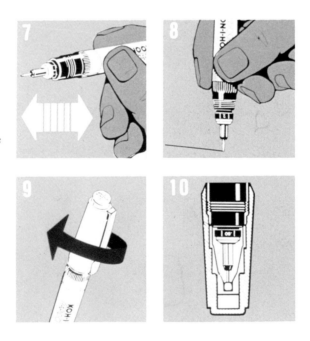

The Koh-I-Noor instruction sheet continues with instructions on how to start the pen: Start ink flow with a gentle horizontal shaking motion (7). Holding pen in a vertical position, draw on scratch pad until a good ink flow appears (8). After using the pen, replace the air-tight cap liner (9). When secure, the cap prevents ink from drying (10). All figures on this and facing page are courtesy of Koh-I-Noor.

CLEANING THE PEN

To disassemble the pen, remove the cap, barrel, clamp ring, and cartridge (if necessary, use the nib wrench from the top of the pen's plastic carton). Throw out any remaining ink in the cartridge, and remove the pen nib from the pen body.

Do not remove the cleansing wire and weight from the penpoint assembly. Occasionally this happens inadvertently, particularly with an ultrasonic cleaner. If it does, don't force the wire back into the point. Sit the wire into the point and gently jiggle the point until the wire finds the hole and seats itself. Any point that is smaller than 00 is probably a lost cause, but it is worth a try.

Flush all the parts with water, then clean them with a pen-cleaning solution that will cut the shellac in the ink. If for some reason you can't get to the cleaning immediately, at least put the pen parts into a container of water or cleaning solution until you can.

Flush the pen body and the pen nib using a pressure syringe or paper towel so that all the ink is removed from the interior of the pen parts. A syringe, such as the Koh-I-Noor 3068-SYKT Syringe Pressure Pen Cleaner, in combination with a commercial pen cleaner, is particularly important. It encourages cleaning, since it is fast and relatively unmessy. This one tool may save you more penpoints than anything else you can buy. Either the pen holder (with the pen nib still attached) or the pen nib itself can be threaded into the syringe for flushing. Immerse the pen body completely in the cleaning solution (pen-cleaning solution is preferred, but I've successfully used water in a crunch), then flush the solution through the pen body and nib assembly using a slow squeeze-release pressure action. Repeat this flushing action until the nib is clean. Remove the pen body, nib assembly, and

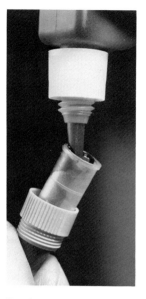

Hand pouring ink into cartridge. Tipping the cartridge for filling will help avoid bubbles in the ink. The ink will run down the inside of the cartridge until it meets the fill line.

Hand tapping top of pen. The most preferable way to start the pen when it is first filled is to tap the top of the pen while holding it point down.

Hand rapping pen on table. After tapping the pen, turn the point upward and sharply rap the end of the barrel against a hard surface to kick the air to the top of the cartridge.

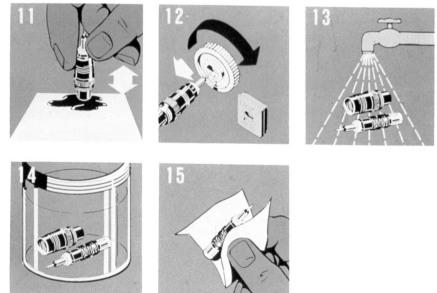

According to Koh-I-Noor's instruction sheet, cleaning is recommended before each refilling. Disassemble pen following directions 1-4 (see p. 16). Gently tap rear of pen body on paper wipe to remove residual ink (11). Using nib key, unscrew nib from pen body (12). (Circular nib keys are included with pen sets. The square color-coded end cap of the individual pen packaging tube is the nib key.) Clean nib and pen body under lukewarm running water (13) or by soaking in Rapido-eze pen cleaning solution (14). Shake out remaining liquid. Dry nib and pen thoroughly with paper wipe (15).

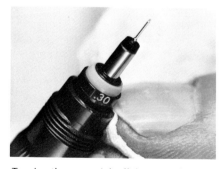

To wipe the excess ink off the penpoint, use your thumbnail to press a tissue around the point and slightly under the collar of the threads.

syringe from the cleaning solution and force excess liquid out by repeating the squeeze-release action with the syringe. The pressure from the bulb forces out all residual ink so you don't have to use a paper towel to leach out the residual liquid from the point, as you would do if you just rinsed or soaked the point.

This same syringe has a small plastic attachment that allows you to insert the pen nib point first into the syringe and to start the ink flow with the suction from the bulb. This is sometimes handy if there is debris or some other obstruction in the point.

Build-up of the ink's binder, such as shellac or latex or acrylic resin, is a problem with pens that have been neglected. Water alone doesn't break down binders. For difficult cleaning problems, soak the parts overnight and then use an ultrasonic pen cleaner for a minute or so with a commercial cleaner or alcohol. Be sure you avoid using any kind of plastic solvent.

Ultrasonic cleaners are simply reservoirs that vibrate at a high frequency, breaking loose and shaking off any hardened ink that might be coating a pen's mechanisms. Their virtues are that they can affect ink that is resistant to soaking, as well as the internal parts of the pen that might not be reached by cleaning solutions alone. Ultrasonic cleaners come in a variety of sizes and prices. My first one was a small (2 oz.) K&E Leory unit, which cost about $40.00. I later replaced it with a Rapidograph 25K42, which can handle nearly a pint of pen cleaner and retails for about $100.00. You can also use an ultrasonic jewelry cleaner instead. Any of the units are easy to use: Just fill the ultrasonic bowl with water or cleaner, drop the penpoints in, and let it vibrate for as long as it takes to clean the points. Normally the process takes a few minutes.

MAINTENANCE

Good maintenance is the key to extending the life of your pen's mechanism. If you use the pen on a daily or weekly basis, the ink usually remains liquid and the pen works with a modest amount of coaxing. If you don't use the pen for two weeks or more, you are risking dried ink in the pen's mechanism. At that point, you would have to thoroughly clean the pen, and there is a chance that the pen could not be cleaned well enough to work again.

The most important mindset you can adopt for successful use of the technical pen is based on the realization that

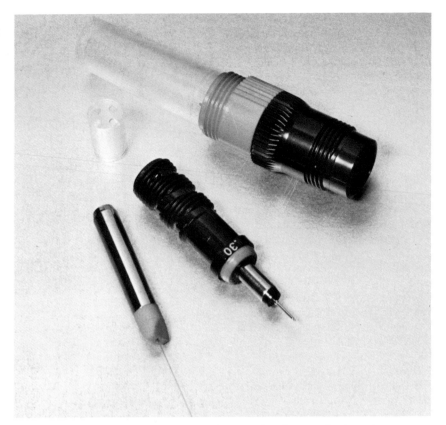

Penpoint, pen holder, and cleansing wire. After removing the penpoint from the pen holder, do not intentionally remove the cleansing wire and its weight from the pen nib. Sometimes the small plastic cap keeping the weight in the point will accidentally come off or will be vibrated off in an ultrasonic cleaner. If that happens, do not try to insert the wire back into the point. Doing this almost certainly will bend the wire and ruin the pen.

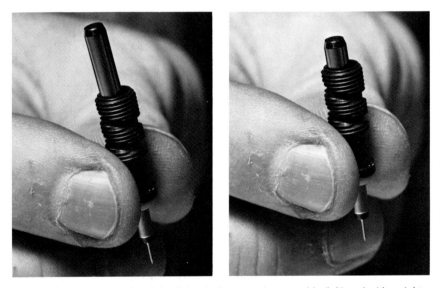

Fingers holding point with weight sitting in the penpoint assembly (left) and with weight seated down into the penpoint after jiggling it (right). The best option is to gently set the wire into the point, jiggle the point, and let the wire find the hole and seat itself.

cleaning is a quick and simple process if done routinely. Most resistance to cleaning or to even using technical pens is based on the memory of having ink on your hands, of struggling with the removal of a point that is encrusted, or of endlessly soaking a point and trying to make it work. Actually, almost any painting, printmaking, or photography cleanup is much more troublesome than a five-minute pen cleaning. Here are some maintenance tips to make using the pens a simple operation:

1. Clean routinely. Clean every month or two if the pen is used daily. Clean every week or two if the pen is used weekly. Clean anytime you have doubts about how soon you will use the pen again. The manufacturer understandably recommends a much more rigorous cleaning schedule than any of us maintain. Generally there are minimal problems if you use and clean the pen weekly.

2. Listen for the rattle of the cleansing wire. The only moving part in the pen is a small cleansing wire attached to a cylindrical weight. This weight is what you hear rattling when the pen is shaken and when the pen is in working order. No rattle means that the wire is bent, that ink has dried and frozen the weight into a fixed position within the penpoint, or the weight has been broken off the wire. If any of these circumstances occurs, you may have to get a new penpoint.

3. Prevent ink from drying in the pen. The cap is designed to prevent the ink from drying out. Its double threads seal the cap on the pen's barrel, and a small rubber ball in the cap liner seals the penpoint's opening when the cap is on. The cap should be habitually placed on the pen when it's not in immediate use, even if it's a matter of minutes. This prevents the ink from drying out, and it also prevents damage to the point when it inevitably rolls off the drawing board or is scraped against some hard edge.

4. Protect the plastic parts. The majority of the pen's parts are plastic, so any excessive tightening of threaded parts will eventually split them. When you screw the barrel onto the clamp ring, the length of the barrel gives you a mechanical advantage that enables you to really shower down on the threads. Moderate hand-tightening is enough. The clamp ring holding the cartridge onto the penpoint is particularly vulnerable to damage. When

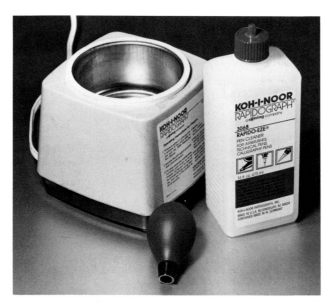

The top left photograph shows the ultrasonic cleaner (1), syringe bulb (2), and cleaning solution (3). The next photograph (below left) shows the bulb with penpoint being inserted, and the third photograph (below right) shows the penpoint being immersed in the solution.

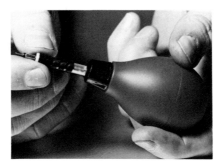

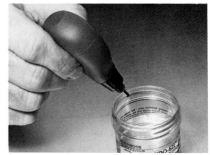

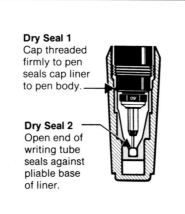

Dry Seal 1
Cap threaded firmly to pen seals cap liner to pen body.

Dry Seal 2
Open end of writing tube seals against pliable base of liner.

Cross section of cap with penpoint threaded into it. It is important to form a habit of replacing the pen's cap when you're not using it, even for a minute or two. The point of the pen is fragile, as you will learn when you accidentally jam the point into your drawing board or drop the pen. But even more of a problem is allowing the ink to dry out in the point when the pen is inert. The cap is designed specifically to help prevent the problem. It is threaded in such a way that a seal is formed at the shoulder of the pen holder and at the tip that seats into a pliable bead. Courtesy of Koh-I-Noor.

the cartridge is overfilled, the spillage gets ink on the clamp ring threads and seals the ring onto the penholder.

TROUBLESHOOTING RAPIDOGRAPHS

The following are some of the problems you are likely to encounter with Rapidographs. The solutions I suggest are not guarantees, but they are a place to start.

The first line of attack should always be cleaning the pen, since so many problems stem from dirty points. As with any piece of equipment made to fine tolerances, there are occasionally mysterious problems that solve themselves, seem to have happened for reasons completely beyond you, and may never happen twice. Don't fight it!

Leaking

1. The clamp ring that secures the cartridge to the point may be cracked, allowing air to force out ink in a drip at the point. Get a new ring and clean the pen.

2. The cleansing wire may have been pulled off the weight, especially in larger points. Get a new point assembly.

3. There may be residual ink in the point after the pen has been filled. Clean the pen.

4. The ink cartridge has been overfilled; excessive ink is forced out through the point and around the sides of the point

assembly, clogging the breathing channels. Clean the pen.

5. A radical change in air pressure from altitude (when flying or driving) or from temperature (hand or environment) can cause the air in the ink cartridge to expand and to force ink into the point. If the point is capped, the ink will flow out around the point and into the cap. Clean the pen.

6. Vigorous shaking can force excess ink down into the air channels and out around the point assembly. If this happens, clean the pen.

Skipping

1. A likely cause of skipping is air in the ink flow. An inadequate ink supply in the cartridge allows air to lodge between the ink and the point. The symptom is often the need to shake the pen every few strokes. As the ink gets low, the warmth of your hand and the air pressure in the cartridge conspire against you. Air can be discharged by tapping the pen's barrel (point up) on a hard surface.

2. The pen will skip if the ink supply is low. Occasionally, when you pull the cartridge off for refilling, ink forms a bubble at the mouth of the cartridge. The ink dispenser itself can sometimes form a bubble, so that a pen that looks full is really empty. Refill the pen.

3. Debris or dried ink in the point will cause skipping. Pressing the pen into the drawing surface or pushing the point into instead of over the surface can cause the point to plow debris into the tube and block the ink flow. This often happens with clay-coated papers, soft-fiber papers, or plastic-coated surfaces that will score. The point can sometimes be cleared with a gentle horizontal shake to move the cleansing wire in the point. If this fails, rap the pen barrel (point up) on a hard surface. If these procedures do not work, try cleaning the pen.

Dripping

1. When the pen forms a drop of ink at its point every time you lower it, clean the pen. Dripping can also result from a nib being overtightened with the nib key. Make sure that the nib is not too tight before you begin drawing.

Clogging

1. Ink can dry in the point. The shellac in the ink will eventually harden if the cap is left off or the pen is simply allowed to sit unused for an extended period of time. Always put the cap on the pen when you are not using it, and be sure to clean the pen before storing it.

2. Clogging will result if the tubular nib is bent and the cleansing wire can't move freely in the tube. Replace the point.

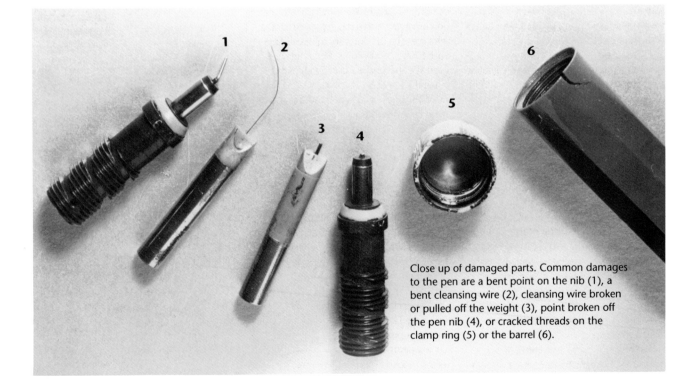

Close up of damaged parts. Common damages to the pen are a bent point on the nib (1), a bent cleansing wire (2), cleansing wire broken or pulled off the weight (3), point broken off the pen nib (4), or cracked threads on the clamp ring (5) or the barrel (6).

3. If the pen is used in an inverted position, preventing ink from flowing to the point, clogging results. Avoid using the pen in an inverted position.

4. If the ink is too thick to flow freely with just the pull of gravity, the pen will clog. Use an ink designed for the pen.

Snagging

1. Points can acquire flat sides or burrs if used on abrasive materials. You can tell this by rotating the pen a quarter turn to see if the drag is eliminated. Use a jewel or Tungsten Carbide point.

2. Paper surfaces too rough or too soft snag the point. Draw on hot-pressed paper whenever possible.

Broken Parts

1. With older pens the threaded collars of the clamp ring and the barrel are the most likely parts to split. The clamp ring particularly gets a lot of abuse from ink spillage onto its threads. This freezes the ring into position. Force is usually necessary to free it if soaking has failed to loosen the threads. I have heated it with a match, used pliers and even a nut cracker to get a grip on the ring and force it. The eventual result of these tactics is a foregone conclusion.

2. If the pen is dirty and hasn't been cleaned for a long time, it's possible to twist the point off while trying to free it. Soaking and ultrasonic cleaners are the only real hope. Penpoint replacements, however, are readily available from dealers or the manufacturer.

3. Solutions caustic to plastic will dissolve anything but the metal cleansing wire. Use water, recommended pen cleaners, or a 20 percent ammonia solution for soaking.

4. Bent points are usually a result of dropping the pen or running it into a hard surface when the cap is off. Usually this spells doom for the point, because unless you do it very carefully, straightening the point will break it off. Try to straighten the point, but it's only a matter of time before it breaks. Points will also break off from fatigue if the pen is used heavily, but this requires more hours of use than most pens get.

5. The cleansing wire can be broken or bent. This usually occurs when the cleansing wire is removed from the penpoint and replacing it is attempted. It's

Cap plug recessed into the cap. Occasionally when the cap is off the pen, the cap plug is inadvertently pushed back into the cap. It is not noticeable until you try to put the cap on the pen and it won't thread.

Pencil inserted into cap and pushing plug out. The temptation is to work with the threads, but the problem is solved by simply inserting a pencil or something similar into the cap and pushing the plug back out of the cap.

best to leave the wire in place when cleaning, but ultrasonic cleaners will occasionally shake them out. Set the wire down into the point and jiggle it until the wire seats itself. Don't try to thread the wire back into the point! Bend the wire, even slightly, and it's usually all over: when the ink dries, the bent wire can't help reactivate the ink flow. The point must them be replaced. Occasionally a wire is shaken loose from the weight when it is frozen into the point and the pen is banged against a hard surface to get it started.

6. Sometimes the cap won't thread back onto the pen. This happens when the colored plug in the top of the cap gets pushed down while it is off the pen. Use a pencil or similar object inside the cap to push the plug back into position.

INKS

Inks for technical pens come in three basic varieties. The traditional black India ink that most people think of is comprised of carbon particles suspended in water with shellac added as a binder. The ink is noted

for its blackness, permanence, and waterproof qualities. Koh-I-Noor's 3080-F Universal Drawing Ink, Higgins India Ink, and Pelikan India Ink are examples.

Dye-based inks are colored inks comprised of dyes suspended in water. They are very fine, nonclogging, and they are fugitive, which means that they will fade in sunlight. These are the inks used in fountain pens, ballpoints, and many markers. Dr. Ph. Martin's Dyes, Winsor & Newton Dyes, and Pelikan Dyes are examples.

Pigment inks are a recent innovation. They are actual paint pigments that have been ground so fine that they can be suspended in solution and used in technical pens. Their virtue is their variety in color and their permanence. Acrylic inks, such as Rotring Artist Color and Winsor & Newton Inks, have the same qualities as acrylic paints, being translucent and fast-drying, as well as keeping their brilliance over time.

India Inks

A universal waterproof and permanent black India ink is the most common ink for technical pens. The Koh-I-Noor 3080-F ink bottle has two caps, a small black one and a larger white one. The black cap threads off the white to give you a trickle of ink, and the white cap threads off for refilling the bottle. These bottles have a manufacturer's date stamped on the bottom part of

Ink bottle.

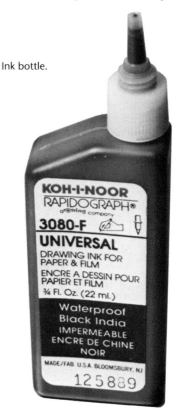

the label. India ink has a shelf life of about two years before it begins to settle out of solution. The last four numbers of the Koh-I-Noor bottle date stamp give the date of the ink's production.

India inks are solutions of carbon particles suspended in water and a shellac binder. This creates a very black, waterproof, and permanent ink. There are a wide variety of inks and ink manufacturers. Koh-I-Noor's line is a good example of that variety:

1. 3080-F Universal Drawing Ink, for paper, film, and cloth. Available in black, white, and eight transparent colors.

2. 3084-F Rapidraw Ink, for adhesion to drafting film or paper. Available in high-opacity black.

3. 3085-F Ultradraw Ink, for paper. Designed as nonclogging and waterproof. Available in black only.

4. 3071-F Acetate Ink, for acetate and other clear film. Wipes clean from overhead transparencies with water. Available in black only.

Dye-based Inks

Dye-based inks are water solutions colored with dyes. They cause virtually no problems in technical pens, but the tradeoff is impermanence. Don't take these inks for granted. Test their resistance to fading for your own purposes before seriously applying them.

Pelikan, Koh-I-Noor, Higgins, and Winsor & Newton all produce these inks with a variety of colors (including black and white). They are translucent and water-soluble. They can be diluted with distilled or boiled water for lighter hues.

Some of these inks, such as the Pelikan "A" series, are formulated for tracing paper and drafting film. The black is advertised as nonfading and waterproof, but the color versions are labeled "fade resistant."

Pigmented Inks

Pigmented inks are permanent, and if the pigments are ground fine enough, they work in the technical pen. Koh-I-Noor's Ultradraw inks come in black, red, blue, and green and are formulated specifically for paper and to avoid clogging technical pens. They have an extended "open-pen time," which is another way of saying that the ink won't dry quickly in the pen mechanism, yet it is supposed to dry quickly on the paper surface to prevent smearing.

Acrylic inks, notably Rotring Artist Colors, a fairly recent innovation in the pen market, provide the pen artist with permanent, waterproof inks that are ground to extremely fine consistencies. Since they are acrylic, they cannot be left indefinitely in the pens, but generally, if they are treated like regular India ink as far as pen maintenance goes, they work very well. They are available in 10 colors and black and white in transparent and opaque versions, but only the transparent are recommended for the pens. They are water-soluble and intermixable. The white and black transparent inks are not recommended for the pens because they cause clogging.

SURFACES

Technical pens will work on any surface that is fairly smooth and free of residual debris or oils. Paper, wood, glass, plastic, Mylar, nylon, canvas, and metal are all candidates, if the surface is smooth enough and clean. The inks are sometimes a factor, but generally a universal waterproof India ink should work. The kind of surface you use is a matter of individual choice.

Papers and Illustration Boards

Most pen work by far is done on paper of some type. Hard, slick surfaces like hot-pressed illustration boards and papers are recommended for crisp line drawings. For purely commercial and reproduction applications, a hot-pressed surface is ideal, as long as you are not staining with a medium such as watercolor. The hard, hot-pressed surface causes the paint to pool and to stain the edges of the painted area, rather than diffusing. If your drawing is a tight rendering, the paper surface must be a reasonably hard surface with a durable fiber. Even with the hard surface, however, the sharpness of the penpoints, combined with the repeated layers of line needed for tonalities, can cut the fibers. This clogs the pens, bunches on the point to make smudges, and causes the ink to bleed into patches. The ideal surface for tight work is hot-pressed surfaces made for pen and inks.

A cold-pressed surface is more absorbent and accepts watercolor or acrylic inks in a wash. It also absorbs the ink just enough to enhance the soft gray effects of line patterns. For gallery purposes, the matte surface of the cold-pressed paper better presents original art.

I occasionally work on surfaces as

Rotring Artist Colors comes in sets of twelve in either 10 or 30 ml. bottles. The set includes black and white, but owing to their thickness, neither is recommended for technical pens. These colors are also available in transparent and opaque varieties.

diverse as watercolor blocks, watercolor illustration boards, napkins, or newsprint. In all of these cases I understand what the limitations are. With technical pens, it is advisable to avoid soft and fibrous surfaces. A soft, cold-pressed surface will clog the penpoint even more than a hot-pressed one, particularly when you are erasing or wetting the drawing. Your own touch is a factor in this. Experiment with a variety of surfaces to find one that suits your own technique.

I prefer a heavyweight, cold-pressed illustration board with a 100 percent rag paper surface, such as the Crescent #110 board, which is very forgiving. The board, as opposed to a loose paper, offers a comfortable rigidity of surface, so I don't have any bounce when I make the pen stroke and I don't have any fear of wrinkling or creasing the paper. I like the cold-pressed surface because it offers a little more absorbence of the ink, and it allows me to get watercolor effects when I apply color. I like the rag surface because it can be scratched, erased, and heavily crosshatched without breaking up. It is also archival-quality and won't disintegrate with contact with water and won't discolor with age.

OTHER EQUIPMENT

An opaque projector, such as Artograph DB400, is an extremely useful tool, particularly with commercial work and with work that you intend to draw photorealistically. By projecting the image you want to render, you can quickly establish proportions, basic outlines for shapes, and arrange compositions of several images that comprise your drawing. There are a couple of pitfalls in using a projector. One is that there is still a lot of drawing to do after the basic outlines are projected. Incomplete shapes, obscure borders, and indistinct values must be redrawn in pencil before you can draw them confidently with the pen. The second and more serious pitfall is allowing the projected image to control your creativity, your sense of composition, and your ability to reinterpret shapes for a less literal rendering of your subject.

A drawing board is also important. I use a 3' x 5' Plan Hold Hi-Tech board that raises, lowers, tilts, and has a parallel rule. It allows me lots of room to do 30" x 40" pieces. Originally, I used a four-post drafting board, but I found that I spent most of my time standing because I couldn't pull the board down into my lap. I also draw a lot of pieces 20" x 30" or smaller in my lap while I watch television.

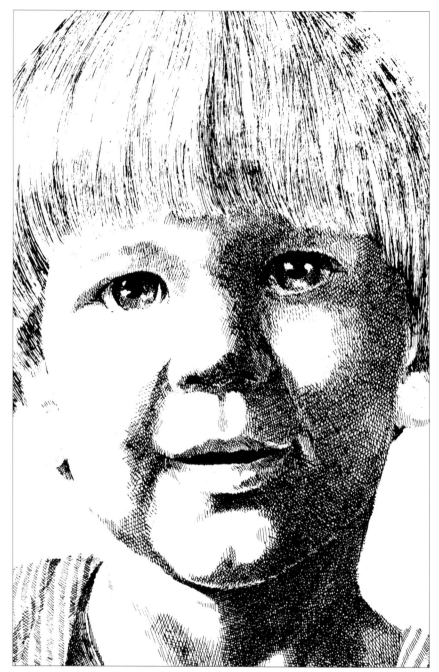

Portrait of Justin Wallace (detail). 30" x 40". In any medium, using high-quality materials pays off. This is a detail from a pen-and-ink portrait I did on Crescent's ArtTech board, which is no longer available. As the result of a flood, the portrait was found underwater, face down in the mud. After it was washed up, there were two wrinkles and virtually no damage to the image. The face shown in this detail is just as it was without retouching. The ink's obvious waterproof characteristic and the board's rag content saved the portrait. Collection of Ken and Jenny Wallace, Hot Springs, Arkansas.

STRATEGIES FOR PEN AND INK

A French Helmet. 24" x 24". This is a *tight* drawing, a strategically planned, carefully constructed accumulation of pen strokes. I did a careful pencil drawing to identify volume in the helmet, ornamentation, texture, and tonality. Even though the pen strokes themselves are inherently imprecise, the placement and consistency of the strokes produces a very precise impression.

Perhaps one of the least understood strategies for the novice pen artist is identifying where the source of difficulty with the technical pen really is. Most artists think that the problem is simply their own lack of skill. Actually, most people start with or quickly acquire a physical ability to make decent strokes with the pen. What can frustrate their efforts is indecision about what they are trying to accomplish with the pen. In all likelihood, they are visualizing one version of the drawing while applying a method that is incompatible with it. This chapter addresses that difficulty by describing the various types of drawings and the sequence of decisions the artist must make in order to achieve the intended results.

Virtually all pen drawings utilize similar tools, materials, and such drawing skills as patterns of pen strokes. The biggest differences among drawings are how complex or simple the image is and how stylized or realistic it is going to be. This all points to thinking and perception more than physical skill as the strategic focus of successful pen work.

Before you start to draw with the technical pen, decide what you want it to do by answering three important questions:

1. Is the drawing to be loose or tight? A tight drawing's shapes are precise and specifically placed. A loose drawing's shapes are more freely placed and are often suggested more than precisely defined, and the marks are made with a gesture that conveys a spontaneous rather than a carefully constructed look. This first decision is important, because once either type of drawing is begun with the pen, it is almost impossible to successfully jump to another type. Your choice determines the answers to the next two questions.

2. How much detail and precision does the drawing call for? Shapes are any areas that are defined by actual edges of a volume or by the boundary between two different values. The more literal the drawing, the more specifically you must define the nuances of the image as shapes, and the more precisely you must apply the pen strokes to indicate volumes, values, colors, and textures.

3. What kind of pen strokes are appropriate? Base your pen techniques on your intentions for the drawing's final look. The strokes and skills required for tight ink drawings differ from those needed for loose drawings.

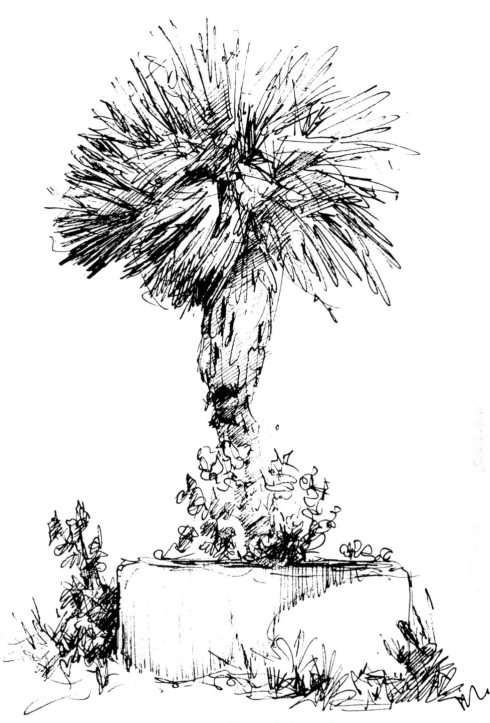

Tampa Palm, 11" x 14", was sketched on location. It utilizes approximate shapes that are literal enough to symbolize the image, but are defined with imprecise strokes. The technique is spontaneous, suggesting rather than specifying the shapes.

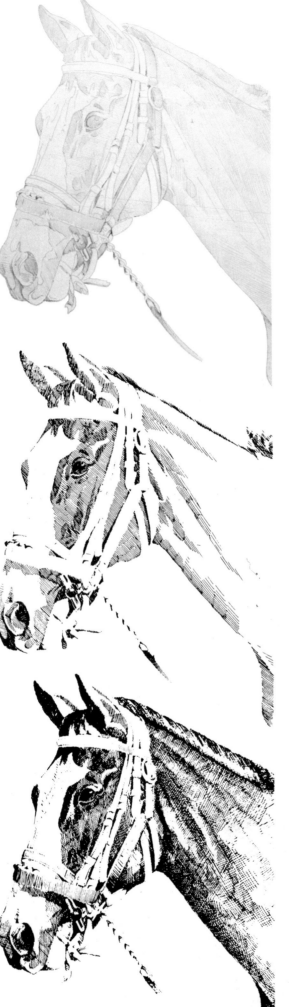

Pretty Lynne, A Study. 11" x 14". In the pencil layout (top), the shapes of volumes have been precisely outlined, as have the shapes of the most important values. The first pen strokes (center) were placed on the drawing within those pencil outlines and are made consistently in order to establish the overall values of the shapes. The finished drawing (bottom) reflects the precision of shapes that is characteristic of a tight pen drawing.

LOOSE TECHNIQUE

Loose drawings consist of quick, spontaneous strokes, suggesting edges of the most obvious shapes, basic areas of texture, and the basic values for contrast. These strokes are applied without a lot of planning, as though the penpoint were exploring the image.

Loose pen strokes generally have a gestural feeling about them, looking as though the pen is actually trying to mimic the motion of the shape. The pen stroke should portray in its own shape the energy and direction of the shape it is representing. A single stroke can be a single shape. Successful loose drawings should have little in the way of very carefully calculated shapes or strokes.

You can sketch the outlines of the shapes of your subjects in pencil or directly with the pen, foregoing much planning or preliminary pencil drawing. Success often results primarily from the artist's ability to see shapes during the drawing process and to indicate them with a single stroke rather than a complex pattern of strokes.

In either case, you can use a combination of gestural outline and combined strokes to develop tonality.

TIGHT TECHNIQUE

Literal and tight drawings are constructed with strokes that are as carefully made as they are placed. These strokes are less likely to stand alone as a shape and are more likely to work as regular patterns that serve as values and help to sharply define the edges of shapes. These strokes often lack the dynamics of gestural strokes, but very predictably create accurate images.

Tight drawings require that you develop very specific shapes in pencil and then fill them in with pen strokes. In some cases this means simply outlining the very carefully drawn pencil shapes. In most cases, however, the pencil outlines serve as guidelines for patterns of strokes that fill in the shapes.

In planning and executing a tight pen drawing the actual pen technique and the skillful construction of patterns are as much at issue as the artist's draughtsmanship.

Autoharpist. 20" x 16". Tighter pen strokes depend on the construction of a shape to make their point. In this drawing, the playing hand is in motion, but the action is described by carefully constructed shapes that have indistinct edges. With a looser technique, the stroke of the hand might well be indicated by a series of sweeping lines in the direction of the strum instead of a series of strokes that are short, closely spaced, carefully placed, and all alike.

UNDERSTANDING HOW TO USE PEN STROKES

Individual pen strokes are limited in variety because of the nature of technical pens. They are either dots or some version of very narrow lines, consistent in width and usually short. Applied individually, strokes can represent an individual shape (such as a wavy line for a hair) or the edge of a shape (such as an outline).

The most versatile use of pen strokes is a combination, which can create clusters of shapes (scribble lines for a tree) or patterns that define individual shapes (gray tonality for a leaf).

Any pen stroke can create virtually any shape if used properly. There are no magic formulas for plugging in certain strokes for specific subjects. There is no "tree stroke," "cloud stroke," or "metal stroke." Some marks come closer than others to imitating certain textures, but there are no guarantees and no universal symbols.

The decision about which stroke to use rests in the artist's preference and in the particular context for which the stroke is used. For example, a cluster of short choppy strokes might be grass, a butch haircut, or fiber. The context and the overall application dictate the use. A stroke's effectiveness depends on what each stroke is doing as part of a group, how each stroke affects the other, and what the cumulative effects are.

The use of a particular stroke is also a matter of what kind of character is needed for the drawing. For example, long wispy strokes are natural strokes for drawing hanks of hair when the intended effect is ethereal, romantic, or very spontaneous. Just as effective are short crosshatched clusters that represent hair as a more solid mass with a wide range of tonalities. These clusters give the hair more volume, softness, and perhaps a more dramatic lighting. Both look like hair, but the feeling is different for each.

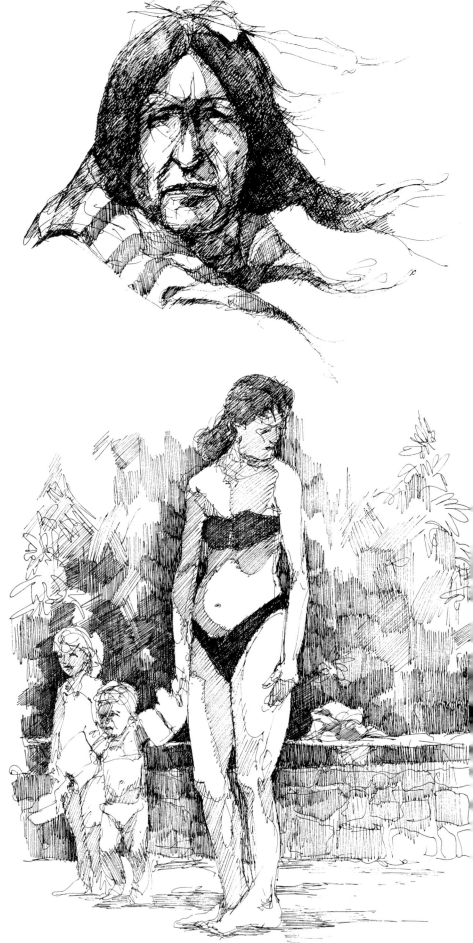

These sketches demonstrate the versatility of pen strokes. The scribbled loop is doing different things in each drawing, and sometimes different things in the same drawing. In the drawing of an Indian, 8" x 10" (top), the loops describe the dark color of the subject's hair, as well as the color and texture of the blanket stripes. In the drawing of a mother and children, 11" x 14" (bottom), the loops describe the texture of foliage in the background and the color of stone in the wall.

Differences in the lengths of pen strokes can create different moods. For example, some types of line have much more energy than others. When line is short and parallel, its energy is confined. In *The Hood*, 8" x 10" (top), the short lines on the hood are active enough to be more than just tonality, expressing a textural quality that suggests fur. The short lines of the shadows in the face are so constrained that they have little texture at all. The lines of the blowing hair, in contrast, are inherently active, as are the long straight lines behind the visual. They suggest something like a ray or current of energy. In the torso, 8" x 10" (center), the cast shadows on the body are described by scribbled loops.

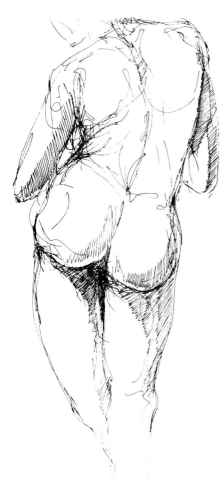

The Bath, 11" x 14" (right), presents a very different kind of effect for hair, using curvilinear waves of line that intermingle to create a simulated twisting motion in the hair itself. The length and convergence of the lines within a constrained shape generate this active look.

CREATING SIMULTANEOUS EFFECTS

Perhaps the biggest pitfall for the beginner in the medium of pen and ink is failing to realize that pen strokes applied for one effect (such as value) will create additional effects (such as texture). This happens because each effect is constructed of a mass of smaller shapes that serve many functions. For example, pen strokes used to suggest a cast shadow on the side of a young girl's face will also suggest whether it is rough, hairy, or smooth.

Since multiple effects are created by one type of stroke, effective pen strokes must be purposefully crafted in order for the artist to keep control of the image he or she creates.

When individual pen strokes are made intentionally, they have a much better chance of being made well. As obvious as this sounds, it's one of those truths that beginning pen artists ignore. When you are unsure about where or how to make the next shapes, it's tempting to simply make excessive strokes in the same place in order

to feel like you are accomplishing something. When you are tired and have a large area to ink, it's tempting to carelessly make large, inconsistent strokes to speed up the process. When you are preoccupied with making a shape darker, it's easy to forget the textural effects that are amassing simultaneously. Confusion, repetition, and tedium all encourage a version of the "brainless" pen stroke that is slapped down with little regard for how well it is placed. Pay close attention to the accumulation of effects as you add every stroke.

Glee and Anna Lee. 20" x 30". As pen strokes create value, they also create texture, which is a function of how the strokes are made. If the pattern of strokes creates a shadow over a girl's face, the nature of the pattern determines whether the texture of the face is smooth or rough. This is particularly important with a face as smooth as a baby's. Putting the strokes together consistently and evenly help create an even screenwire value with a very smooth texture. Collection of Dr. Paul and Glee Thompson, Hot Springs, Arkansas.

THE ELEMENTS OF A DRAWING STRATEGY

Technique is a product of your drawing strategy, and pen strokes express how much or how little you've thought out your strategy. The underlying realities behind all pen-and-ink strategies include the following limitations of the medium: All strokes create contrast and texture; there is virtually no removal of pen strokes; as strokes accumulate, the drawing darkens.

All decisions about strokes as lines or dots, about which patterns they create, and about where the patterns are placed are attempts to accomplish the tasks described below.

Outlines

Outlines are represented by continuous lines or a contiguous series of dots that define the edges of shapes. For example, the images in a coloring book are comprised entirely of shapes that are described by outlines. This is one of the few applications where pen strokes function almost entirely individually, rather than as patterns.

The Rocker. 11" x 15" (top). The outline determines the character of a drawing. Loose sketches like this one tend to use gestural pen strokes to suggest edges that can then be enhanced by more substantial strokes for value, color, or texture.

Literal drawings like Al Lorenz's architectural work (bottom) depend on specific, consistent, and accurate outlines that dutifully portray all the major shapes of the image.

Stylized drawings, like *Stagecoach*, 8" x 10" (top), and other cartoons use overstated outlines that give the shapes a two-dimensional quality, making them look as though they are pasted onto the page.

Not all stylizations with an outline have to be cartoons. Bob Mattis's interior (left) is an excellent example of using outline to present literal subjects with highly simplified shapes.

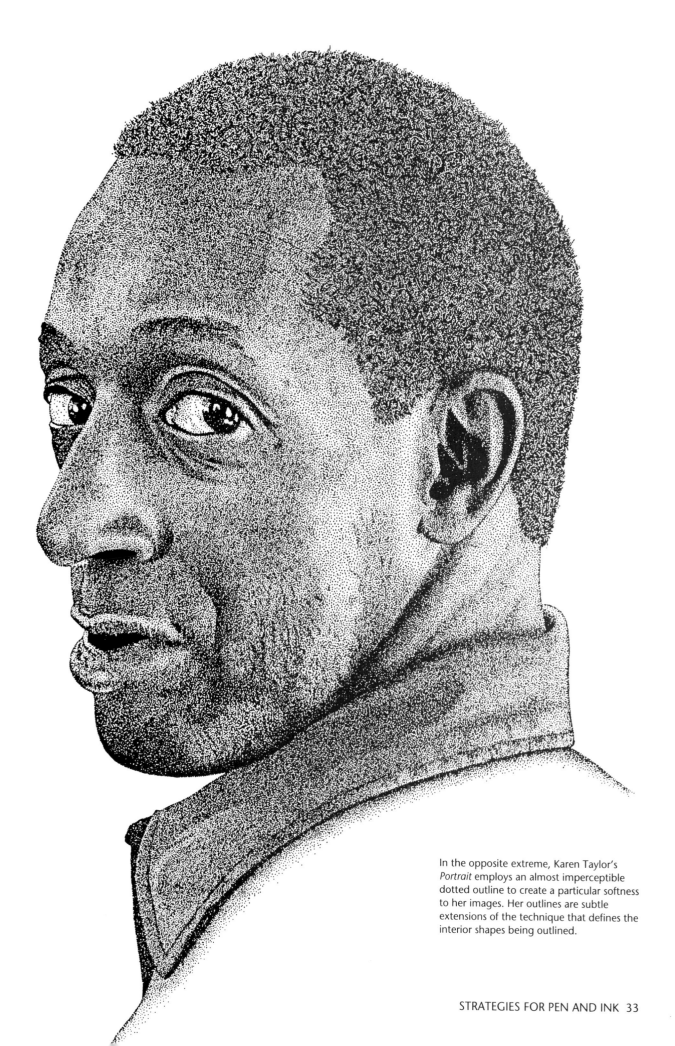

In the opposite extreme, Karen Taylor's *Portrait* employs an almost imperceptible dotted outline to create a particular softness to her images. Her outlines are subtle extensions of the technique that defines the interior shapes being outlined.

Tonalities

Patterns of strokes that are clustered together to create uniform fields of blacks and grays shade the interiors of shapes, giving them the look of a volume or a surface as it reflects light. For example, a photorealistic rendering of an object has no outlines around the shapes' edges. The shapes are "colored" in blacks or grays that are comprised of marks working as a pattern, much like Zip-A-Tone or screenwire, which is a uniform pattern of horizontal and vertical lines resembling mesh.

Pen strokes that create little texture can still create tonalities by defining shapes. For example, The *Old State House*, 16" x 20", uses tonalities almost to the exclusion of texture generally. The flat silhouette of the fountain, the smooth surface of the building's facade, and the limited texture of the foliage makes this drawing a study in values.

Patterns

Individual strokes or some combination of strokes can be repeated as a pattern that may or may not take on a very textural appearance, but can be counted on to create unity among the shapes it covers. For example, a background in your drawing may be an arbitrary design with no symbolic or textural meaning at all, but the patterned background still functions to create visual movement, or visual interest.

One of the most exciting and interesting uses of pen strokes is creating patterns solely for decorative or nonfigurative spaces in a drawing. In *Power*, 11" x 14" (top), the background strokes are purely for visual interest. In *The Stretch*, 12" x 18" (bottom), the background is a mass of ambiguous strokes that keep that area of the drawing from dominating the composition.

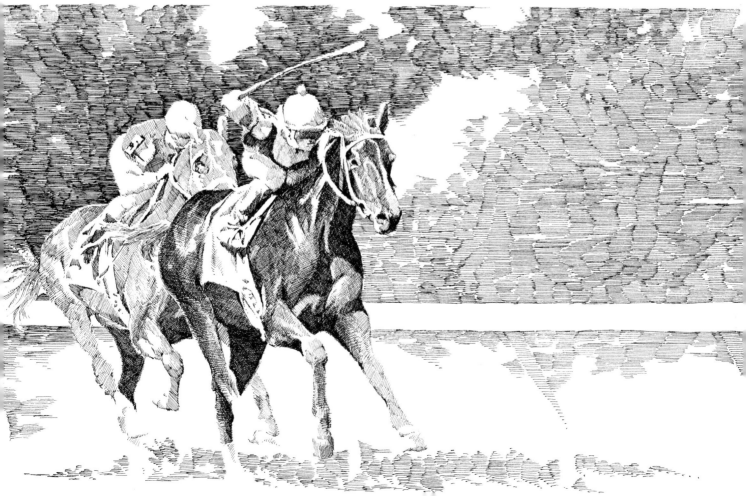

Textures

Pen strokes can combine to symbolize specific surface features of an image. For example, a series of short vertical strokes in the right shape can look like grass or hair. Long parallel strokes can look like a reflection on a shiny surface. Consistently alternated clusters of strokes can look like a basket weave, or clusters of dots can look like dust or clouds.

By their very application, pen strokes imply texture. Skillfully applied, pen strokes combine into an amazing array of specific textures. Used strategically within an image's shapes, pen strokes can create surface textures like the metal of the *P-51 Mustang*, 20" x 30", shown above (collection of St. Joseph's Regional Health Center, Hot Springs, Arkansas). Combined with a sense of surface color and light, pen strokes can be shiny in a different context, like the *Crow's Feather*, 16" x 20" (opposite page).

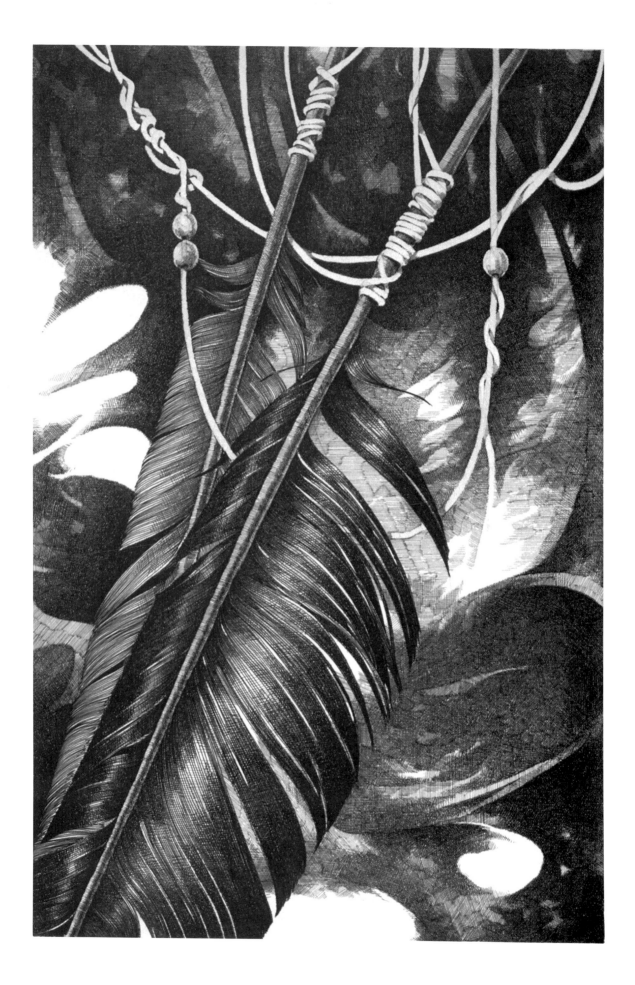

COMMON ERRORS IN PEN STROKE PATTERNS

The artist's first efforts to make effective pen strokes are often hampered by some simple craft problems. Failure to execute a group of marks with consistency and rhythm compromises continuity of pattern. When this consistency is lacking, the individual marks within the pattern begin to assert themselves as little shapes, breaking up the pattern's overall effect. The problem is compounded when additional pen strokes are used in order to compensate for the disorderly pattern, leading in turn to a darker drawing. The figures below show the difficulties that arise when trying to repair a faulty pattern by darkening a drawing with additional strokes.

Mistakes are more a function of misuse than of poorly made strokes. Inevitably the two are related, but effective drawings can be done before virtuosity is achieved. The errors that I have earmarked in the chart of common mistakes made with pen strokes on the facing page are more serious for tight rendering than for sketching and gestural drawing. The two overriding errors are strokes that are inconsistent within a pattern and strokes that are either too far apart or too long.

The process of adding progressively more strokes to correct earlier ones is more successful if the intended value is dark. If the intended value is light or middle gray, there is little opportunity to correct poor strokes with just one or two more layers of strokes. In this example of progressive layers of strokes that obscure the texture of random strokes, chaos of the initial strokes remains apparent until about the fourth or fifth application of covering strokes, by which time the overall value of the shape is dark gray to black. This example argues for accurate strokes in the very early stages of the drawing, usually based on a preliminary pencil outline of the shapes.

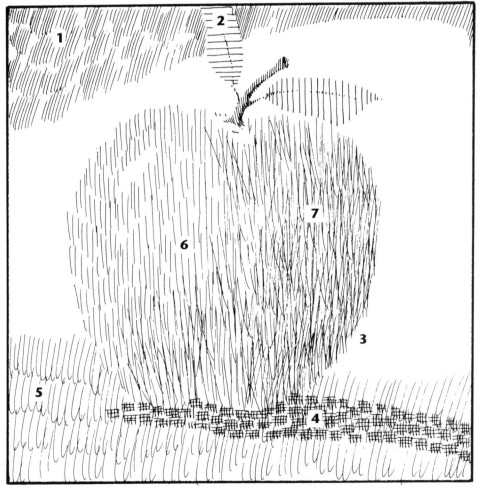

Mismatched hatching creates a texture rather than even tonality (1). Continuous lines through a shape create a flat look (2). Poor edge control distorts the boundaries of the shape—in this example, it also creates a hairy texture (3). Small hatched clusters with large spaces create a texture rather than an even tonality (4). Hooked lines create an active surface (5). Lack of uniform clusters prevents a sense of even tonality or color (6). Lines hatched in irregular directions and acute angles create a rough texture with a slight moiré pattern (7).

Common mistakes made with pen strokes:

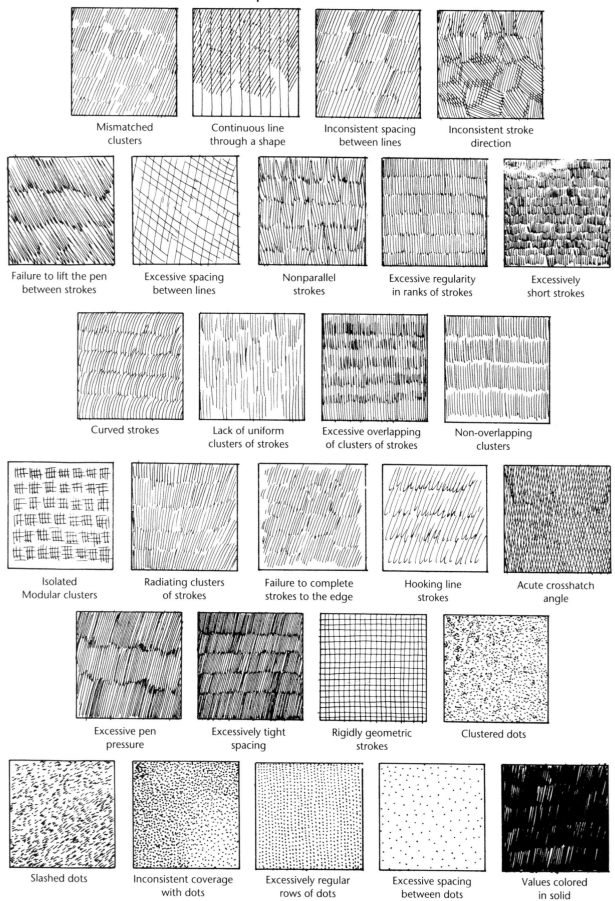

Mismatched clusters

Continuous line through a shape

Inconsistent spacing between lines

Inconsistent stroke direction

Failure to lift the pen between strokes

Excessive spacing between lines

Nonparallel strokes

Excessive regularity in ranks of strokes

Excessively short strokes

Curved strokes

Lack of uniform clusters of strokes

Excessive overlapping of clusters of strokes

Non-overlapping clusters

Isolated Modular clusters

Radiating clusters of strokes

Failure to complete strokes to the edge

Hooking line strokes

Acute crosshatch angle

Excessive pen pressure

Excessively tight spacing

Rigidly geometric strokes

Clustered dots

Slashed dots

Inconsistent coverage with dots

Excessively regular rows of dots

Excessive spacing between dots

Values colored in solid

BASIC PEN STROKES AND THEIR USES

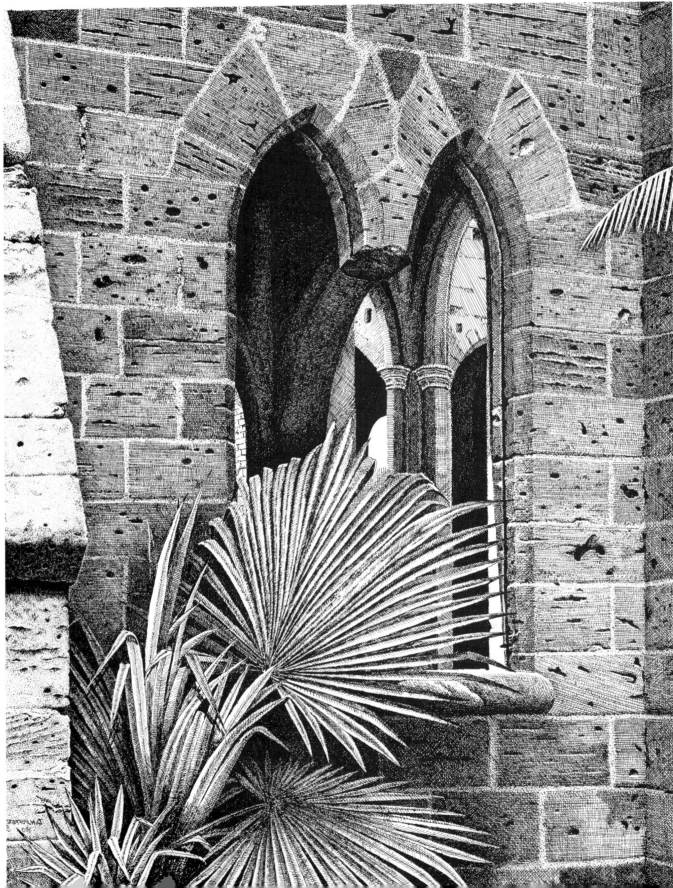

Any description of pen strokes is ultimately a description of how lines and/or dots can be combined into patterns that describe an image's edges, volumes, values, textures, and colors. In traditional black-and-white drawings, all of these functions are performed with values of black, grays, and white. How dark the specific values of the drawing's shapes are depend on the individual stroke pattern's density. Density is a result of how close strokes are to one another, how many are piled one on another, and how big the individual strokes are within a prescribed space.

Most artists understand this application of strokes. But texture is where the artist can get into trouble. As the strokes are grouped into a pattern that shows the values within a shape, the same pattern describes the texture of that shape.

FAMILIES OF STROKE PATTERNS

This chapter describes the most common types of patterns pen artists create with lines and dots. The categories I describe are labeled for the purposes of talking about them, but there are no hard-and-fast rules about how they are to be used or how they are

to be combined. They are simply a base for the artist to build on.

I have identified nineteen patterns and a total of thirty basic strokes (see chart on pages 70-71) based on the techniques used to construct the patterns. The physical technique with the pen is the basis for the patterns, some being very free and random, while others are very contrived and carefully constructed.

THE STROKES

In virtually all of the descriptions, there are many variations of any one type of stroke. For example, continuous line might be a pattern only in the sense that it is an accumulation of the outlined edges of the image's shapes. Other times it is a compilation of parallel or crossed lines within a shape. Or it can be the basis for nonstop scribbling throughout a shape. All of these categories could be redefined or combined to accommodate any particular stroke. I have presented the strokes in a manner consistent with how I use them. A few strokes comprise your entire pen-and-ink arsenal, and if you understand the principle behind the patterns they create, you can control the pen and draw in the manner that best suits you.

Families of pen stroke patterns. The family names of pen stroke patterns simply indicate the most common ways of building up patterns of pen strokes. Strokes are generally applied to a shape in some systematic fashion, and the family names reflect those approaches. The only importance in actually categorizing these approaches is to alert the artist to the importance of consistency in the process of creating a pattern of strokes. Inconsistency within the process or in combining the processes usually leads to a poorly constructed drawing.

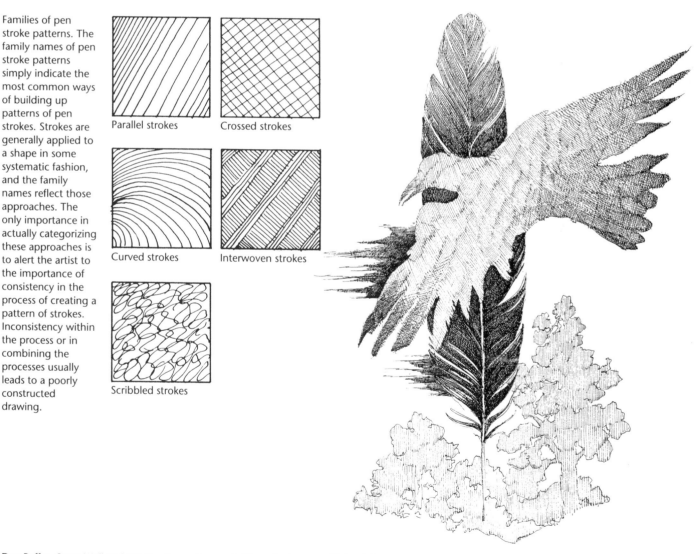

Parallel strokes

Crossed strokes

Curved strokes

Interwoven strokes

Scribbled strokes

Dan Puffer, *Stone Wall and Window* (opposite page). The artist has stippled texture over the continuous lines he drew through the shapes that define the stone wall and arched window. This unique combination of line and dot expresses the volume of the architectural subject very effectively.

Flight of the Crow. 11" x 14". The tree line in this drawing shows that even when the outlined shape contains tonality, flattening persists.

Continuous Line

This is the most natural stroke made with a pen. It is highly controllable, and when it is used to create an outline of the edges of a shape, its results are immediately obvious.

Continuous line, however, imposes a stylized, two-dimensional effect on a drawing. The technical pen's consistent line width makes outlines look flattened and devoid of the dynamic gestural quality and sense of volume produced by a flexible-nib pen.

Another way to use continuous line is to draw a series of parallel lines from one edge of a shape to another, similar to the symbolic indication of a cross section in an engineering blueprint. The presence of the lines is obvious and enduring, regardless of the marks put over it. The effect is a flattening of shape, reducing the sense of volume and making it difficult to blend subsequent lines with the continuous ones. The flattening effect is counteracted if the continuous lines follow the contour of the shape being described.

Noodles, 14" x 11". The continuous line is the most obvious pen stroke for defining the edges of shapes whether or not the shapes include tonality or texture. *Noodles* uses an obvious outline that is two-dimensional and flat in character, especially with the consistent line width of the technical pen.

Ralph Scott, *The Painted Turtle*. When continuous line is drawn from one edge of the shape to the other, the result is very flattening.

Becky's Trophies. 30" x 40". One way to use continuous line without flattening the shape is to make the line conform to the contour. A modeling effect is even greater with the addition of crosshatching.

Becky's Trophies (detail). This detail shows how the texture of the continuous line remains visible.

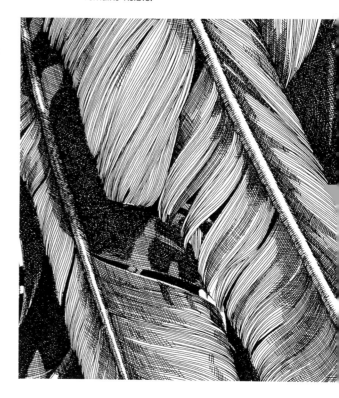

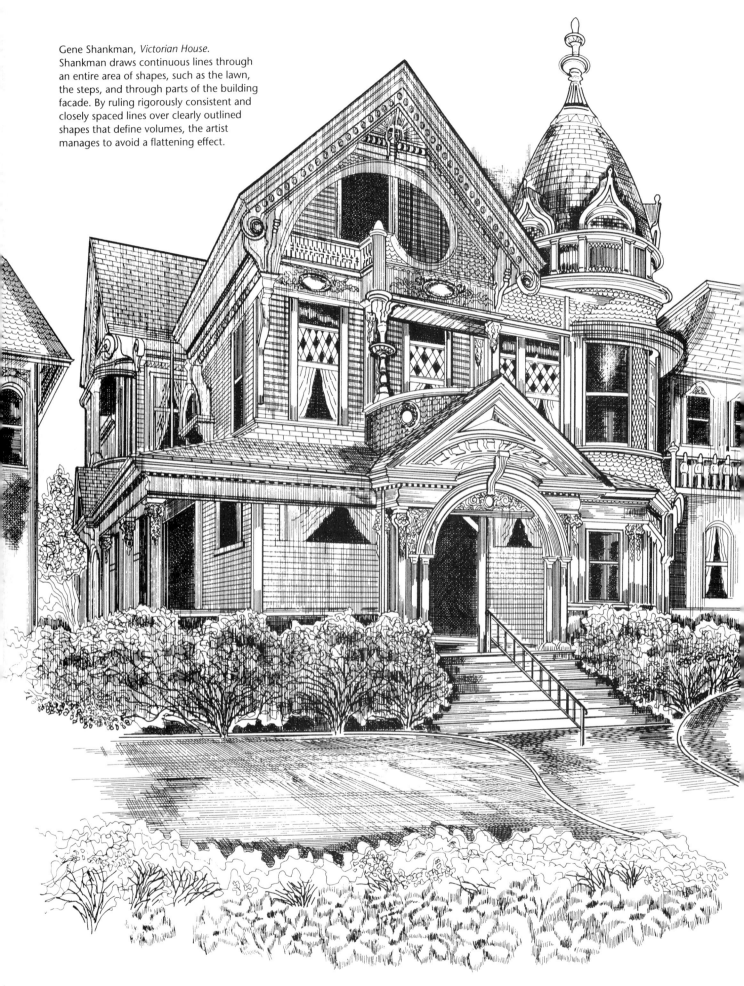

Gene Shankman, *Victorian House.*
Shankman draws continuous lines through an entire area of shapes, such as the lawn, the steps, and through parts of the building facade. By ruling rigorously consistent and closely spaced lines over clearly outlined shapes that define volumes, the artist manages to avoid a flattening effect.

Engraving Effect

In this variation of continuous line, lines and intervening spaces are the same width. The effect simulates woodcuts and

2

engravings, providing an interesting and distinctive texture to the drawing. The artist Franklin Booth was perhaps the most accomplished pen artist with this technique.

The engraved effect is unusual in that it takes an inordinate amount of skill to consistently maintain the spacing and the definition of shapes, while not allowing either negative or positive space to dominate. The technical pen's consistent line width offers some advantages over flexible-nib pens with this technique.

Geometric Patterns

3

This is a contrived derivation of continuous line, offering a viable alternative for some kinds of background and border enhancement. All of the major geometric shapes and their various combinations can be used in this manner. Its permutations are endless.

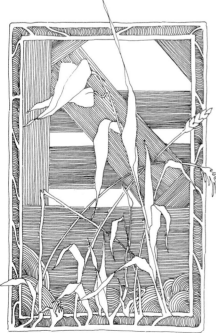

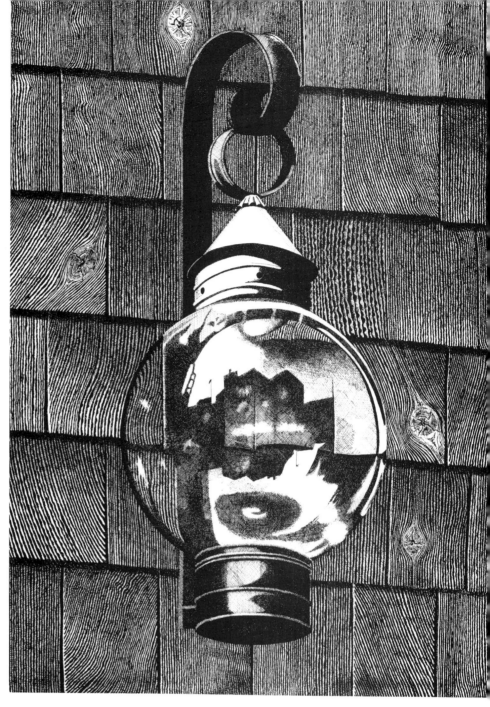

The engraving effect is created when the width of a continuous line and the intervening white spaces are about equal throughout an entire pattern. The engraving effect is not commonly used, but when used well, its texture is one of the most appealing. In *Grasses*, 8" x 10" (left), I have used it as a decorative background effect. A more impressive application is Dan Puffer's *Lantern* (right), where the shingles in the drawing have a definite engraved feeling.

Randomly Scribbled Line

The most obvious derivation of continuous line, this mark is quite useful for creating mass or imprecise tonality. It is probably among the first pen strokes the beginner considers for drawings and the easiest to underestimate. Frequently what looks like scribbling is in reality a controlled, although spontaneous, application of line. Like any other stroke, scribbling usually takes on its own rhythm, its repetition creating a uniform density and suggesting a loose order in the shape it is filling.

Like all other pen techniques, scribbling is about defining shapes, even if they are rather indefinite or lack specific edges. The danger with scribbling lies in simply using it as a means for piling on line in an effort to create darkness. To make it work, use it in conjunction with some specific edges, so that the general mass of scribbled line "feels" more defined than it is. A mass of leaves, for example, can be scribbled within a few specific leaf shapes, and the whole mass will take on the characteristics of leaves.

Scribbling is a popular technique because it's fast and spontaneous like brush work. The line can be pushed into spaces without a lot of specific placement, and a dark tonality can be built up rather quickly.

The hair in the afro, 8" x 10" (top right), represents one of the most common applications of the randomly scribbled line. The scribbled line also symbolizes complex and tangled masses like the tree boughs in *The Slope*, 11" x 14" (bottom right). Both of these examples utilize hatched line over the scribbled, giving the mass value as well as texture.

Scribbled Loops of Line

This technique is a controlled variation of scribbling, using long narrow loops that are practically parallel lines. The difference is in the looser feeling of the line and the speed with which it can be put down. It can be used as a texture, but it's much more likely to be used for tonalities.

5

These loops of line are put down with the spontaneous scribbling stroke, but the stroke is constrained to form the long and narrow loops that work like a very loose hatching stroke. In the caricature of the cowboy, 8" x 10", the loops are obvious because they are bigger and less dense. As with any other stroke, the more you apply, the less you see of the stroke's basic shape and texture.

Reticulated Scribbling

This is a contrived pattern that should be used in small doses. It isn't scribbling in the most common sense of the word, but the exploratory and random nature of its pattern makes it similar. It is active by nature and inherently interesting to look at, but it will dominate virtually any part of a drawing. It makes me think of circuit boards and mazes.

Reticulated scribbling is essentially scribbling, but the path of the scribbling has a geometric quality about it similar to a maze or an electronic circuit board. The example behind the fish, 8" x 10", has no rationale other than its rather interesting texture, which perhaps implies brain coral. Continuous line is drawn over the whole pattern, effectively "coloring" it.

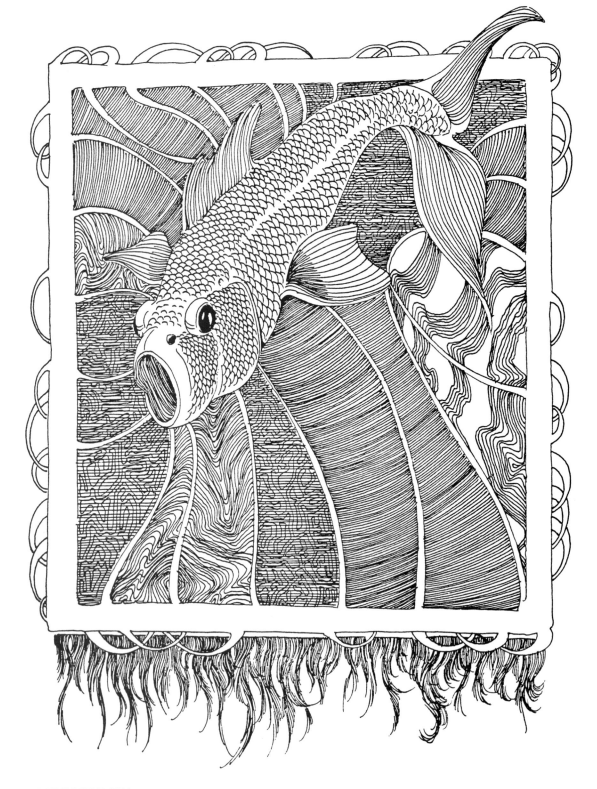

Clusters of Hatched Lines

After scribbling, this stroke comes to mind for filling in a shape with pen marks.

7

Possibly the most useful and controllable stroke of all, it is applied in two versions, one with the clusters touching and the other with the clusters deliberately separated (*reticulated clusters*). The stroke, in both cases, is based on clusters of short parallel lines spaced evenly or with increasing or decreasing spacing over the expanse of a shape. This change in spacing is an important way to create various levels of gray without resorting to additional, and therefore darkening, layers of line.

Hatching is a simple way to achieve an even gray tonality with a minimum of texture. For this reason it is often used to create the illusion of distance in landscapes, for a metallic look, for nontextural values, or simply to imply local color.

When parallel hatching lines are placed very close together, they create a soft texture and a consistent local color. Also, with hatching you can control tonality in small and discreet shapes, defining clean edges without outlining. And you can maintain a high degree of tonal consistency over large areas, because the lines are short and extremely consistent. Line length can vary from little more than a dot when making line shapes to nearly half inch marks for larger shapes. Anything much longer creates problems with consistency and blending.

For a "wash" of tonality, clusters of hatching strokes are made to just barely overlap the preceding cluster or to fall a fraction short. Exact matching of strokes from cluster to cluster is not only unreasonable technically, but it is likely to produce a mechanical look to the strokes and to the overall pattern.

Within a shape, subtle variations of spaces between hatching strokes produce a variegated appearance or a gradation of tone from light to dark within an individual cluster or within the overall shape covered by the clusters.

An interesting camouflage effect is possible when clusters of parallel lines, all running in the same direction, are used to define all the shapes in an image. Each shape is subtly suggested where the parallel lines stop and restart at the shapes' edges. Once the parallel lines establish all the shapes, selected shapes can be obscured or clarified by adding strokes.

The hatched line cluster is an extremely useful stroke when the stroke pattern needs to follow the contour of the shape. In the dragon, 8″ x 10″, it's easier to work clusters of line parallel with the edges of the shape than it is to work diagonally, as was done in the wings. As the clusters conform to the body shape, they are easily placed to suggest scales as well as value. One of the chief virtues of this technique is the control you have over tonality within any one cluster of strokes.

By simply expanding or narrowing the spacing between successive strokes, you can lighten or darken the value without using additional strokes. Nancy Ohanian's portrait of Henry Fonda is a good example of the potential for both of these effects. Note also that the artist outlines some of the image's shapes with a fragile ink outline that is sometimes incorporated into the tonalities and sometimes left to define the edge of light shapes against a light background.

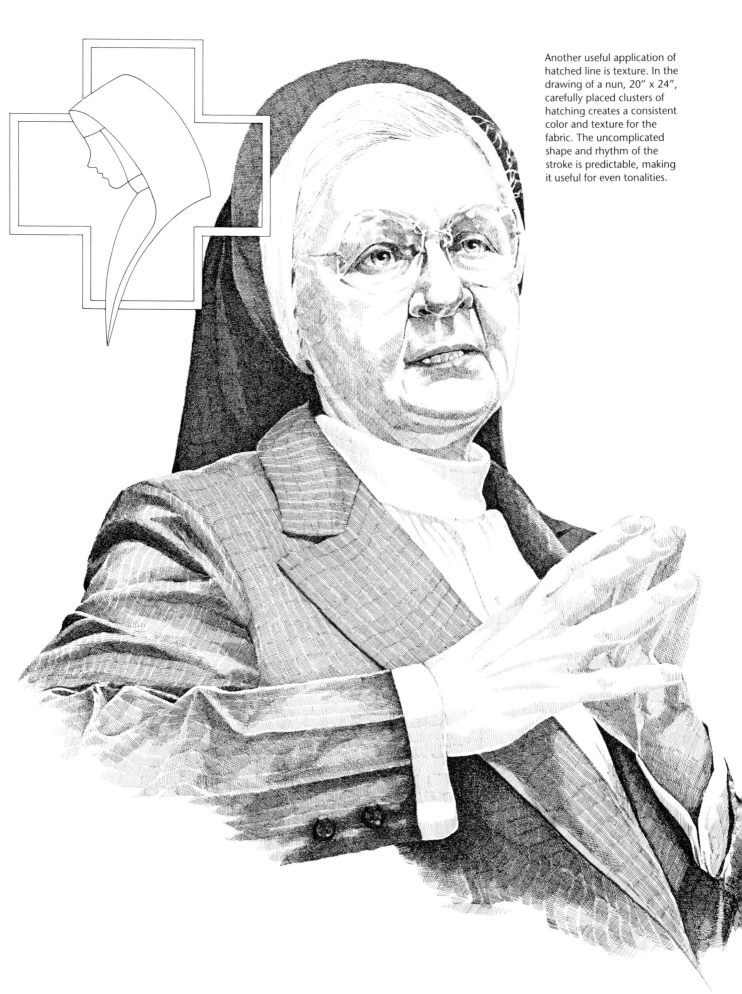

Another useful application of hatched line is texture. In the drawing of a nun, 20" x 24", carefully placed clusters of hatching creates a consistent color and texture for the fabric. The uncomplicated shape and rhythm of the stroke is predictable, making it useful for even tonalities.

Layered Parallel Line

This technique applies clusters of parallel hatched lines followed by additional clusters of the same kind of line placed over the initial clusters. All the strokes are applied in one direction without regard to their piling up in the spaces between. The effect is a directional and dynamic feeling of sweeping lines, much like a stylized version of driving rain. It's particularly useful for conveying motion and for suggesting indistinct shapes within larger shapes, like trees emerging from a fog bank. The emerging shapes are put down first, followed a general layer of strokes right over them. Where the strokes double up, the shapes seem to have a subtle presence, suggested by slightly darker shapes where the overlapping is most obvious. These types of strokes can also be overlapped to give the appearance of woodgrain.

8

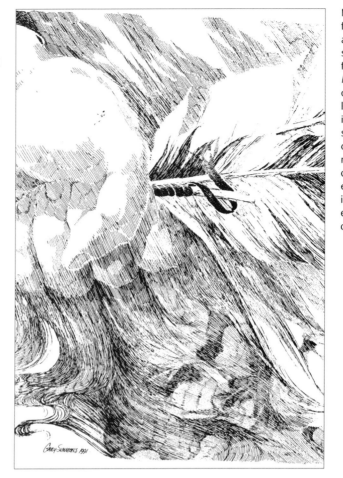

Motion is a frequently an effect achieved with this stroke. In the detail from *Fist and Feathers*, 12" x 14", one layer of parallel lines forms the basic images and is then selectively compounded with more layers, darkening them enough to be visible in the gray, but not enough to be distinct.

Layering parallel lines, or drawing one series of parallel lines over another and then drawing over them with more lines in the same direction, creates an indistinct edge for shapes that looks like a misty atmosphere or something in motion. In J. R. Koser's *Boathouse*, the stroke creates strong negative shapes for the sails of the boats, pushing the building even further back into the page's space.

Reticulated Clusters of Hatched Lines

This is simply the hatching of line clusters that are purposely separated by white spaces from one cluster to the next. The stroke can add visual interest, creating such special effects as reflected light patterns underwater and making such irregular surfaces as tree bark. Placed very regularly, reticulated clusters take on a textural quality that can suggest bricks, flagstones, shingles, patches of grass, and so forth. In a background, this technique can produce a feeling of indistinctness, as though the image is broken by light or atmospheric conditions.

9

Leda's First Feather. 30″ x 40″. When clusters are purposely separated at regular intervals, the pattern takes a distinctive look, forming what is called reticulated clusters of hatched lines. The cast shadows of the water over the top of Leda's entire body are created by clusters of hatched line that are reticulated in a recognizable pattern of reflections.

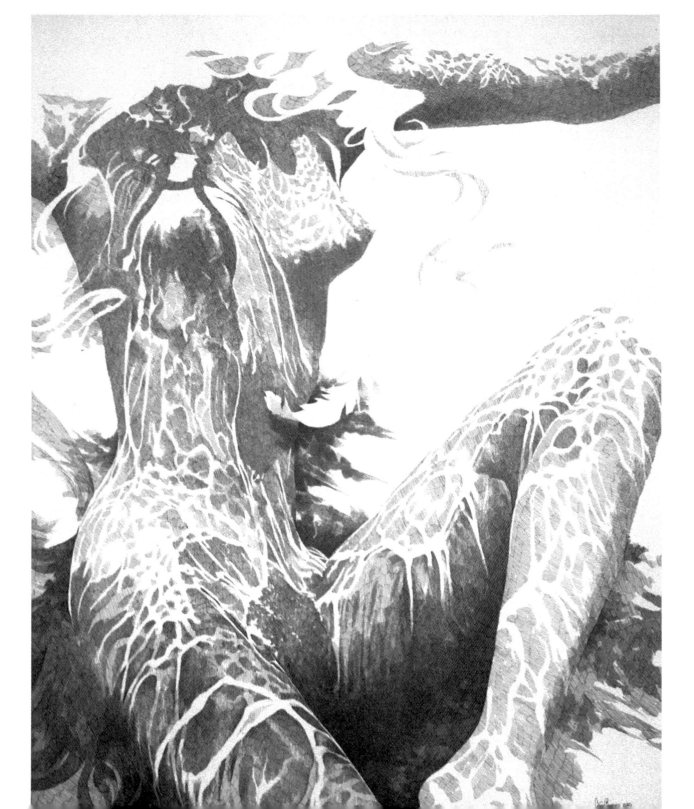

Radiating Clusters of Line

This is a very useful pattern for fur, hair, grass, or any other texture that is made up

10

of short, parallel, or slightly radiating projections. The strokes often radiate slightly with the contour of the subject, such as the nose of a deer or a tuft of grass on a small knoll. The strokes usually overlap just at the base of the clusters, and the line is kept quite short.

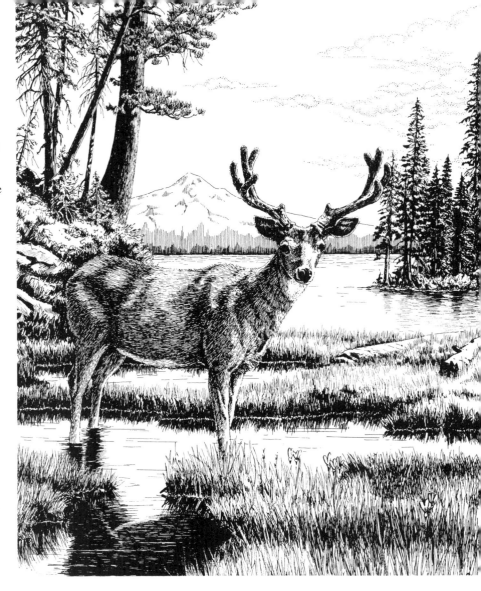

A common application of radiating clusters is their use in short tufts that look very much like fur or grass. Claudia Nice's deer is a good example of the pattern working with the contour of the shape, as in the cowlick on the animal's face.

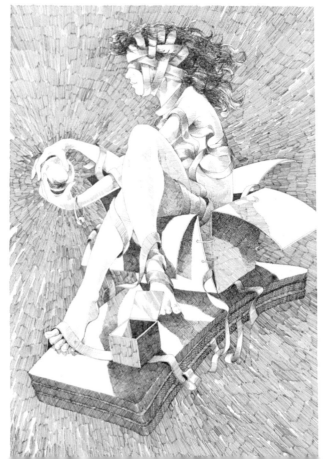

In *Pandora*, 16" x 20", radiating lines simulate a light bursting from the ball. It's easiest to do these strokes in concentric rings.

Crosshatched Lines

11

12

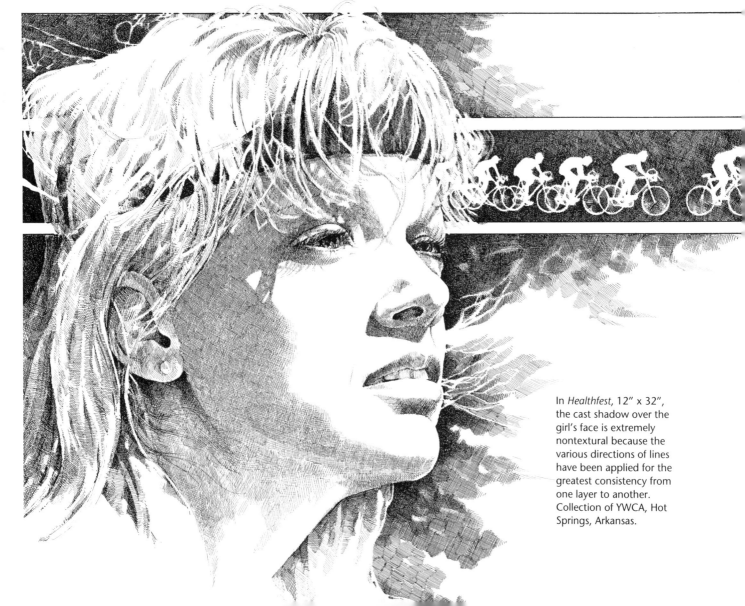

13

Crosshatching is the crisscrossing of lines over one another in varying directions. The basic units of this technique are the small hatched clusters of parallel line and the resulting spaces between the lines. Together they make a pattern of gray much like halftone dots in a photographic screen.

The pattern changes in character with the consistency of line length, parallelism, and spacing. Control is easiest with small clusters of lines, all strictly parallel and closely spaced. If the lines radiate rather than sit parallel to one another, the inconsistency in the pattern takes on a textural quality rather than just a tonality or color. A similar thing happens if the lines are not close enough. The impression is that of a waffle rather than a block of screenwire. The individual lines in the pattern begin to assert themselves and the pattern suffers.

In the first two or three layers of crossed lines, inconsistencies will compound. Beyond that, the added layers start to obscure the lines as the pattern gets darker and darker, finally looking black and showing very little inconsistency. The first layers are important, because it is within those first layers that the subtle middle grays are developed. If they have to be continually crosshatched in order to impose uniformity, the same strokes that impose that order are also making the tonality darker.

A cardinal principle of crosshatching is: The more consistent the line spacing and line direction in the layers, the more geometric and even is the tonality of the pattern. Draw the first series of lines parallel and evenly spaced. Draw the second series in the same way and at right angles to the first cluster, and then draw the next two series of lines diagonally at 45 degrees, one from the right and the other from the left. As you develop your own technique, you will discover how to achieve this uniformity with a less rigid sequence of lines. As long as you understand what is happening with the line, you will be able to find an adaptation that suits you. This is important to the artist who is rendering local color or the effects of light without implying textures. The effect is similar to tightly woven screenwire or fabric.

The more acute the angle of crisscrossing in the clusters of crosshatched line, the more active the pattern becomes. An acute angle produces a pattern of crossed lines that makes long diamond shapes that shimmer, like a moiré pattern. This type of pattern can be useful, but most of the time you will want to avoid this effect. It is a very distracting pattern if not used well.

In *Healthfest*, 12" x 32", the cast shadow over the girl's face is extremely nontextural because the various directions of lines have been applied for the greatest consistency from one layer to another. Collection of YWCA, Hot Springs, Arkansas.

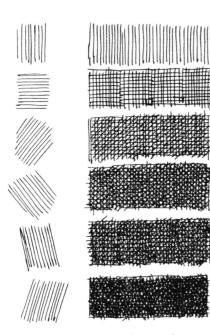

Crosshatched lines provide a significant amount of control over texture and tonality if the individual strokes are parallel. To master this control, practice a rather mechanical progression of strokes starting with vertical, then horizontal, followed by 45 degree diagonals from the left and then from the right. As your skill improves, the rigidity of this system won't be as important. The symmetry of the system is what makes the pattern uniform and nontextural.

The crosshatch stroke is extremely adaptable, serving well for texture in the garments of *Lisa and Spuds*, 16" x 20" (top), and for color in *The Clydesdales*, 30" x 40" (bottom left).

Symmetrical-Weave Patterns

Individual or clustered lines can be interwoven to create distinct textures that look like baskets and some fabrics. One of the virtues of this texture is that it feels alive and interesting, yet doesn't necessarily interfere with the central image. The variations are literally endless.

Extending the length of the lines in a symmetrical-weave pattern is one way to vary it. The pattern can graduate from a very specific weave to a blend with the background, where the weave gives way to a blending of values.

14

15

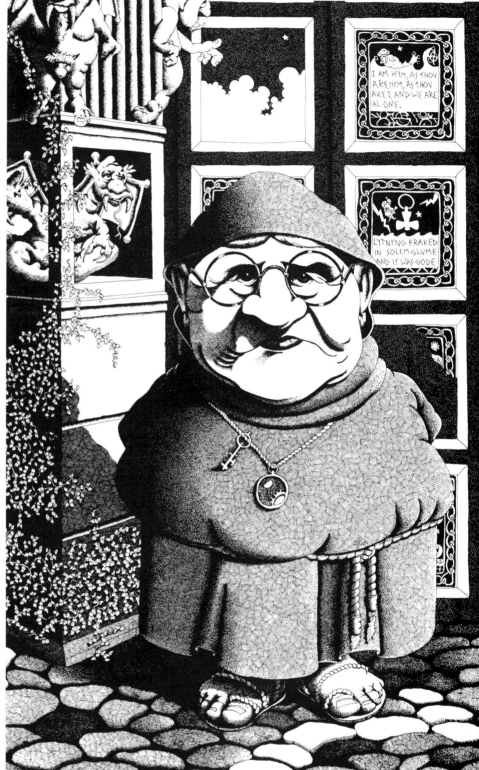

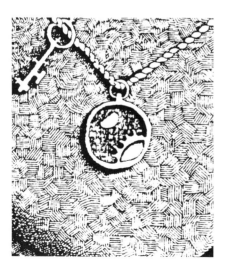

Dennis Joern, *The Portal of Truthe*. Virtually any pattern of strokes can be alternated to look woven. Weaves can be symbolic of textures in baskets, fabric, or decorative borders. An impressive application of symmetrical weave patterns is shown in the figure (top); note the detail of the fabric (left). Great control is necessary to avoid having the pattern take over the drawing.

Irregular-Weave Patterns

Irregular-weave patterns are comprised of series of strokes that butt one another in opposing directions, but unlike symmetrical patterns, alternating directions are inconsistent in their length and directions. These patterns tend to be more serendipitous in their creation than the symmetrical weaves.

The irregular-weave pattern is a derivation of the more uniform weaves. The strokes can be straight or curvilinear. The complexities of the weave and of the line directions are a matter of personal taste and artistic intentions. Pen artists of the early 1900s used it to break up the monotony of large gray areas, particularly in architectural and landscape drawings.

This is the type of pattern that starts as an innocent experiment or an alternative to boredom and eventually becomes so prevalent in the drawing that it dominates the overall feeling of the piece. Use the effect as purposefully as you can.

Waves and Zigzag Lines

There is a whole category of lines that seem to incorporate parallelism, curvature, merging, and radiating directions. A good

example is line that is essentially parallel, but dips and bellows like the contour lines of a topographical map.

This is another technique that requires purposeful application and restraint in order to avoid fragmenting the drawing. Lines of this nature are dynamic and will draw the viewer's eye away from the drawing's point of focus. I have found very limited application for this technique unless I am scribbling or drawing in haste. This is a rather artificial distinction from the other curvilinear lines, but it is useful.

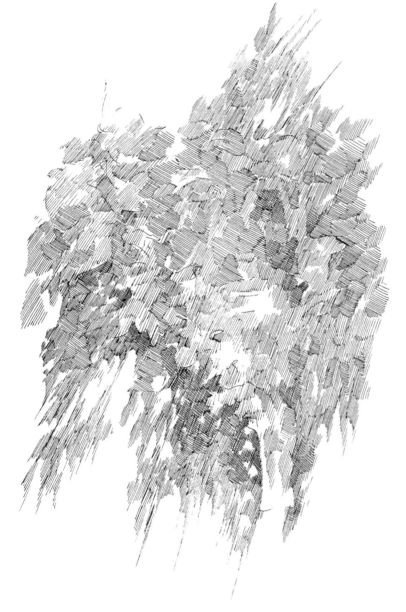

Breaking up the regular placement of interwoven strokes offers much more variety than simple weaves. There is a tendency to make the irregular weave pattern curvilinear and dynamic, but other possibilities include such abstract combinations as crosshatching and alternating patches of vertical line (left).

The curvilinear pattern of waves and zigzags is such a contrived and dynamic stroke that it is more likely to be used in stylization and design than in rendering. It is used by some artists to break up large areas that might become tedious with just one stroke and one direction of stroke. The wave pattern is used effectively by Marv Espe in *North Country* (opposite page) to break up the monotony of the strokes and to create a unique texture in the overall drawing.

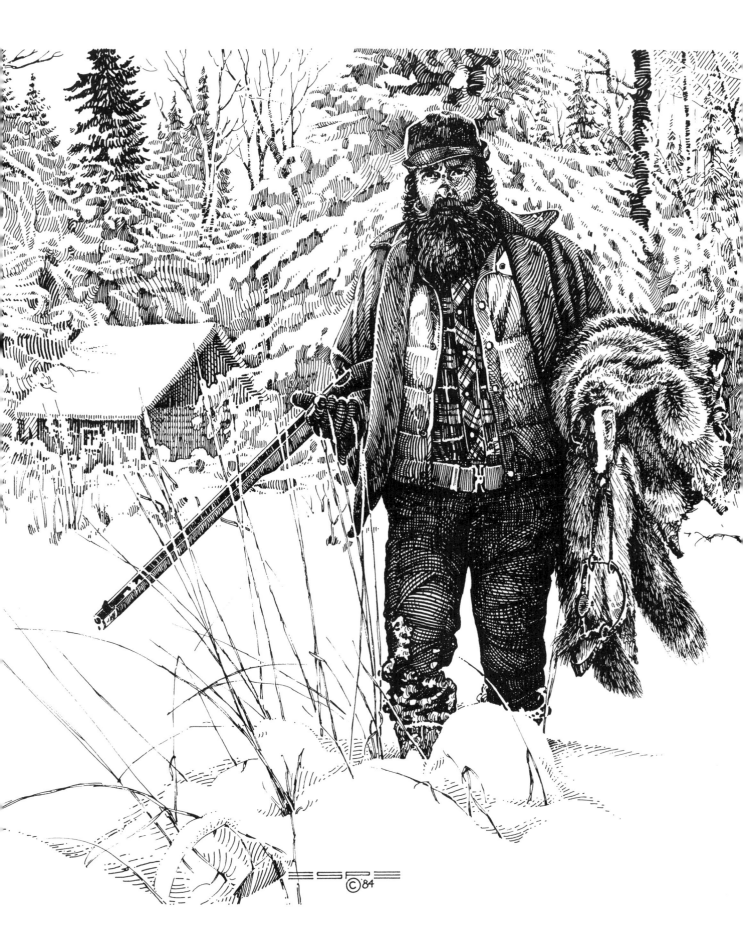

Merging and Radiating Lines

After establishing an outline of a shape, draw an interior set of lines that merge and radiate with the contour of the shape. The effect is similar to stylized woodgrains flowing around a knothole. This is a good exercise for motor control with the pen. Obvious uses are for hair, feathers, stylized water, or air currents.

20

21

22

Radiating concentric circles also work well to simulate woodgrains, some water effects, implied air currents, or fog. On your drawing, the pattern might not reveal a full circle of line, but the implication is that if the view of the pattern were large enough, the lines would eventually connect in a circle. The technique for applying these circles is virtually the same as the technique for applying curvilinear parallel lines.

If you want to use this type of line to accurately render shapes, you must draw them out with pencil first. The very nature of this type of line will make it flow in unplanned directions if small deviations are present, eventually leading to large changes in the overall pattern.

The longer the lines, the more control you must have, but there are some ways to work up to that control. One is to break the line, but make the joint carefully so that the break is obscure. This is useful when the drawing is too big or the location of the image on the page makes it difficult to draw long concentric lines.

One of the secrets to drawing consistent patterns of this type is to rotate the drawing in order to maintain a consistent wrist action with the pen. You can unintentionally change the pattern simply because you have trouble reaching an area of the drawing. For example, if you are concentrating on the end of a feather vein where the lines sweep to a point, you might want to start each stroke near the quill in order to maintain a consistent motion from line to line.

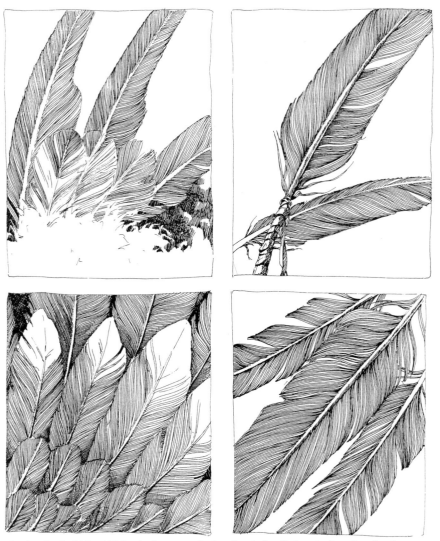

Feather Study, 11" x 14" (top), shows a calculated use of radiating strokes. One line is developed as the central quill with the radiating lines growing out of each preceding stroke. If you are less interested in serendipity than in specific shapes, it is wise to pencil in the guidelines first (bottom left) in order to keep this stroke from drifting into an unintended shape.

Feathers, and sometimes hair, are the principal items that I draw with merging and radiating strokes. I frequently experiment with this curvilinear pattern in my sketchbooks because it is so much fun to do. Sketches like *The Listener*, 11" x 14" (right), begin as one curved line, developing into a shape as the fancy strikes me.

Before I drew *Pan*, 16" x 20" (left), I penciled in the profile and the leaves in order to protect the negative spaces. All of the merging lines were drawn spontaneously, working around the negative shapes.

Loops and Scales

Most repetitive shapes fall in this curvilinear pattern. Its success often depends on consistent repetition of a shape. This repetition changes perspective and size to follow the contour of a volume, as fish scales change to follow the contour of the fish's cylindrical body.

23

24

25

Because there are a lot of variations in the actual shape of scales as they follow the contour of large volumes, it can be difficult to accurately render them. When drawing this pattern on a flat shape, you can work with a system of ruled lines to guide your pen work, but if the shape is contoured, your guidelines must match the curvature of the volume. This is usually done better freehand than mechanically, but even then slight deviations from the guidelines will dictate the direction the pattern takes. You have to concentrate considerably to maintain consistency and perspective.

This technique can consist of textures within textures. Larger shapes can each be embellished with different tonalities, shadows, and additional shapes within shapes. Overlapping loops can create an interesting chain-mail texture, particularly when combined with some local color and cast shadows around the individual shapes.

A more subtle version of this technique uses tonalities rather than outline to define the edges of repetitive modules. Another variation is a manufactured look created by making the modules with a compass or a template.

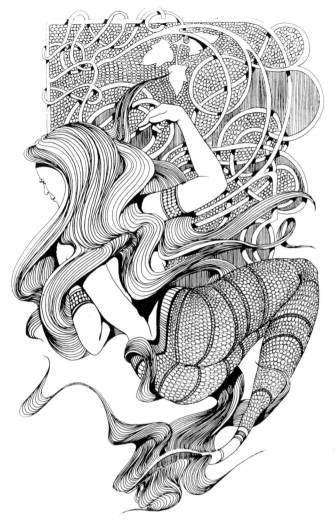

Practically any shape can be drawn with a curvilinear pattern of loops and scales. The most common use, however, is in semi-circular shapes, such as scales. If the shape to which these strokes are applied has any perspective, the pattern must be adjusted accordingly. For example, the scales on *The Nosy Mermaid*, 11" x 14" (left), diminish in size and change in shape as they wrap around the body. This effect is best accomplished by setting up a pencil pattern, as in the fish sketch (bottom), to follow for the scales, any highlights on them, any special textural considerations, and any areas of color.

Dots

Stippling, or pointillism, rivals crosshatching as a predominant pen-and-ink technique. It is popular with artists just starting pen-and-ink, because it offers considerable control and assurance. You literally construct an image one dot at a time. It is particularly effective for very subtle tonal gradations and textures. But as simple as it seems, this technique is paradoxical: It is easy to construct an image with it, but it is very difficult to construct a good image. It's slow and methodical and can be agonizingly slow for the wrong personality.

26

27

Dots create an image at a slow rate. There is much less risk in using one dot at a time than there is in making a long mark. The dot can be incorporated into an overall image more easily than a line. Also, an image constructed of dots seems less abstract than one constructed of crosshatched lines. Even though it is safe, it is difficult to place the dots consistently and not create clumps of dots that look like a pitted texture. It's hard to work initial tonalities dark enough to avoid having to make adjustments with later applications of the dots. On the other hand, to come back to tonalities that already exist and to make them darker requires more careful placement of dots in order to maintain the evenness of the gray tones.

Dots are also very useful as line. You can create a subtle dotted outline around the major shapes of the subject. The dotted line can also provide preliminary edges and outlines in a drawing without making them obtrusive. Subsequent line work can then be worked right over the dots, which will virtually disappear.

Stippling can be combined with line, but its success depends upon knowing what you're trying to accomplish without creating a sense of inconsistency in the drawing.

The effects of stippling are more controlled than the effects of lines. Usually, the feeling of the stippled drawing is a little on the airy or hazy side, since the image has no real substantial marks in it. The crosshatched image is much harder to make subtle and is more likely to feel chaotic in spots. On the other hand, the crosshatched image is solid and inherently uses the motion of line to suggest energy and direction. Stippling, unlike crosshatching, forces the artist to approximate the final tonality from the beginning of the drawing. This is fairly safe to do because the dots are so controllable and the values so long in developing that you have time to correct as you go.

A variation of stippling is the use of white dots on a black field. Some artists combine pen with scratchboard, scratching a black surface to get the white dots and inking the non-scratchboard part of the surface to get the black dots. In other words, the areas that need white lines or dots are brushed with India ink and worked as scratchboard. The remainder of the board is left white and marked with the pen like any other inking surface.

Robin Jess, *Botany*. Science illustration is often stippled because it requires subtlety of tonality and texture and the subject is strictly controllable. This botanical illustration shows the subtle texture, lighting, and shapes that stippling makes possible. Note particularly the effective use of stippling for such shapes as plant leaves. From A. Conquist, *An Integrated System*, reprinted by permission of the New York Botanical Garden.

Circles, Bubbles, and Boxes

Pointillism is using clusters of dots to construct shapes, so it stands to reason that virtually any kind of module can be adapted to a pointillist application. Computers do this when they create portraits with symbols, and cameras do it when they translate images into half-tone dots.

28

29

Circles and bubbles, as derivations of the dot, are modules used to build tonalities or specific textures. The nature of the bubble creates a much looser look than stippling with dots, giving the image a very stylized, indistinct appearance.

Because the circles cause the image to look slightly fragmented, it is important to place them accurately enough to suggest recognizable shapes. To create a literal image with these marks, start with a well-defined pencil drawing as a guide. This technique seems to support the premise that virtually any mark works as a tonality if it is used in a pattern format.

Like the other modular versions of pointillism, repeated boxes can function just like circles and bubbles to create tonalities.

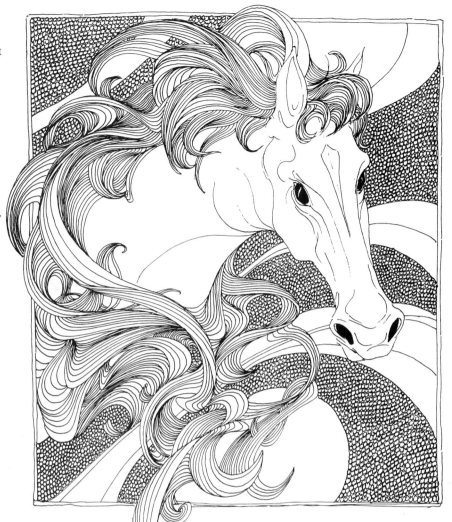

The Stallion. 11" x 14". The bubble technique is seen more in the work of early pen artists than in contemporary pen work. I tend to use it more for design texture, as in this figure, than for literal shapes.

This figure illustrates white bubbles used in a black background as texture.

Solid Black

This is one of the most powerful strokes in your arsenal. For that very reason, it's

30

frequently abused when used to hide the inadequacies of the drawing, or in the other extreme, when it is avoided for fear of making the drawing too dark.

Solid black is an effective design element for stylizing and for silhouette, for creating a point of focus, for suggesting a mood, and for indicating depth.

One of the most successful applications of solid black is in cartoon and comic book art, where it is a powerful tool for implying dynamics of force, direction, and mood.

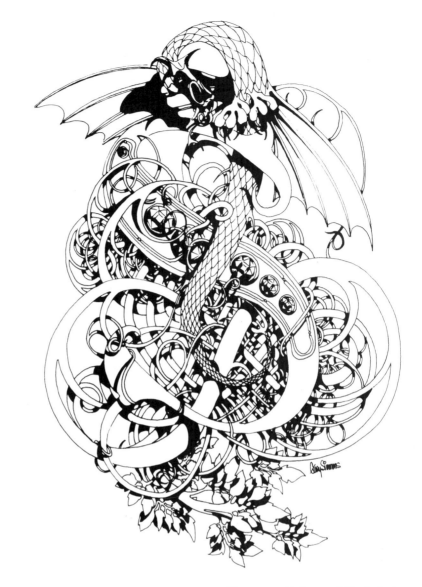

Monogram with Dragon. 11" x 14". The solid black technique combined with outlined drawings creates illusions of depth with black cast shadows. This combination is easy to watercolor because the solid blacks maintain a strong image even when the color is bold.

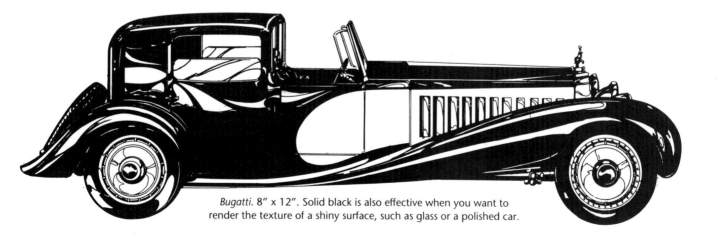

Bugatti. 8" x 12". Solid black is also effective when you want to render the texture of a shiny surface, such as glass or a polished car.

SOLID BLACK CROSSHATCHED
BLACK

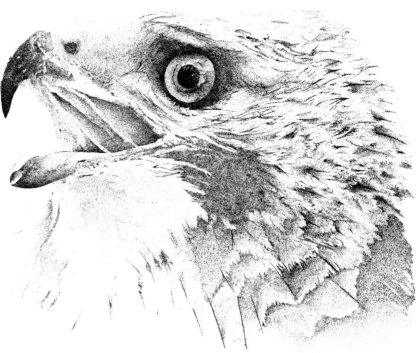

When solid black is needed in a drawing that is crosshatched, it is usually wise to crosshatch the shape to a near blackness, allowing the white specks of the paper to show through (top left) and keeping the black consistent with the rest of the drawing. A compromise method is to paint in the solid black and then stipple or crosshatch the edges of the black until it looks like the blackness is breaking up and flowing into a gray tonality. Ken Hull does this with his hawk drawing (top right).

Integrating large areas of solid black with a textured and intricate image requires a strong sense of composition and control over tonality. Frank Hnat does a good job of integrating strong blacks with the rest of the image. Hnat controls the tonality so well that the ducks in his drawing (bottom) never lose their modeling to the black areas.

Silhouetted images or parts of images in a drawing can create a considerable sense of depth if the rest of the drawing has the right contrast. Curtis Woody uses black in his figures in a powerful contrast with very soft and luminous stippling. The black is selected and placed so well that the drawing is accentuated rather than overwhelmed by these solid tonalities.

PEN STROKES IN DESIGN AND COMPOSITION

The specifics of a drawing are developed by creating and controlling the individual strokes and the patterns they form throughout the drawing. Just as the individual strokes do not work in isolation, so the accumulative patterns of strokes do not work in isolation as the overall composition develops. The patterns are, of course, defining the image's shapes, values, textures, and local colors. But they are also establishing such compositional effects as point of focus, overall mood, sense of movement, and general cohesiveness. In this next chapter I use the same image in twenty-four variations to show how varied the overall effect can be by using different combinations of stroke patterns.

THE MONK SERIES

This chapter presents twenty-four versions of the same image (see figure on this page) to demonstrate some of the variations that are possible when the same stroke is applied in different ways. The monk series also shows the effects of strokes when they are combined and how some compositional effects are achieved with these combinations. In order to eliminate some of the confusion in demonstrating the differences in strokes and their effects, I have designed an image with lots of isolated spaces that enable me to maintain the image's integrity and still use a wide variation of strokes. I have purposely experimented, risking combinations of textures that don't always work, trying various areas of focus, using strokes that are of questionable merit, and generally trying to present as much variation as I could with one image. The results are perhaps the most important and revealing of any demonstration in this book, because they clearly show that the artist's imagination and intent are the only real guidelines to the use of pen strokes.

None of these drawings is relegated to one type of pen stroke. In addition, there are duplications from one drawing to the next; nevertheless, the drawings demonstrate the many varieties of pen strokes and their applications.

On the following two pages is a visual summary of the thirty basic pen strokes, which were discussed in the previous chapter and are used in the monk series. Each of the twenty-four monk drawings is accompanied by the relevant pen-stroke "icons" identified by number from this chart.

William Henson, *American Portrait (opposite page)*. In this Indian portrait, the loops are tight enough to look like parallel line, but they are free enough in their application to give the impression of texture, almost as though the loops were part of a highly controlled sketch. In areas where a smoother texture is needed, such as the face, the strokes are applied more as small slashes than as loops.

BASIC PEN STROKES

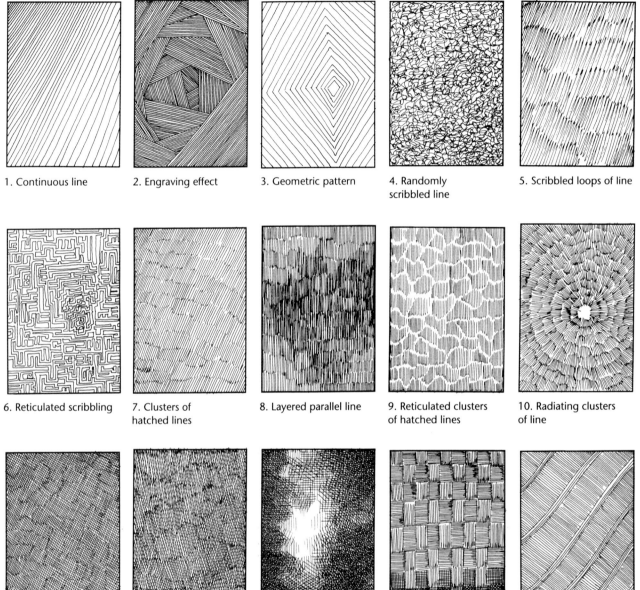

1. Continuous line

2. Engraving effect

3. Geometric pattern

4. Randomly scribbled line

5. Scribbled loops of line

6. Reticulated scribbling

7. Clusters of hatched lines

8. Layered parallel line

9. Reticulated clusters of hatched lines

10. Radiating clusters of line

11. Crosshatched lines—variant 1

12. Crosshatched lines—variant 2

13. Crosshatched lines—variant 3

14. Symmetrical-weave pattern—variant 1

15. Symmetrical-weave pattern—variant 2

16. Irregular-weave pattern

17. Waves and zigzag lines—variant 1

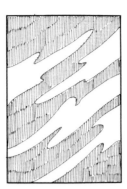

18. Waves and zigzag lines—variant 2

19. Waves and zigzag lines—variant 3

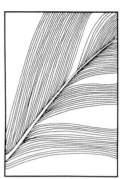

20. Merging and radiating lines—variant 1

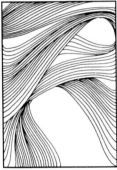

21. Merging and radiating lines—variant 2

22. Merging and radiating lines—variant 3

23. Loops and scales—variant 1

24. Loops and scales—variant 2

25. Loops and scales—variant 3

26. Dots—variant 1

27. Dots—variant 2

28. Circles, bubbles, and boxes—variant 1

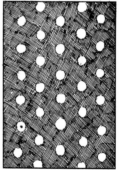

29. Circles, bubbles, and boxes—variant 2

30. Solid black

MONK NO. 1

MONK NO. 2

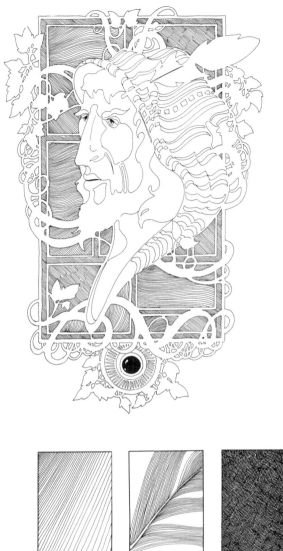

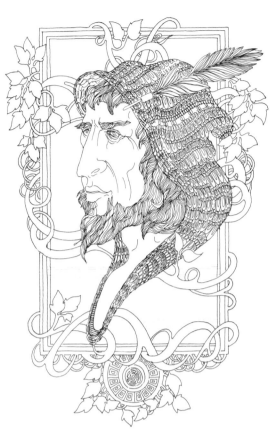

In these two examples, virtually all the shapes rely on outlined edges to make their statements. In monk no. 1 there is no tonality development other than the implied textures of the background shapes and the shiny black button at the bottom of the frame. This *negative silhouette* effect is very flat, even with its detailed shapes. Without the grayness of the background, the whole composition would lack depth.

In monk no. 2 there are more internal shapes defined, such as the edges of the leaves and vines. The beard, hat, and feather have internal shapes that create a texture even though those shapes are merely outlined. This is strong evidence of the cumulative quality of strokes. Even without tonality, the strokes will eventually acquire a textural feeling if there are enough of them close enough together. Another interesting effect in no. 2 is the strong sense of depth created by the contrast of the dark monk head with the white background.

MONK NO. 3

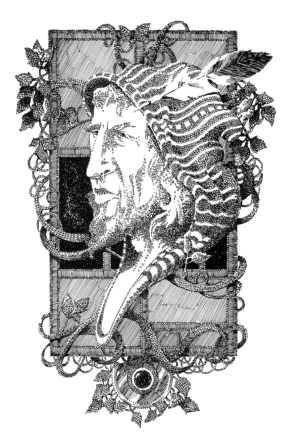

MONK NO. 4

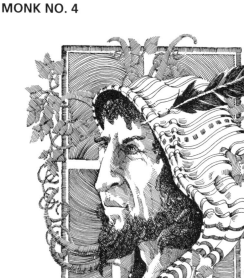

Both of these monks have depth even though they represent opposite applications of light and dark. Monk no. 3 has a dark background with a light facial area, and monk no. 4 has a dark beard and hair that provide weight to the face. The important point is that contrast works for depth in either case. The continuity of the back-grounds also assists in the effect.Both figures are fairly active, particularly in the curvilinear quality of monk no. 4, and the two monks are consistent in tone. In monk no. 3, the middle section of the background provides an added punch to help lift the light face. Many times in pen and ink the artist has to create an arbitrary tonality to solve a problem of contrast. If the black section in no. 4 was used in no. 3, the compromise with the beard would pull the face farther into the background instead of lifting it.

2 19

28 30

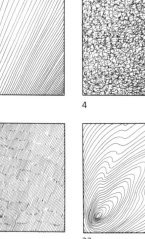

1 4

7 22

MONK NO. 5

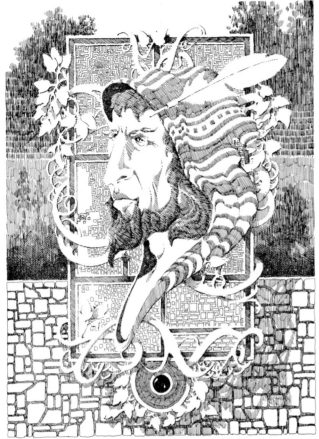

MONK NO. 6

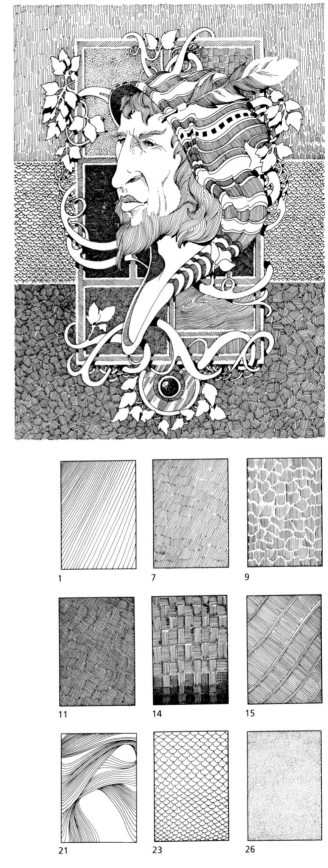

The backgrounds in these cases lack continuity of shape or tonality. Monk no. 5 is less uniform than no. 6 because of the large negative spaces in the stone pattern. The tonality of the monk's face and hat in no. 5 are too close to the background to have much depth. In no. 6 there is again that one area of significant contrast that rescues the whole drawing. Even the little black cast shadows in the vines and the black squares in the hat help give the major image some substance. The texture in no. 5 is attractive, but its tonality prevents it from having any dynamics. In both of these drawings, too much diversity of texture fragments the composition.

3

6

7

8

30

1

7

9

11

14

15

21

23

26

MONK NO. 7　　　　　　　　　　　　**MONK NO. 8**

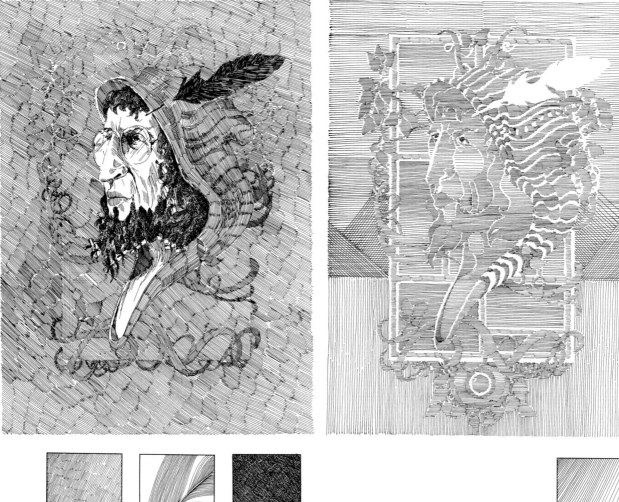

　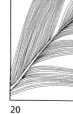　　　　　　　　　　　

7　　　　　　　20　　　　　　30　　　　　　　　　　　　　　1

Both of these compositions use uniformity of stroke to the extreme, almost, but not quite, obliterating the edges of the interior shapes. In monk no. 7 the edges of the frame and vines are preserved simply by the small lines where strokes stop. This can be an extremely useful technique for creating camouflage, enhancing only the shapes you want to declare with the others appearing almost subliminally. In no. 8, the edges are preserved by the small white river between shapes. The effect is a negative outline that flattens the shapes as much as or more than positive outlines. This flattening is compounded by the long, continuous lines extending from one edge of the shape to the other. In no. 8, I experimented with a series of crosshatched lines, but stopped as they added to the confusion. Stopping under these circumstances is something the beginner usually fails to do. There's a compulsion to keep trying even though the effects don't quite feel right. Sometimes stopping soon enough saves the drawing. That's not a claim I am making for this one.

MONK NO. 9　　　　　　　　　　　　　　　**MONK NO. 10**

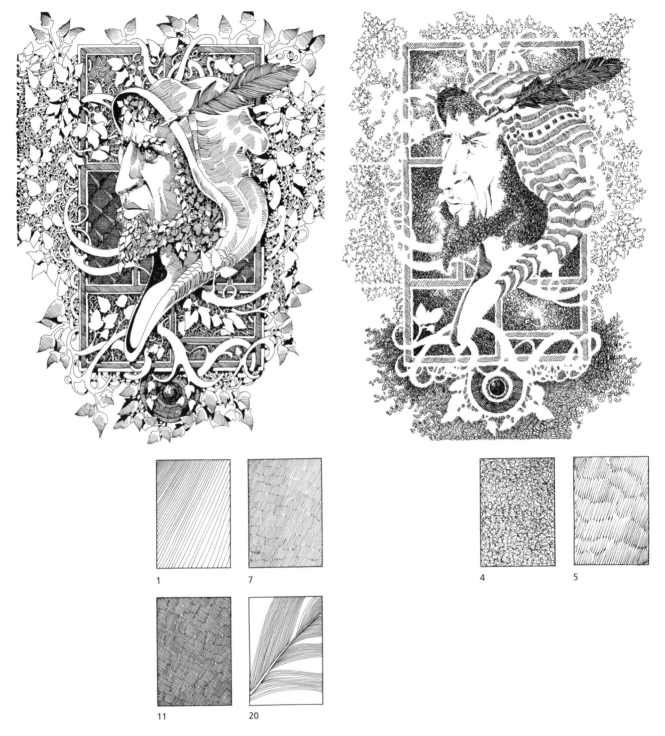

1　　7

4　　5

11　　20

In both of these drawings I went beyond the initial layout and enhanced the shapes with additional foliage. In both cases, the complexity in the background compromises the subject, but more so in monk no. 9. Monk no. 10 has a large negative shape in the face and neck that help distinguish the figure from the ground. The lesson here is two-fold: complexity per se is often counterproductive without a good reason for it, and saving the negative shapes until you have evaluated the overall composition is a number one priority. Both drawings would be improved by enhancing the value of the subject or the background. In monk no. 9, the values are already dark in some of the areas of the background, so it would probably be safer to darken the whole background by adding color in the leaves, as I started to in the top and bottom ones. In monk no. 10 there is more opportunity to go either way, since there are no real darks anywhere.

MONK NO. 11

MONK NO. 12

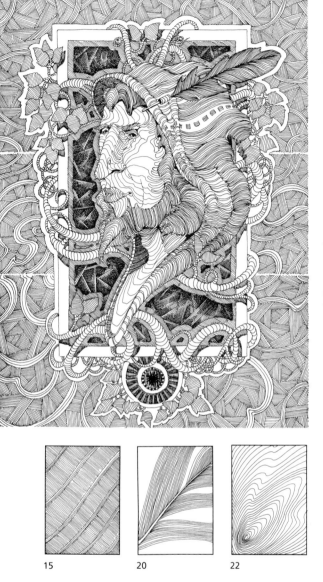

The striking similarities in these two drawings are the incredibly active patterns in the background and the extent to which they cover the whole composition. In monk no. 11 the pattern unquestionably overwhelms the drawing, even with the dark interior of the frame space. Darkness alone won't save a shape or a composition. In monk no. 12 there is some salvation in the strength of the central figure and the light gray value of the background. The central figure would be even stronger if the edges of the leaves were done in line instead of dots, which tend not to hold up well when a substantial shape is needed. An alternative approach would be to reinforce the values of the frame edges so that the frame and the monk become a strong unit contrasting with the background. Another aid to monk no. 12 is the fact that the patterns on the face, even though they are bold, don't really compromise the negative space of the face. On the other hand, in monk no. 11, the patterns are weak in value, but they pervade the whole space as well as confuse the face's shapes, so there is no one negative space strong enough to compete with the background.

MONK NO. 17

MONK NO. 18

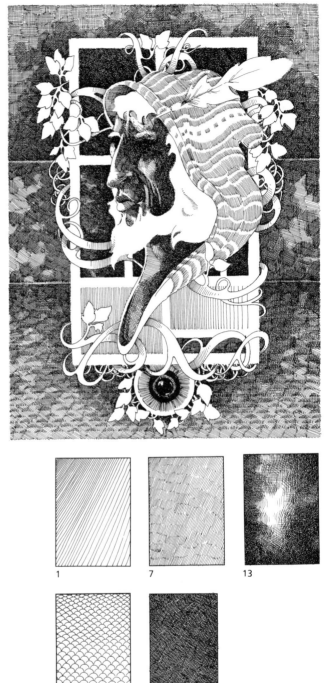

The most obvious characteristics of these two drawings is their brooding darkness. The application of the dark effect is a sketched, even scribbled one in monk no. 17 and a constructed one in monk no. 18. I think there is more danger in scribbling with the looser technique, because the effects of the scribbling require more lines to create the shape than the carefully applied strokes do. The darkness in monk no. 18 has a consistency that enables it to work as discrete areas, such as the face, where the dark shapes convey a strong sense of side lighting. Strong negative shapes are part of the key to no. 18, uniting frame and face as a unit in front of the background.

5

10

16

30

1

7

13

23

30

MONK NO. 15

MONK NO. 16

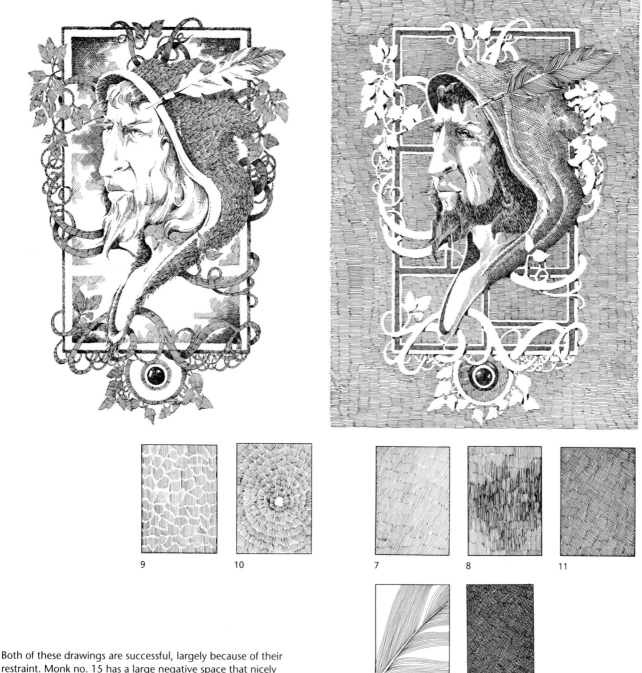

9

10

7

8

11

20

30

Both of these drawings are successful, largely because of their restraint. Monk no. 15 has a large negative space that nicely contrasts with the texture of the cap and the selective tonalities within the frame, particularly the brow and cheek where the negative shape needed definition. There is also considerable uniformity in all the various stroke applications. The radiated clusters of the fur are consistently made and placed. The hatched strokes in the vines provide a consistent and believable color. Monk no. 16 is strong on several counts, primarily contrast and restraint. The uniformity of the hatched clusters in the background provide an even tonality and unobtrusive texture that do not compete with the face. The strong negative vines provide a nice buffer between the gray background and frame area. The face includes enough strong blacks to contrast with the hair and cap and to help lift the face out of the background. The negative shapes in the face are not large, but they are very strong against the uniform background and the black hair.

MONK NO. 17

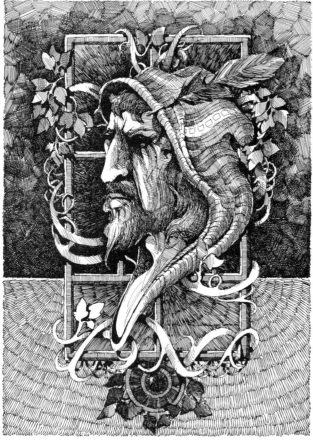

MONK NO. 18

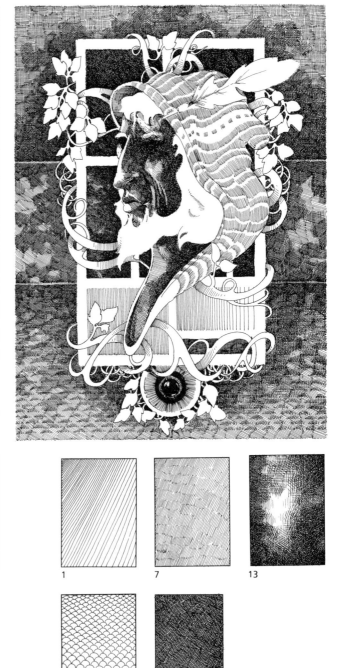

The most obvious characteristics of these two drawings is their brooding darkness. The application of the dark effect is a sketched, even scribbled one in monk no. 17 and a constructed one in monk no. 18. I think there is more danger in scribbling with the looser technique, because the effects of the scribbling require more lines to create the shape than the carefully applied strokes do. The darkness in monk no. 18 has a consistency that enables it to work as discrete areas, such as the face, where the dark shapes convey a strong sense of side lighting. Strong negative shapes are part of the key to no. 18, uniting frame and face as a unit in front of the background.

5

10

16

30

1

7

13

23

30

MONK NO. 11 **MONK NO. 12**

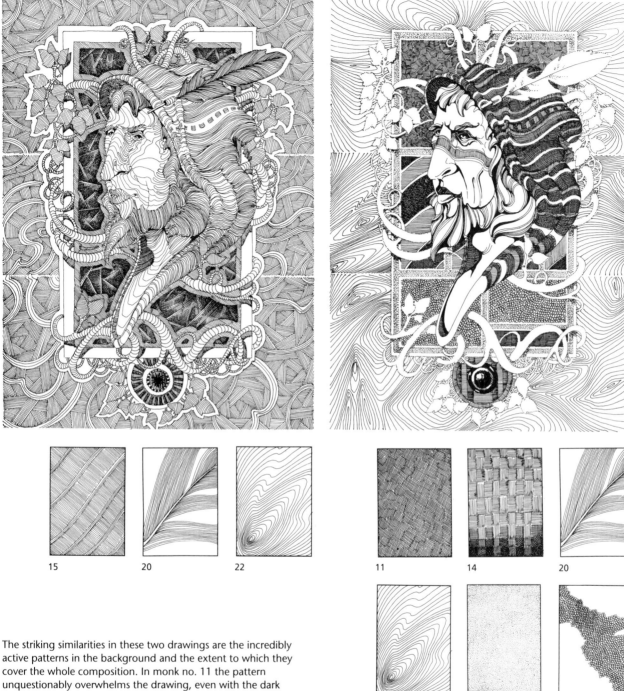

15 20 22

11 14 20

22 26 27

30

The striking similarities in these two drawings are the incredibly active patterns in the background and the extent to which they cover the whole composition. In monk no. 11 the pattern unquestionably overwhelms the drawing, even with the dark interior of the frame space. Darkness alone won't save a shape or a composition. In monk no. 12 there is some salvation in the strength of the central figure and the light gray value of the background. The central figure would be even stronger if the edges of the leaves were done in line instead of dots, which tend not to hold up well when a substantial shape is needed. An alternative approach would be to reinforce the values of the frame edges so that the frame and the monk become a strong unit contrasting with the background. Another aid to monk no. 12 is the fact that the patterns on the face, even though they are bold, don't really compromise the negative space of the face. On the other hand, in monk no. 11, the patterns are weak in value, but they pervade the whole space as well as confuse the face's shapes, so there is no one negative space strong enough to compete with the background.

MONK NO. 13

MONK NO. 14

Neither of these drawings feels particularly planned. Monk no. 13 includes a background that is so diverse in so many small areas that no one general effect is achieved. Monk no. 14 has a background with fairly large shapes and consistent strokes, but the strokes feel like filler. Perhaps if a gray version of the middle band had been imposed over the waves of the top and bottom background shapes, the central figure would have dominated the drawing more. In monk no. 13 there is also indecision about whether the vines are going to be negative or positive shapes. Again, an absence of any strategic dark values in no. 13 prevents any area from dominating. One thing that works for no. 13 is that the background is confined to the frame around the face, allowing the face and frame to be a composition against a white field.

MONK NO. 19

MONK NO. 20

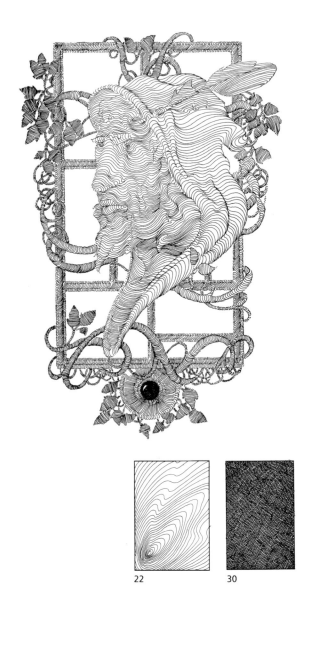

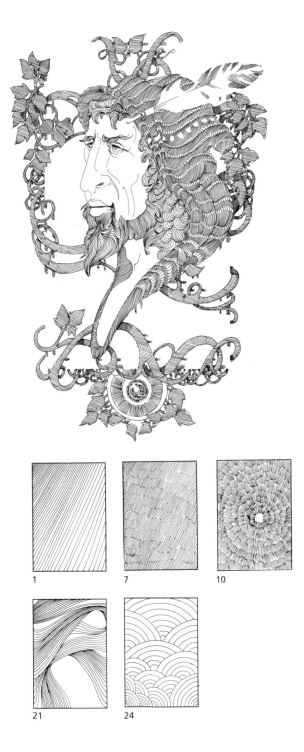

Both of these drawings have a kind of restraint about them. Monk no. 19 is complex with its contoured lines in the shapes, but the absence of background enables the complexities to make sense. As subtle as they are, the shapes in the face are still discernible, and the hat is distinguished from the face. The contour lines merge and form defining edges, which would be obscured if there were more strokes for color or value. In monk no. 20, the absence of frame as well as of background make it an even simpler composition. The truncated vines still work as design elements and even help divide the composition into an upper and lower group. Note also that the loops of the beard are distinguished from the hat simply by their difference in direction. I think that this simple use of line is one of the best effects the technical pen can achieve.

MONK NO. 21

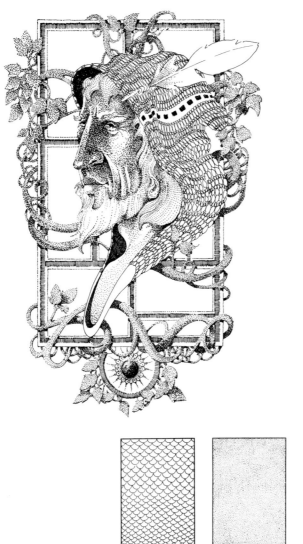

23 26

MONK NO. 22

7 11 28

Both of these drawings are a form of pointillism, one using dots as a module and the other using boxes. One of the outstanding virtues of dots shown in monk no. 21 is their ability to convey subtle coloration without the use of intervening texture. Another virtue is the ability of dots to precisely define edges and junctions. They can also create interesting stylizations, such as the long rows in the hair in no. 21. Monk no. 22 shows an interesting derivation of these principles. Modules larger than dots are inevitably going to make the shapes less distinct. This results in even fewer shapes unless the original drawing is large enough to accommodate boxes small enough to function like dots.

MONK NO. 23　　　　　　　　　　　　　　**MONK NO. 24**

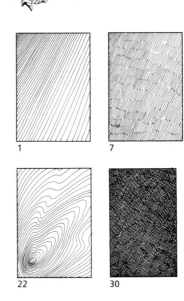

7　　　　　9　　　　　12

13　　　　　30

1　　　　　7

22　　　　　30

These two drawings represent extremes of rendering completely with tonalities (monk no. 23) and stylizing completely with line and solid black (monk no. 24). Each is a successful solution. Monk no. 23 presents strokes that are limited and uniform, the contrasts are evident and placed to maximize their effects, and the figure-ground relationship creates a strong spatial illusion. Monk no. 24 also a has a strong spatial illusion in the figure-ground relationship and in the individual shapes of the image. Limiting the background to the frame helps the simple line work create an effective sense of shape and of texture. In monk no. 24 the major shapes are negative, so the positive shapes pick up the slack by being exceptionally dark and well unified.

PEN STROKE EXERCISES

Achieving facility with the technical pen is entirely a matter of practice and repetition. It is important first to gain manual control, which the following exercises will help you do. As in the illustration, practice drawing: steady and continuous lines that are parallel and evenly spaced; even curves and loops; consistent repeating shapes; and concentric and merging lines. Use this exercise chart to practice pen-and-ink strokes.

Blending and tonality are crucial to pen-and-ink work. The more you experiment with this, the more you'll realize that blending is achieved by selectively layering the strokes. The more control you have over the strokes and the tonalities, the more control you have when blending.

The easiest way to start is by developing gray scales. Use one pen stroke per exercise to create five values from black to white.

There's probably no more effective learning device than "messing" with the pen, trying things that are free of the importance we attach to artwork.

Using the monk pattern (opposite), try a variety of different strokes and effects. Compare them and identify the looks you are most interested in.

The chart and the monk pattern should be photocopied so that you can practice these exercises repeatedly.

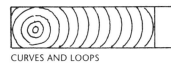

PARALLEL LINES

CURVES AND LOOPS

CONSISTENT REPETITION OF SHAPES

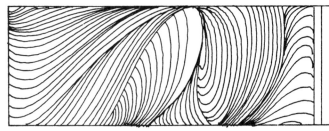

CONCENTRIC AND MERGING LINES

BLENDED TONALITIES

HATCHING AND CROSSHATCHING

GRAYSCALE

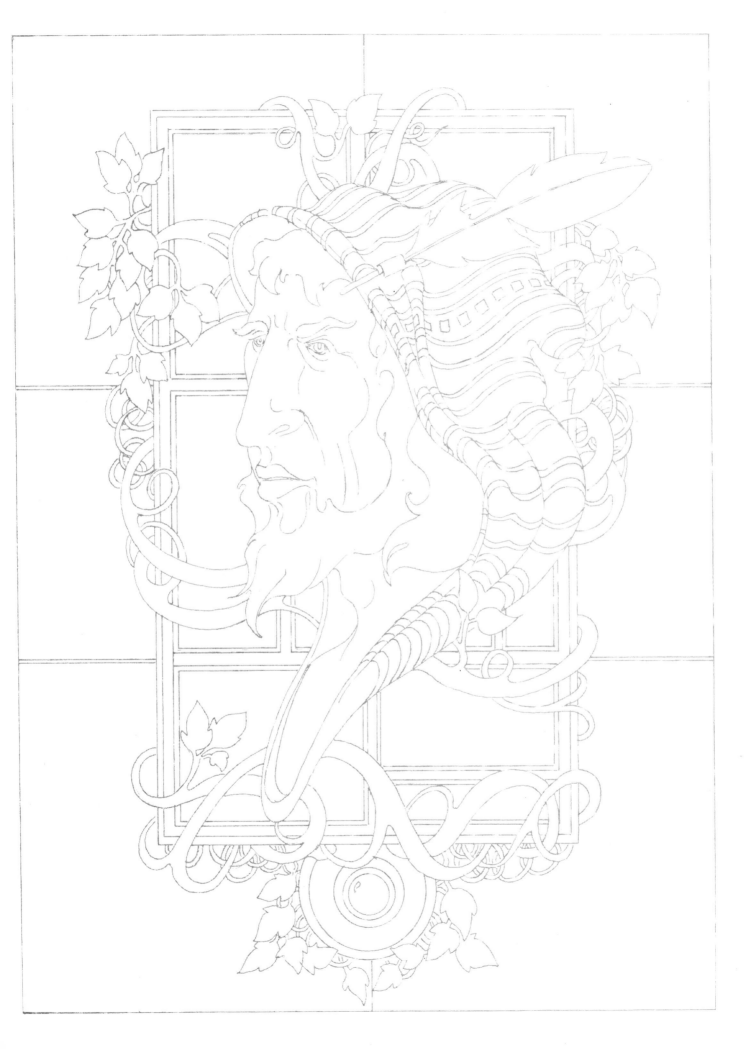

LOOSE PEN-AND-INK DRAWING TECHNIQUES

Indian Group. 8" x 10". When the drawing has a loose gestural quality, strokes can describe a characteristic such as color without being carefully placed. In this loose sketch, the hasty application of almost scribbled strokes effectively describe dark hair colors.

The variations in strokes, patterns, functions, and composition effects can be applied in three ways: with loose techniques, tight techniques, or a combination of the two. Tightly constructed renderings that feature patiently applied layers of pen strokes are most often associated with technical pens. Loose, or gestural, techniques are more commonly associated with flexible-nib pen-and-ink drawings. This chapter, however, shows that loose techniques are suited to the technical pen, as well as being the most fun and useful to many artists. The technical pen is actually ideal for spontaneous and expressive pen-and-ink rendering and sketching.

The secret to loose or tight drawing is the ability to shift mental gears when changing from one technique to another. Speed and spontaneity characterize loose pen drawings, while tight techniques work well with drawings that depend on complex and photorealistic effects. Before you start drawing, you need some awareness of what kind of drawing you expect to create and which pen techniques can accommodate it. You may decide on using loose pen techniques because of the way in which you look at the subject, the speed with which you make strokes, the amount of stroke variations you use, the complexity of the drawing, and, sometimes, the pens you choose.

HANDLING OUTLINE

Loose drawings are seldom based on pencil outlines. As a result, outlining to set up the basic composition is done with the technical pen itself. Outlining with the pen is an important skill to learn for loose pen work such as field sketching. Loose pen outlines usually grow out of direct observation of a subject and proceed to creating shapes on the page with the same kind of light touch used when drawing with a pencil.

I recommend a penpoint somewhere between #0 and #2. Anything smaller tends to snag the paper and anything much larger tends to skip and make the stroke look heavy-handed.

When sketching, break the outline in order to make it resemble a fragmented contour that hints at edges rather than boldly defining them. There are three ways of handling outlines to help set the stage for loose drawing techniques: draw the outline in dots, draw it very lightly, or draw it as broken line. It will then disappear as interior shapes are loosely sketched over the page.

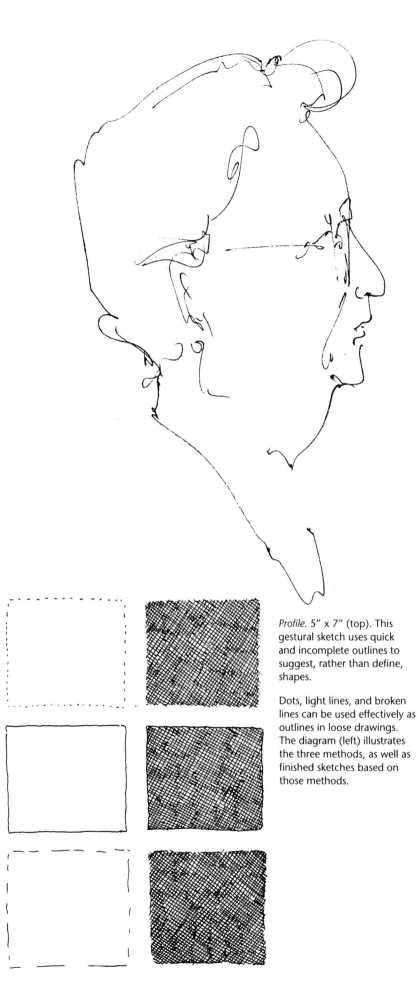

Profile. 5" x 7" (top). This gestural sketch uses quick and incomplete outlines to suggest, rather than define, shapes.

Dots, light lines, and broken lines can be used effectively as outlines in loose drawings. The diagram (left) illustrates the three methods, as well as finished sketches based on those methods.

Stylization with outline is increased if the outermost outlines of the shape are heavier than the interior ones. This gives the *Cavalryman*, 10" x 14", the appearance of being separate from the page.

Tight Outline Work

This exercise for outlining shapes—tracing the edges of the major shapes in a photograph; identifying the edges of volumes, textures, colors, and values; stylizing those outlines with a heavy exterior line; and blackening the most obvious shadow shapes within the outlines—gives you a background in expressing volume that will prove helpful when using loose drawing techniques.

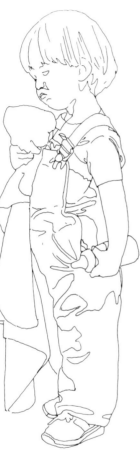

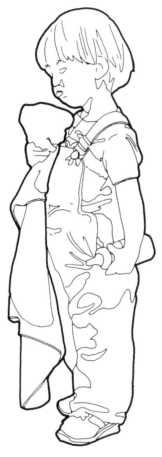

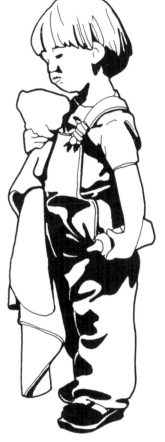

Find a photograph of a subject you can isolate and place a sheet of tracing paper over it. Identify the large shapes that define the subject, in this case, the figure of a little child.

Using a pen at least as large as a 3x0 point, trace a very thorough outline of the most important shapes. Concentrate on expressing the figure's volume; avoid filling in shadows and textures for the moment.

Go back with a #0 or #1 pen and outline only the most exterior shapes.

Working with the same drawing, use tracing paper again, and this time embellish the image with outlines of important textures and the most extreme cast shadows, which can then be filled in black. The result is a bold and multi-dimensional figure.

GESTURAL DRAWING WITH THE TECHNICAL PEN

Quick, gestural strokes are limited to four or five inches before skipping occurs. Therefore, to create a good gestural drawing, you must work *with* the nature of the technical pen. The limited length of a gestural stroke is more than made up for by the consistency of line provided by the pen.

As a rule, the smallest points (6x0, 4x0, and 3x0) are less desirable for sketching than the larger points, because they are sharp and tend to snag onto paper fibers and inhibit spontaneous strokes. My preferences for sketching are #0, #1, or #2 point sizes. There are, however, certain technical pens, such as the Rotring Rapidodraw, that are touted for sketching, because they have a slightly rounded radius on the nib, enabling them to move more freely over the paper.

The techniques described below can help you to put the characteristics of technical pens to work for you when sketching. All of the loose techniques depend on sketching quickly, spontaneously, and on making decisions on the spot with your eyes and hand.

Visual Note Taking

Gestural drawing and loose sketching are visual note taking, a shorthand that suggests as much as it declares, relying on impressions of a subject more than on details. Edges and values are indicated with a few strokes that suggest an entire shape and its motion.

In order to respond to an impression, you have to be selective with the pen, choosing the shapes and values that strike you as most obvious and most important to the effect you're interested in. If the most interesting thing about the subject is movement, as in a walking figure, then concentrate on the lines that suggest that movement. Look at the curve of the leg, the sweep of the coattails, or the line of the hair as it streams off the head. Subordinate your interest in the details of the ankle, the pattern on the coat, and the intricacies of the hairdo.

The texture and shadows of this tree in Longwood Gardens (left) captured my interest. First, I narrowed the 11" x 14" sketch to the tree, then to a section of the tree, and finally to the trunk and limbs. In another instance of outdoor sketching, I limited the tree at Lake Degray to one small twig of leaves (bottom).

Carrie Jamieson. 8" x 10" (left). In this sketch the shapes are suggested more than developed. The cluster of flowers on the hat is really no more than suggestive loops of line. In this case, the context of the hat helps suggest the flowers.

Because you're dealing with impressions when sketching using loose techniques, exploration of the image is necessary. And because you're using the technical pen, secondary marks are usually necessary to follow up that exploration. Watching a man in a chair during a poetry reading, I drew an 8" x 10" sketch (right) showing the positive strokes of the arm and leg shapes, then I doodled in secondary areas, such as the armpits and waist.

The starting point for a sketch is highly subjective. When I saw a lady strolling in an airport, my most immediate impression was of the entire profile of her right side. I saw it as one line, so the first mark of my 8" x 10" sketch started right at the top of her head.

LOOSE PEN-AND-INK DRAWING TECHNIQUES 91

Start Where You Are Most Interested

Before you start drawing, examine your subject for one or two of the most significant lines that impress you. There is no formula here. Your drawing is a statement of individual priorities and vision.

An inappropriate concern for accuracy and precision can prevent you from making the first marks, particularly with a pen. Force yourself to start somewhere. Anywhere you start will still lead you to a result worth examining.

Explore with the Pen

Look for a comfortable point of entry into a sketch and build from there. Unlike the process of careful construction in a realistic rendering, loose sketching is a spontaneous process of exploring, of leaping from one construction to the next as they become apparent, of working your way through the visual points of least resistance.

The more you can keep the penpoint on the paper and in motion, the more spontaneous and accurate the sketch will be. This helps you maintain eye contact with the subject. Your visual excursion through the subject is more critical than your attending to the location of the pen on the page.

Narrow the Scope of the Project

When you are preparing to make a loose gestural sketch, think about emphasis. It is a good idea to narrow the scope of the project, because trying to incorporate too much subject matter will lead to indecision and a composition without any area of emphasis. Select a part of the subject (such as a tree within a landscape) that will make a compact composition and will require limited values. Options include choosing something close, such as a detail of foliage at the base of a tree, or choosing something more inclusive with distinct foreground, middle ground, and background.

If you choose a landscape, first decide where the emphasis is going to be, and then look at the values that strike you. Study the subject for a strong contrast, such as a dark cloud against backlit leaves, or contrasting textures, such as a tangled mass of vines against smooth water, to help you re-create that impact.

If the gestural stroke of a technical pen is too quick, the pen will usually skip, not because of malfunction, but because the pen is designed to deliver ink at the rate of typical handwriting. In loose sketching, this can be an advantage and can deliver a line with its own kind of charm. A light touch was used in drawing the leg lines of *Leda*, 11" x 14".

In this 11" x 14" sketch of a Naperville, Illinois, landscape, I deliberately established a foreground, middle ground, and background division, separating the subjects by value.

Don't Concentrate on Details

Avoid the temptation of looking at the details of interior shapes before you see the larger shapes that contain those details. One of the most disruptive things that can happen to a sketch is to stop the pen's gestural description of a larger shape or line in order to draw details. Draw as though the larger shape were all that you had to deal with at the moment, because the continuity of that shape will make more visual sense than all the details you can build into it.

The pen's accuracy depends on this continuity of the movement. It's like drawing a circle quickly instead of very slowly. The gesture often feels like an exaggeration, particularly when you're drawing figures. The sweep of a leg from thigh to shoe may feel like a large gesture, but if you trust your eye and your hand, the gesture will contain accuracies that you would have trouble drawing slowly. Even more amazing, the gesture will feel like the motion you see in the leg.

You can help these gestures by using the pen as though you were physically feeling the shape as you draw it. Sweep along a shape's edge, push into pockets of shadow, and turn with the corners. Drawing is literally a sensual exploration of the motion you see. Make few marks, but make them as extensive as the gesture will carry you.

Don't Work Too Small

Drawing small shapes tempts you to draw details you really don't see. If you make a small drawing, limit its values and details to a level of complexity consistent with an impression of distance from the subject. For example, if you're looking at a grove of trees on the distant horizon, draw only those values and shapes that are triggered by the immediate perception of what you are seeing. This is particularly useful for drawing textures that can be suggested by a few marks rather than by the development of a complex shape. The eye reduces distant foliage to masses of values, so masses are what you should draw, rather than leaves. As you move closer to the subject, you can include token leaf shapes to suggest the entire leaf mass. If you move very close, begin drawing the actual leaf texture of the bough.

Faces look like small, fleeting patches of values from a distance. Draw dark masses rather than detail if you can't see the detail.

A Lady and Her Earrings. 8″ x 10″. This sketch was made from television. The gestural sweep of her neck line was made in two motions. To capture the small dark recesses of her blouse as it crosses her shoulders, I had to "color in" the value with the pen. Without the variable line of a flexible nib, the technical pen requires that you compound the line to make another width. This is similar to dallying a moment in some small recess and poking into it with the pen, but it is not a distracting detour.

If you insist on working small, remember that details will be even smaller; they will become small clusters that convey value. The sketch of the man in the hat and coat (left) is reproduced at the actual size I drew it. So are the small figures of the couple (right). In both drawings the shapes were drawn at a size that I could actually see, not as I imagined them.

Look for Negative Shapes

As a rule, the negative spaces in a loose sketch are even more important than they are in a careful rendering. We are conditioned to look for organic volumes, the positive shapes against the background.

But many times the negative spaces of that background define edges more simply than the shapes that are obscured with detail. For example, a bough of leaves against the sky reveals very defined shapes of sky between the complex limbs and leaves.

Drawing those sky shapes is more accurate than drawing the leaf and limb shapes.

Set up major shapes with sketch lines that are obvious enough to guide your pen strokes but not so obvious that they dominate the drawing the way an outline does.

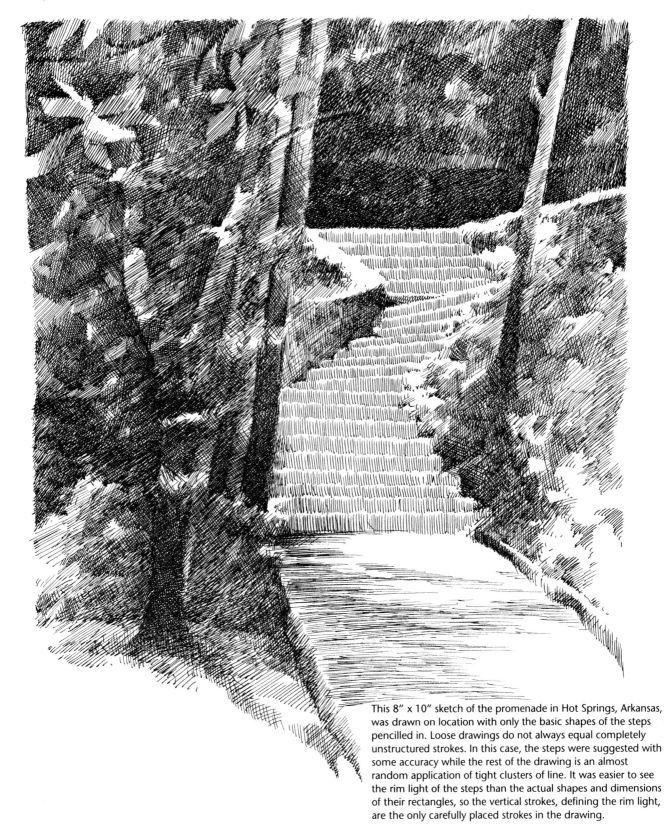

This 8" x 10" sketch of the promenade in Hot Springs, Arkansas, was drawn on location with only the basic shapes of the steps penciled in. Loose drawings do not always equal completely unstructured strokes. In this case, the steps were suggested with some accuracy while the rest of the drawing is an almost random application of tight clusters of line. It was easier to see the rim light of the steps than the actual shapes and dimensions of their rectangles, so the vertical strokes, defining the rim light, are the only carefully placed strokes in the drawing.

Use Solid Blacks

Unlike rendering, sketching allows a more cavalier use of solid blacks because the sketch itself is not supposed to be a realistic likeness of the subject. Let the pen's exploratory marks serve as energetic parts of the picture's statement, and don't be afraid to "color in" value freely with solid black.

Solid blacks in sketches can be visual coordinates for establishing an image's shapes and proportions. They are also very useful for establishing weight and presence in a sketch. Often the sketching process is tentative and a drawing may lack any substantial area of values and contrast. A little solid black can do wonders for such a sketch.

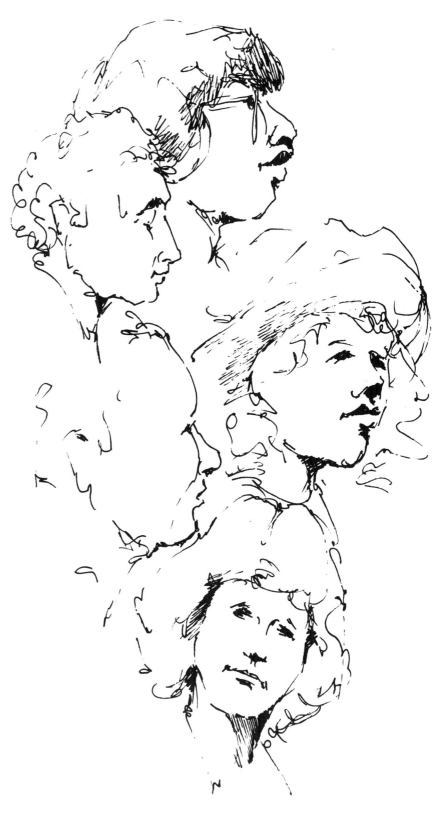

One way to get more black into a drawing is to use a bigger pen size. These sketches were done with a #2 rather than a #0 pen. The whole character of the sketch is different because of the heavier outlines and more massive blacks.

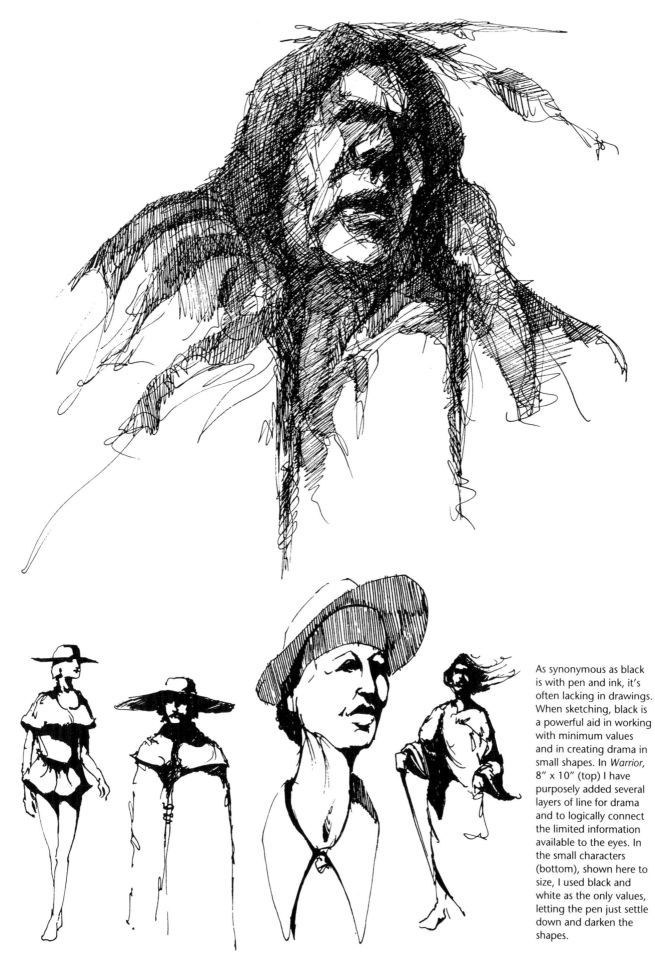

As synonymous as black is with pen and ink, it's often lacking in drawings. When sketching, black is a powerful aid in working with minimum values and in creating drama in small shapes. In *Warrior*, 8" x 10" (top) I have purposely added several layers of line for drama and to logically connect the limited information available to the eyes. In the small characters (bottom), shown here to size, I used black and white as the only values, letting the pen just settle down and darken the shapes.

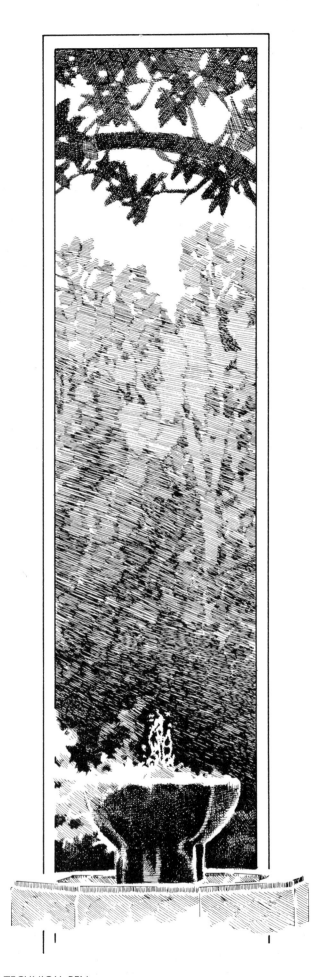

Use a Minimum Range of Values

For loose sketching, values are more likely to be the extremes of black and white with very few middle tones. Contrast can shore up a part of the composition that lacks definition. An area of strong contrast can link up with a similar value in another part of the drawing. This creates a visual flow in the composition. Not only does this help establish the larger composition by integrating subject and background, but it sets up visual anchor points for constructing accurate proportions and placement among elements in the drawing.

Concentrate on your area of emphasis and don't hesitate to be arbitrary with values. If a row of trees behind a barn looks rather light, but they are behind a sunlit side of the barn, arbitrarily darken the trees or the barn for contrast.

Have Fun with the Pen

Loose sketching and gestural drawing are the answers to enjoying the technical pen and exploring its potential. For the beginner, immediate immersion in the tedious and exacting process of rendering exacts too much effort for too little reward. Learn from repetition, variety, and spontaneity, all available with sketching. Don't be too concerned about precision too soon. You'll know when you're ready for that step. Entertain as well as instruct yourself.

Varied drawing exercises are for personal use, not public display. To expertly use the technical pen, you should feel comfortable experimenting. This will develop your skills and improve the look of your finished art.

When a subject lacks definition, contrast can shore up the drawing. Contrasting values work well for this 4" x 8" drawing of a fountain, creating atmosphere with very simple shapes.

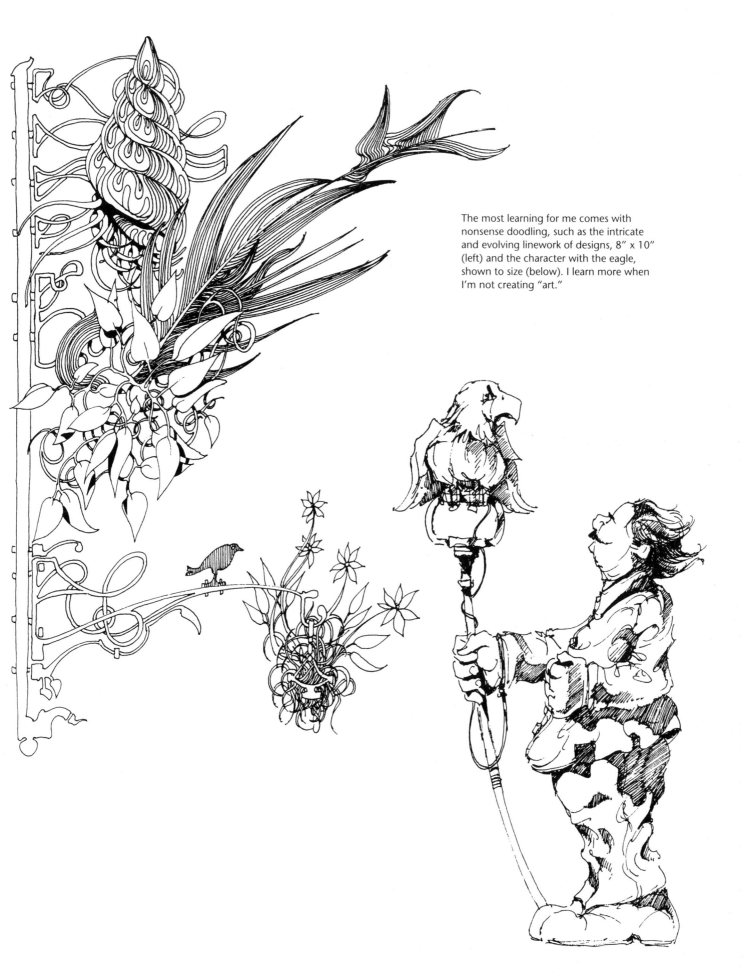

The most learning for me comes with nonsense doodling, such as the intricate and evolving linework of designs, 8" x 10" (left) and the character with the eagle, shown to size (below). I learn more when I'm not creating "art."

EXERCISES

Gestural Sketching

Using the pen is as much a question of familiarity as it is talent. The more you dare to use it in different ways, the more you will discover its secrets. Avoid the trap of repetitively drawing the same thing in the same way. Memory and imagination are good sources, but they need to be challenged. This exercise is based upon drawing what you actually see.

Forget the pencil at this stage. It will cause you to concentrate on precision rather than a feel for the pen and its potential. Don't worry about failing. These exercises are for you, not for the public. As you do this kind of drawing you will naturally evolve to more complex pen techniques.

1. Take your pen and drawing pad to a mall, an airport, a zoo, or some other area with lots of people and activity. Try gestural sketches of people and the things around them, but limit your expectations to visual note taking. Don't try to draw any more than the impression of the person. Limit your strokes to contour outlines that simply suggest the subject and its movement.

2. Similar exercises can be done from your television. Dance and music video programs offer lots of gesture and interesting garments. Talk shows and dramas repeat closeups of the same faces, often in the same light and at the same angle. Look for major impressions such as profiles, hair lines, hats, or cast shadows and try to put them down with two or three lines, drawing directly with the pen.

3. A derivation of this exercise is using your VCR and pausing it. Complete the drawing within the few minutes before the pause automatically kicks off.

4. Similar subjects might be your pets or the people sitting in the room with you. Don't get too ambitious at this stage. Draw parts of things, capturing the simplest outlines that reveal the subject.

In this 8" x 10" sketch of a friend in my livingroom, I concentrated on the basic shapes; head, torso, arms, legs, and feet. Details were avoided so my pen would not be sidetracked. I made one motion from the left knee to the toe in order to capture the gesture of the turned-in foot. The total gesture was used to capture the line of the right leg and knee.

These drawings were 30- to 60-second sketches made in airports of people walking by. They were done with a #0 Rapidograph and included no pencil work.

Developing Visual Memory

1. Identify, then capture the contours of a subject's basic masses with three or four lines only.

2. Look at a subject for 30 seconds, then make a sketch of the subject's basic shapes and gestures from memory.

3. Using 3 or more slides of a zoo animal moving through a sequence (such as a rhinoceros turning around), do a 10-minute sketch of each position. Repeat the exercise with 5 minutes each and then 2 minutes each, finishing with 30-second sketches of each move.

4. At an airport, mall, or public gathering, sketch individuals as they pass by within a 30- to 60-second time frame. Limit the sketches to moving individuals.

Materials for Field Sketching

For outdoor sketching, technical pens offer the advantage of cartridges and portability. Additional materials that may be helpful include: lapboard or tablet with sturdy cover; pencil, eraser, and sharpener; paper (8" x 11" to 16" x 20" range); pens and ink (#2, #0); paper towels; chair/cushion; hat; sunglasses.

Television offers a fine opportunity to grab quick impressions of things, particularly people. The cowboys (top), were part of the "Lonesome Dove" miniseries. Each drawing was approximately 3" x 4" on an 11" x 14" page. The bull, a 4" x 5" drawing, is from a documentary. I used the pause on the VCR to capture him.

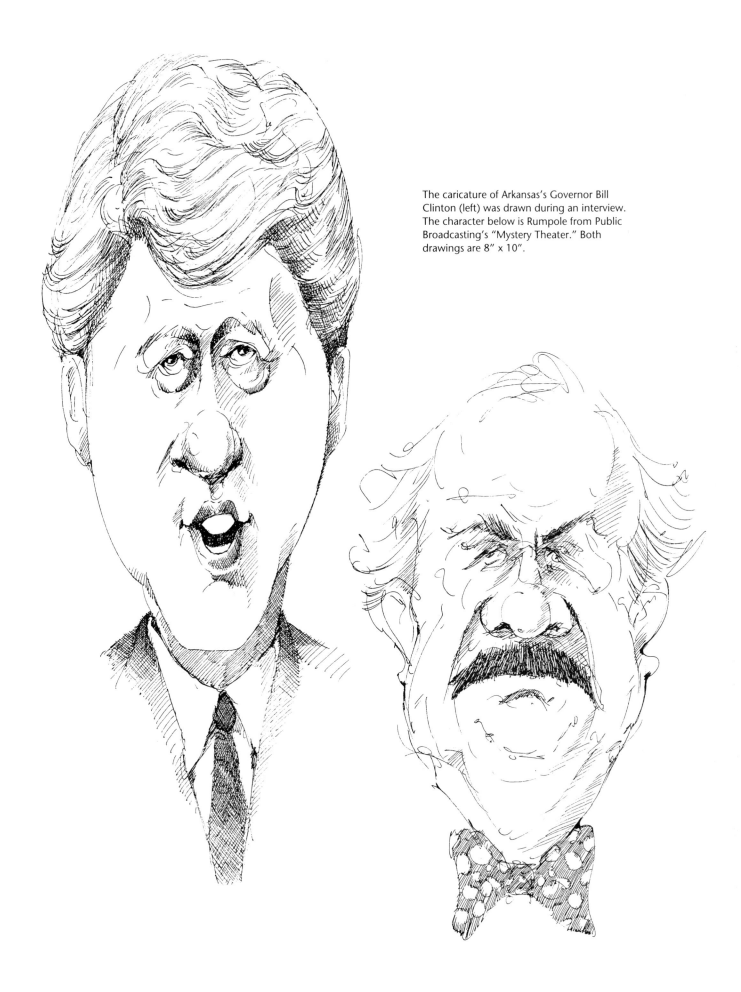

The caricature of Arkansas's Governor Bill Clinton (left) was drawn during an interview. The character below is Rumpole from Public Broadcasting's "Mystery Theater." Both drawings are 8" x 10".

TIGHT PEN-AND-INK DRAWING TECHNIQUES

Unlike the spontaneous and gestural strokes in loose drawing, tight drawing is very precise. Because the most limiting factor of pen-and-ink work is its indelible stroke, the contour of shapes is outlined, values are indicated, and composition is set up before any inking begins. For tight drawing, therefore, plan on doing a pencil drawing before inking.

The inking stage is also controlled. Strokes are put down in a precise, purposeful fashion in order to make patterns predictable. This technique is useful for creating accurate renderings of realistic images or any other planned, rather than spontaneous, imagery.

This chapter introduces you to the strategies that will enable you to be precise with the pen. What kind of final drawing you want will determine how carefully you plan the shapes in pencil and which strokes you will apply to create patterns for value, "color," texture, and volume.

While some tight drawing techniques may seem obvious, delay in using them until the drawing is in progress can bring disaster. To control the medium, plan your drawing carefully using this checklist:

1. Decide how realistic you want the image to be.
2. Plan the overall composition before you ink.
3. Decide where the emphasis will be.
4. Decide how specific to make the details.
5. Indicate the details as shapes and values.

The examples discussed below are not absolute and will not necessarily be a factor every time you make a tight drawing. The important thing is to develop some sense of how to evaluate the drawing as you set it up and where the pitfalls are as you do the inking. The pitfalls inevitably lurk somewhere between what you had planned to create and how you went about it.

SET UP THE COMPOSITION

The first thing you must do to create a tight drawing is determine the level of complexity for the drawing. This involves deciding how much detail you will include, how the details are to be arranged, and what challenges you anticipate facing in rendering the details for value, texture, and color. For example, if the drawing is a portrait, do you plan to create a literal interpretation of such features as hair texture and skin color, of jewelry, and of special effects needed to render leather clothing or transparent scarves?

In addition, you must determine how the details will be "packaged" as a total composition with regard to such effects as mood, the sense of movement, and logical placement of subjects. Larger composition concerns must be addressed, and a progression of decisions about contrast, emphasis, background, and borders must also be made, in the set-up stage.

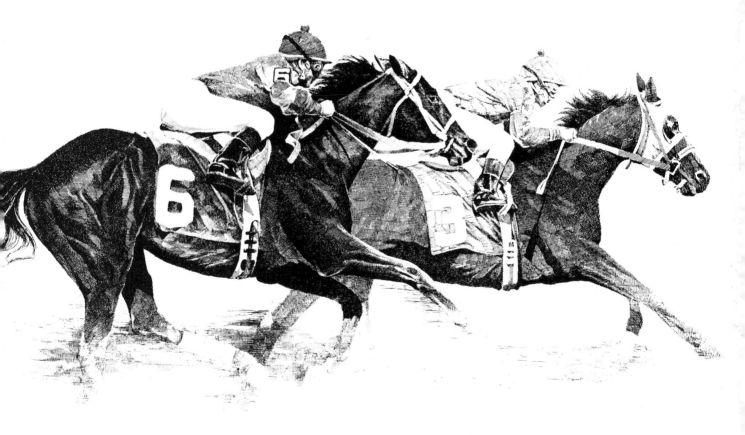

Richard DeSpain, *Victorian Home* (opposite page). DeSpain has outlined the edges of all the shapes with continuous line rather than using the more common rendering technique of indicating edges with hatched lines, dots, or some other less distinct indication. He fills the shapes with continuous ruled lines, confining the individual lines to the individual shapes, such as shingles. Continuous lines drawn through an entire area of shapes are confined to shadow areas, such as the large shadow under the porch roof.

Gainin'. 20" x 30". This figure was first drawn in pencil and then in India ink using tight drawing techniques. Collection of Mr. Don Schnipper, Hot Springs, Arkansas.

When I first drew *Ponygirl in Saddle*, 14" x 25" (left), I made the mistake of not allowing the white space in the lower part of the picture to remain open. I remedied this in the print version (right), and because of the improved contrast, the composition has become more attractive.

The Daughter, 20" x 30" (opposite page). In order to integrate the mountain man's image into this composition, I tied it to the girl's head with sweeping tonalities. It looks as though the man was being drawn out of the girl's hair. This action is counterbalanced by the white areas on the other side of the composition, which create contrast.

Contrast

The principle here is simple: plan for light against dark values unless you want to place similar values against one another. Contrast is the only tool you have for creating depth and edges between shapes.

White spaces in pen-and-ink drawings work like they do in watercolor. The white of the paper is generally the only white available to the artist and can't be retrieved once it is used up. The planned use of contrast is a major tool for the pen artist, so the elimination of white space is like a progressive surrender of options. Once the drawing is reduced to a uniform gray, the possibility of using white space is gone. Before drawing, remember that a small white space in a dark pen drawing can create more emphasis than all the other strokes in the drawing.

Emphasis

Any composition is generally more dynamic if there is a dominant image to attract the viewer's eye. Creating an area of emphasis with contrasting tonalities, precise and sharp edges, or a consolidated group of shapes gives the viewer a place from which to start exploring the image.

A composition may lack an area of emphasis because all the components are approximately the same size or same visual weight. As you plan the drawing, consider making one element in the image two or three times larger than anything else and build the other elements around it. For example, a portrait montage with several views of a person usually works better when one large view dominates the composition.

Background

If you include pen work in the background of a composition, it is important to consider whether it contrasts well with the subject and whether it has some kind of unity or logic. The values in the background can be so uniform and so similar to those in the subject that the drawing appears flat. Contrast can be introduced by darkening some areas of the subject or some areas the background adjacent to the subject. An interesting effect can be achieved with the painterly use of lost edges—areas where the subject actually blends into the background—which helps integrate the subject and the background.

With largely minimal backgrounds, any single item that strongly contrasts with the subject can overwhelm the composition. If you draw a butterfly on a white page and decide to place small black flower shape in the background, the flower is a contender for the viewer's attention. Complex backgrounds can also compete with the subject, particularly if there a lot of different textures or line directions are used. Plan what effects you want from the background, sketching them in pencil before inking. Avoid using random patterns of strokes in the background to compensate for a weak subject; the large open background spaces of a pen-and-ink composition must be constructed as purposefully as the central images.

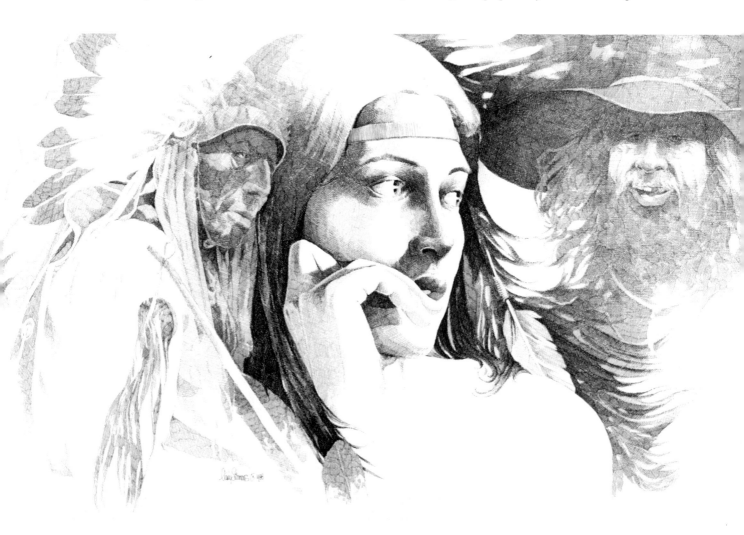

Borders

Borders serve several functions and must be planned from the start. Some borders are actual extensions of the subject matter, such as a frieze of plant leaves around a botanical drawing or a complex pattern of knots around a nautical drawing. A border looks best when it is part of the central image. Sometimes the border is simply a frame around the interior spaces, such as ruled lines, which may intersect with a protruding part of the central image. A penciled border can help establish background edges in the ink drawing, as pen strokes are easier to make with an edge to work against, even if the border is erased later. A guiding edge of this sort helps offset the tedium of crosshatching. It's like having a goal or target to focus on as you work toward an edge.

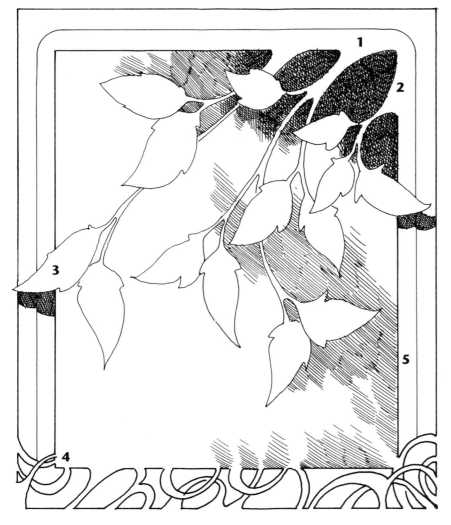

Plan the border to incorporate part of the image so that it looks necessary and not added after the fact (1). A border can help create a variation in background values (2). The border can be used to enhance a three-dimensional feeling and can add interest to the composition (3). Elaborate borders should be designed early to be consistent with the rest of the drawing's personality and values (4). Margins give you a visual target to work against and to help direct a whole layer of strokes (5).

DO THE PENCIL DRAWING

Careful pencil drawing breaks a composition into manageable pieces, like a jigsaw puzzle. These pieces enable you to identify and group your pen strokes. There are two dangers in doing a tight drawing without first doing a pencil drawing: distortion of individual shapes, because you don't have any indicators of edges; and loss of sight of where strokes are needed for different functions. Within a large shape, such as an animal hide, there are other shapes that indicate coloration, such textures as hair, and such values as shadows. Pencil contours of these various shapes help you keep track of which effects you are trying to achieve with specific pen strokes.

A fairly hard pencil (3H, 4H, 5H) makes it surprisingly easy to draw a line that is precise enough to show where pen strokes should start and stop. Hard pencils also don't smudge much. Scoring the drawing surface with the pencil, however, can affect your ink lines, so use a light touch when working with hard pencils.

Precision

The precision of the pencil drawing dictates the potential precision of the ink drawing. For the beginner, it's difficult to overdo this part of the process. In the pencil stage, the temptation is to hurry, avoiding or generalizing details so that you can get on to the inking. With experience, you learn what you can get away with, and you can modify the pencil stage to suit you.

The pencil process does more than just set up guidelines for ink. For example, a pencil drawing of a bison enables you to identify shapes where pen work is needed for texture, value, or color. One set of penciled contours identifies where the tufts of short hair are, another where the overall volume of the hump on the back is, and others where the hide is darker in patches. Without these specific pencil contours, it would be hard to distinguish where short radiating strokes indicating tufts of hair differ from the patches of uniform crosshatching indicating dark coloration. The penciled contours of the shapes help you constrain your strokes to specific areas so inadvertent effects aren't created.

Shapes

Pencil lines are a template for placing your pen strokes. Outline all the shapes to be inked; if your subject is, say, a fish, these would include volumes, the values that help define those volumes (shadows and highlights), the textures that cover the

When creating a pencil drawing as a basis for a tight ink drawing, don't worry about the indications of value or color until contours are established (1). Outline every contour you want to develop (2). Some shapes will be consolidated so only the major contours are needed (3). Make outlines very crisp to preserve the accuracy and size of the shapes (4). The pencil lines, however, can be quite light—they're only for position (5). In the figure, negative highlight shapes are outlined in order to maintain their accuracy (6). Don't overlook contours of major shapes such as the bottom edge of the figure's headband, even if you have to make an artificial edge through the overlying textures (7). Note also that continuous lines help distinguish texture shapes from the overlying color shapes (8). Texture shapes themselves should conform to the volume of the shapes they are covering (9).

As you develop the pencil drawing, you will find that lines of opposing direction help distinguish shapes (1). Little shapes should be added as outline only, since their color and value will be added later with pen strokes (2). Outlines establish the edges of shapes (3). Some outlines indicate where values will change without a hard edge between the shapes (4). Areas like the eye should be developed freehand, as you may not be able to see the details if the drawing is taken from an opaque projection (5). Some values should be indicated so pen strokes can be made closer together in the first pass (6). When values have gradation in intricate areas, it helps to indicate this with two or more layers of line (7). More complex value shapes need actual indication of value in pencil (8). When a large area of value is apparent, pencil outlines are enough to indicate where lines will fill in the shape (9). Darker shapes are texture (10). Covering lines are value, and in this example they are the color of the band (11). Pencil lines in the direction of the shape help indicate texture as well as value (12).

When a composition is inordinately complex, I resort to actually photocopying my sources at various sizes, cutting them out, and then moving them around in a collage until I have satisfied my objectives. The example (right) is a detail from a 30" x 40" layout. It is reproduced to size to show the literal impact of the image sizes. Once the composition was in place, I taped it down, had a reduced copy made, and projected the composition onto the final drawing surface and inked it (bottom). Collection of First National Bank of Russellville, Arkansas.

volumes (scales), and the local color—that is, the natural color of the volume or texture (the overall gray of the fish). The more shapes you indicate, the more literal the control you have over the ink drawing. This same planning extends to the background as well.

Values

Indicate important values in pencil. (A complex drawing will be built around four to six major values.) There are times when it's helpful to actually pencil in the values or to at least indicate where values are, particularly the extreme lights and darks. I indicate which shapes are going to be the darkest by filling them in with lightly hatched pencil lines. Too much pencil, however, can create confusion and affect the ink coverage.

WORKING WITH THE PENCIL DRAWING

If you create your first pencil composition directly on the final drawing surface, avoid damage to the surface from excessive smearing or erasing. An even bigger problem to avoid is the reluctance to make important changes in the composition simply because it is too much trouble to repeat the effort of redrawing in pencil. A preliminary layout on another surface, though, allows you to create a much more flexible plan for the composition. You can reserve the really diligent pencil work for the actual drawing surface that you are going to ink.

Transferring the Drawing

The initial version of a tight pencil drawing can be transferred to your drawing surface in several ways. You can simply copy it freehand, or you can use a grid system. Divide the original image's surface into squares. On the drawing surface for the final drawing, replicate the same number of squares at a size that covers the drawing. By redrawing the original image one square at a time on the larger surface, you can control proportion and placement for an accurate version of your original image.

Another method is transfer paper. Transfer paper is covered on one side with a substance that will transfer the image drawn on it to the surface beneath it.

In all of these processes, the greatest boon to planning a composition is a photocopier capable of reducing and enlarging an image. It enables you to take photos or drawings and scale them, cut them out and position them until you find a good solution. You can then use reduced

versions of the photos or the layouts on a projector for final placement on the drawing surface.

Projectors

The best way to transfer a layout to a drawing surface is to use an opaque or slide projector. The opaque projector will project reflected copy—magazine pages or photos that you can't see through—onto a drawing surface, where it can then be traced. Some opaque projectors have slide adaptors that enable you to project transparencies if you don't want to use a standard 35mm slide projector. Whether projectors inhibit creativity and compromise the legitimacy of the art are issues to be resolved by the individual artist. The reality is that projectors have become a major tool in the art world, particularly in commercial art and in most photorealistic techniques.

Refining the Pencil Drawing after Transfer

Once the outlines of the major shapes are on the drawing surface, a considerable amount of free-hand pencil drawing is usually needed in order to refine the image enough for pen work. Projection of the outlines inevitably leads to some distortion or confusion of small and complex shapes.

I use projected outlines for placement. Then, looking at the photo references, I combine the facts from the photo with my imagination to create the version I want to ink. I concentrate on clarifying confusing and distorted shapes, and frequently I need to indicate values that are important to that clarification. Usually, this means creating the small interior shapes that comprise the details of the larger, more obvious ones. These small shapes and edges can be extremely subtle, but they are critical to the successful inking of the image. Examples are the obscure edges of cast shadows (the underside of a nose), small shapes of the same value but different volumes (the shapes in an eyeball), and small construction details (the seams on a baseball cap).

If you intend to vignette part of the drawing by fading out or underdeveloping part of the image, construct the pencil version as though you were going to ink the whole image. It's easier and more effective to ink part of a complete image and later erase the unused pencil section than to attempt inking a partially constructed image.

Anything you can devise to help you set up your own road map for the inking is legitimate. For example, if I am drawing a very complex pattern, like underwater reflections on a surface, I establish a system of pencil marks that help me distinguish between the positive shapes I will ink and the negative shapes of white space I need to leave alone. I place a small penciled X in the spaces I want to leave unmarked as a warning. An alternative is to place pencil values in all the positive spaces I will ink, but that takes a lot of time and can be messy. It is cleaner and easier to simply mark the shapes where no ink work is to be done. Tedium defeats precision by eroding your interest in the drawing. Protect yourself from this whenever possible.

Heads Up. 30" x 40". When I plan to vignette part of a drawing, I do a pencil version to define each shape in the composition, even though I do not plan to ink every one. In this composition, the horses and jockeys in the background were drawn completely, but inking was done only on the first series of lines to set up the most fundamental shapes. I then developed the primary image and erased the pencil from the areas that I wanted to leave incomplete. Collection of Dr. Walter Springer, Hot Springs, Arkansas.

THINGS TO CONSIDER BEFORE YOU INK THE DRAWING

The beginner's biggest problems with pen and ink are problems of organization. Organization gives you control over the effects you are trying to achieve with the pen. It helps you distinguish between pen marks that are supposed to be values, textures, or color. When you don't understand which one you are working on, you are usually making the shapes too dark too soon, inadvertently covering up white spaces, creating pen strokes that confuse the shapes, creating inappropriate textures, and making edges too dark. All of these problems can be handled by purposefully and slowly building the shapes in controlled stages, adjusting the effects as the drawing develops. It's similar to glazing with paint, where you create shapes with a slow accretion of value and color rather than a one-time application of the brush.

Apply the Ink in Stages

The safest way to begin applying ink is in stages. First, place pen strokes in such small dark shapes as shadow areas and in the edges of strongly defined shapes. I keep all of the initial values light, using them primarily to identify boundaries of shapes. Edges are enhanced as needed in order to keep track of them, but rarely are they made dark in the initial stages. In the second stage, establish middle tonalities and any prominent textures that need to be set up. The third major stage involves the refinement of edges, of contrast, and of local color for groups of shapes. The last stage is development of the white areas that are the most risky to ink.

Build the Drawing in Groups of Shapes

As I put each stroke down, I think about it in terms of the shape I am developing and how it affects the surrounding shapes. Every few moments I check the overall drawing to see where I need to adjust line spacing, parallelism of strokes, contrast, accuracy of shapes, or the definition of edges. Waiting until the entire area is developed usually means it's too late to make successful changes.

Beware the Dangerous Middle Grays

The extreme values—the darkest darks and lightest lights—are easily identified and developed. It is the middle grays that are easily lost and the most likely to encroach on the precious white spaces. They look safe because they aren't dark and, consequently, we work with them under the illusion that we can always do a little correcting with more line. The root of the problem is thoughtlessness in applying the initial pen strokes. Avoid being careless with the accuracy of shapes or filling in shapes with too much line. Another trap is creating patterns with large spacing that eventually requires more strokes to make it look like tonality.

Indelible pen strokes make it almost impossible to correct grossly inaccurate shapes, to blend two values separated by black edges, to add new elements where pen strokes already exist, or to change the drawing's focal point once certain shapes have become too prominent. When the pen strokes are still in a light-gray to middle-gray stage, these options are negotiable, but there is virtually no opportunity to lighten values at any stage of the drawing.

Know the Purpose of Every Pen Stroke

The nature of actual pen strokes can pose a dilemma for the beginner. Pen strokes either function independently to define shapes or are components of a pattern that is its own shape or becomes part of a larger shape. The geese drawings below function as comparative examples of how strokes are applied for certain purposes, for example, to describe color versus texture, etc.

This distinction in functions helps the artist identify what the pen stroke is doing

Strokes used as color without any indication of modeling or texture. These are consistent in weight and length and are symmetrically placed. The result is flat.

Strokes used as value. These are consistent in application but vary in quantity according to the darkness or lightness of the area.

Strokes used as texture. These are placed to simulate the surface texture of the shape. Slightly radiating strokes with layered edges look furry or roughed up.

Combination of strokes. This figure contains varied strokes for value, consistent strokes for color, and layered strokes for a ragged texture.

when it goes down on the page. It justifies the individuality of certain strokes or condemns it as disruptive to the pattern, depending on the artist's purposes for it.

Generally, using pen strokes individually to define shapes is less likely to cause trouble than applying them as part of a pattern. When shapes are created with single marks, such as a single line for a crease in drapery, the nature of the pen stroke is usually less critical than the decision about where to put it, about how many to make, or how long and how wide to make it. Strokes used in this way don't necessarily have to harmonize with different strokes around them. This is basically the nature of sketching or gestural drawing.

Patterns, on the other hand, though more difficult to manage, serve more functions. They come in a variety of guises. Some are accumulated marks that form regular tonalities, like the look of screenwire. Some are chaotic, like scribbles in a mass. The need for uniformity makes it difficult to use pen strokes as patterns. When the individual strokes in a pattern become too chaotic, the pattern starts to look more like a texture than like a tonality, and the viewer's eye is more likely to see the individual strokes than the overall pattern. It is essential to remember that the more geometrically regular and systematically

combined the strokes are, the more they express "color" and the less they express texture.

GENERAL RULES FOR RENDERING

Here are some generalizations about constructing a pen-and-ink rendering that can help you control the effects of the pen. These are recommendations, not hard-and-fast rules.

Start with Small Pen Sizes

One of the most challenging characteristics of the pen is the perseverance of a line once it is put down. Even when you know that the area you are working will be dark in the long run, I recommend that you always begin the process with the finer points (6x0, 4x0, or 3x0) and then escalate to larger points. You are not only creating value with the pen, but you are also creating texture with the line, and a heavier line will create a much coarser texture and tonality than a fine line. Blending the coarser lines is a problem because the lines remain obvious and the values get much darker much faster.

Start Where You're Most Comfortable

In spite of my recommendations to start with small, dark shapes, there is no

substitute for your own feeling about the drawing. For example, in a portrait, I almost always begin with the center of the eyes. The shapes are small, black, and important to the personality of the face. You will find someplace in your own drawing that you are most interested in or have the most confidence about. Don't be afraid to start where you want.

Start with Small Shapes

The defining edges of small shapes get lost if they aren't inked early in the process. Once the small shapes are established with a layer of line, you will be able to see them even though you apply other ink marks over them.

If a small shape is described with only one set of pen strokes, it will remain visible through two or three more applications of line. As more layers are added, however, the edges of the underlying small shapes may need reinforcing in order to remain visible.

In addition to preserving the definition of small shapes, you should work over the whole drawing rather than concentrate on one area at a time, keeping shadow and local color values in the right relationship. This prevents you from having to constantly readjust the values of each small interior shape every time you add more lines to your drawing.

Strokes following the shape's contour. These tend to have a textured feeling and require fewer strokes to define individual parts of the larger shape.

Dots have their own texture, but the variation is limited, unless the dots are circles or bubbles.

When the stroke changes in size or the closeness of strokes change, the shapes are altered.

Strokes as edges. These can work as outline.

Start in the Darkest Shapes

The first marks are always a little nerve-racking, so it makes sense to work first in areas where you know you'll have a chance to alter the effects with additional lines. Work from the darkest toward the lightest values, since you know the blank paper is your least negotiable value.

There is a temptation to overwork the darker shapes of the drawing at the very start. They are easily identified and represent a safe place to make marks when you're unsure about the next step. But setting up any value too soon can box you in later, forcing the drawing in a direction you don't want. To avoid this, you must force yourself to make decisions about the

shapes throughout the drawing and about the values you want in them. Then go to them very deliberately and slowly. Work, stop, look, and adjust. This process will continue throughout the entire drawing process.

Start with Short, Narrow, Closely Spaced Strokes

There's a temptation to make the first marks too far apart out of fear that the shape will be too dark too soon. Remember, these first shapes are going to be darkened later with many layers of line. Also, the penpoint you're using should be fairly small (4x0 or 3x0 for example). These small points tend not to produce

really black values even when the shape has several layers of lines.

When crosshatching, I try to make the lines no longer than about 3/8". If I make them any longer, they tend to curve or hook at the end. Don't overreact and make lines excessively short (1/16" or 1/8" inch) unless the shape you are inking is small. Clusters of short lines tend to give the shape a texture rather than a tonality. On the other hand, lines that are long and span the entire length of the shape tend to make the shape look like the cross section of an engineering drawing. Continuous lines have their own "color," which is hard to blend once it is all over the shape. Lines that follow the contour of a shape, however, should be made as long as possible.

Start with a Series of Strokes All in One Direction

The first lines of a drawing can create a sense of order among various shapes by avoiding lots of different directions within and among the various shapes. Even though it is true that changes in line direction can indicate a new shape, it is also true that many directions make the image look like a patchwork quilt instead of a single composition; smaller shapes will start to work independently rather than as parts of a bigger shape.

In the initial stages of inking, there is little danger of losing the boundaries of shapes, even though they may have similar strokes all in one direction. Stopping your strokes at the boundaries of shapes will create a trail from one shape to the next. As successive layers of strokes are added, extra care is required to preserve those edges between shapes. Sometimes you have to reinforce the edges a little so that they will remain visible until you are ready to fully develop the shapes.

Keep the Strokes Uniform Within the Pattern

Strokes that deviate in shape, size, or placement within a pattern disrupt its effectiveness as a value without texture. A stroke that is slightly oblique in a series of parallel strokes, or is a short length among long ones, is an example of disruption.

As organization in the composition is established, you can begin to darken values and edges in order to create emphasis, contrast, texture, and definition of shapes. Likewise, you can be less specific in the direction of the pen strokes, since as you build up layers of line the various directions become virtually undetectable. It

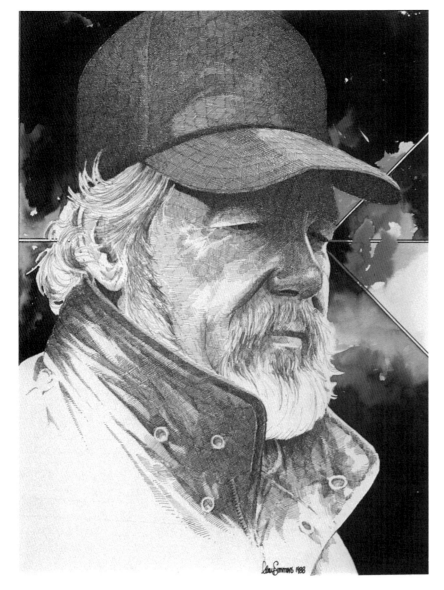

The small shapes in the hat of this self-portrait (*Transition*, 18" x 22") are the types that get lost if they aren't inked before the larger shapes. The seams in the crown of the hat and the stitches in the bill were set up first. As the inking proceeded, I reinforced the small shapes with more strokes to prevent them from becoming indistinct.

is only in the very beginning stages that uniformity of line is so important.

Make Strokes Out to the Edges

Be particular about edges. They create precision, depth, and contrast. One of the most important principles in laying down the first layers of line is to be precise in starting and stopping the marks at the shape's edges. If you don't do this from the beginning, the edges take on a ragged look. The compounded effect of this is fuzziness or imprecision. It is hard to fix this, as it is difficult to go back and work just the edges without building up a dark ridge. It's also difficult to see the actual pencil line once the edge has ink lines applied on top of it.

Edges can be constantly refined as the drawing progresses, but usually in the final stages there will be some important ones that need work. Be careful at this stage, because it is easy to get impatient and hurry the process. It is also easy to define too many edges. Work in small areas and with precise moves. To reduce the contrast created by an edge that is too sharp, you can sometimes scratch the edge with a knife as though you were using a pen, breaking up the solidity of the edge's value, so that it looks crosshatched or stippled.

Avoid Random Strokes

Decide the kind of strokes you need for the job and remember what the job is. Is a stroke it creating volume, texture, value, edges and/or color? Different jobs may use similar strokes, but in very different ways; for example, consistent parallel strokes might create the shadows on a surface as well as provide the local color that covers the entire surface of the shape.

Build Middle Values

As I've said, it's best to establish the extremes so you have a benchmark for the middle values. At first, middle values are values that have just one less layer of strokes than the dark values. After you've set up the darkest shapes in the drawing with a single set of hatched marks, begin to build your middle values by crosshatching a second set of strokes over the first set, extending the marks beyond your initial shapes to define the next darkest shapes. Maintain as much consistency with the second set of strokes as the first, making them roughly perpendicular to the first set of strokes. This consistency helps identify the second set of strokes as a group. The result is two sets of shapes, the darkest values (which now have two layers of marks), and the dark-to-middle values

The first shapes are dark. Small clusters of hatched line organize the dark shapes. Short strokes define the edges of shapes. Strokes are limited to one layer of line.

Randomly placed strokes can look confusing. Edges tend to be indistinct, and the overall structure of the composition is harder to see.

Long lines through a shape tend to flatten the shape and make modeling with additional strokes more difficult.

Without outlines, only contrast defines a shape. The light background helps establish the shapes. Later, midtones will be added.

(which have only one set of marks). The remaining shapes represent the drawing's light gray to white values.

As this process continues for three or four sets of strokes, the overall composition is translated into dark, middle, and light shapes. Eventually only the very lightest shapes will have no lines and the very darkest will have many lines. As you continue to fine-tune the drawing, the middle range will expand to include several different shades of gray between the two extremes.

Save the White Spaces

At first you may not know for certain how you want to use white spaces. You can always fill them in later. Develop these and the light gray shapes only when you have a solid sense of values throughout the drawing.

One of the real moments of truth in pen and ink is when you have to make marks in a white space you have saved. Negative

shapes should have a purpose, so that when the time comes, you have some sense of how much of the space to surrender. As you work on the drawing, however, you get used to the space and have trouble seeing the drawing without it. Initially, any line you add will look like too much, and you're tempted to compensate by spacing the strokes wide so they won't look dark. The result is likely to be a "waffle" kind of pattern that doesn't feel like tonality. Use a fine point and make the shape with close marks, so the shape has some integrity as a value rather than as a series of lines.

Don't Overwork Shapes or Edges

Remember, it's easy to find security in one dark shape and work it to death. Try to set up tonalities all over the drawing before you start serious development of any one area.

It is also a temptation to overdefine edges early in the drawing. Compromise by giving them some definition just so you can keep track of them, but define the

shapes with a tonality, letting their boundaries be the edges of the shapes. If you just make edges, they tend to be too dark, and you are stuck with an outline of a shape instead of a more negotiable tonality.

Quit Inking When You're Confused, Tired, or Tentative

Your gut reaction is your best guide when it's decision time. If it doesn't feel right, you probably don't understand the problem you are attempting to solve.

The physical closeness you have to the art as you do pen and ink results in a failure to see the overall impact of the composition, particularly when working at a table or lapboard. When I work at my drawing board, I stand up a lot, stepping back from the work in order to see its visual impact. With stippling and crosshatching in particular, tonal patterns are hard to see close up. Close to the work, I am tempted to concentrate primarily on the pen stroke rather than on the value it creates.

Creating a Blended Series of Strokes from Dark to Middle to Light Values

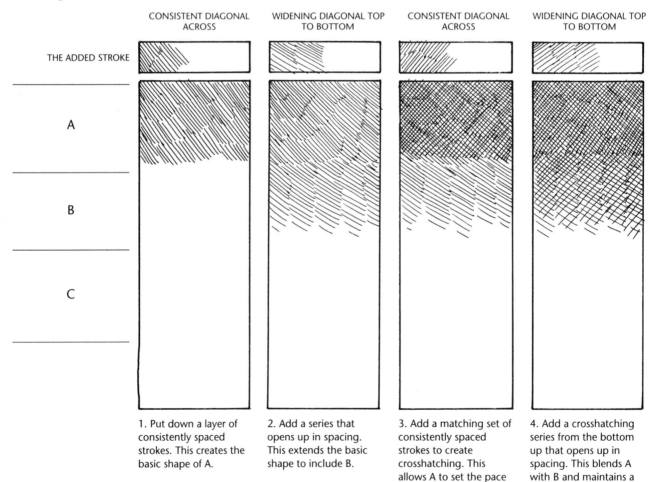

| | CONSISTENT DIAGONAL ACROSS | WIDENING DIAGONAL TOP TO BOTTOM | CONSISTENT DIAGONAL ACROSS | WIDENING DIAGONAL TOP TO BOTTOM |

THE ADDED STROKE

A

B

C

1. Put down a layer of consistently spaced strokes. This creates the basic shape of A.

2. Add a series that opens up in spacing. This extends the basic shape to include B.

3. Add a matching set of consistently spaced strokes to create crosshatching. This allows A to set the pace of the darkest area.

4. Add a crosshatching series from the bottom up that opens up in spacing. This blends A with B and maintains a gradation of values.

Regularly step back, look at a drawing, and think about the difference between what you expect to see and what you actually see. Check your reference material (photo, model, or location) and then adjust the drawing accordingly.

I often place my drawing somewhere across from my studio door, so that when I walk in I am struck immediately with an impression. I try to be conscious of the effects that please and displease me and adjust the drawing accordingly.

One of the more likely problem areas is emphasis. If my eye doesn't go immediately to an emphasized area, I look for ways to strengthen contrast within the central image or make notes to fix the drawing later.

Another important aspect of evaluating your work is the light under which you see the it. Sometimes looking at work in low light tends to simulate contrast and deep values. Often when I get my art under strong room light, I realize I haven't yet attained the values I've sought.

Break Up Heavy Outlines Around Shapes

Unless you specifically want the flat, two-dimensional effect of cartooning or the stylized edges in gestural drawing, any kind of outline for a shape needs to be blended with the shapes' tonalities. This can best be achieved with subtle and tentative strokes for outlines.

Use Blacks Deliberately

The lengthy pen-and-ink process lulls you into an acceptance of grayness, causing you to forget what real black looks like. You think you have really worked dark values into a piece, when, in fact, you have established a dark gray as your darkest value. Technical pen points are so fine that they can only approximate blackness before they begin to tear up the paper's surface. The absorption that follows keeps the tonality gray. After you have established a solid tonality of gray with a 4x0 or 3x0 pen, come back to it with a 00 and you'll be amazed at the difference.

Solid blacks tend to create flat shapes, intense points of focus, and a lack of finesse in the drawing.

Stipple One Dot at a Time

Rather than "pecking" dots onto the paper at random, they should be strategically placed to avoid clustering, which will form a pitted texture rather than a uniform tonality.

Consolidate Shapes for a Better Image

Sometimes a large shape such as a tree bough is comprised of a host of small leaf shapes and shadow shapes that don't quite work together as a bough. Covering all the small shapes with an overall sweep of consistent lines can serve as a local color that unifies the lines as one larger shape while maintaining their individual identities. The same effect is useful when working with a background or large shadow area that has too many different directions of line and too many unrelated tonalities.

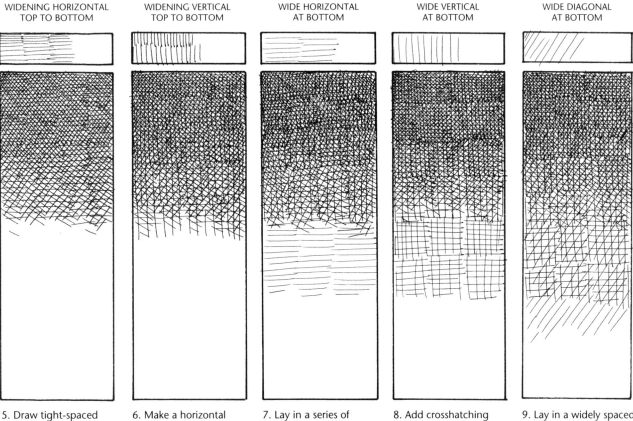

| WIDENING HORIZONTAL TOP TO BOTTOM | WIDENING VERTICAL TOP TO BOTTOM | WIDE HORIZONTAL AT BOTTOM | WIDE VERTICAL AT BOTTOM | WIDE DIAGONAL AT BOTTOM |

5. Draw tight-spaced strokes. Work your way down, opening up the spacing as you go. This consolidates A and B and smooths the blend.

6. Make a horizontal sweep of vertical strokes. Work your way down, opening up each sweep as you go. This darkens A and B proportionately and keeps the gradation.

7. Lay in a series of widely spaced strokes at the bottom of the previous strokes. This extends B to C for an added level of gradation.

8. Add crosshatching with similarly spaced horizontal strokes. This adds value to C.

9. Lay in a widely spaced series of diagonal strokes. This helps blend B and C.

Broken outlines can suggest
shapes enough to serve as
guides, and even as edges,
while not intruding on the
modeling and blending of
the interior strokes.

As the strokes are applied
against the broken outline,
the line itself tends to
disappear into the interior
strokes, especially when the
interior shapes are made
with strokes that are parallel
to the outline stroke.

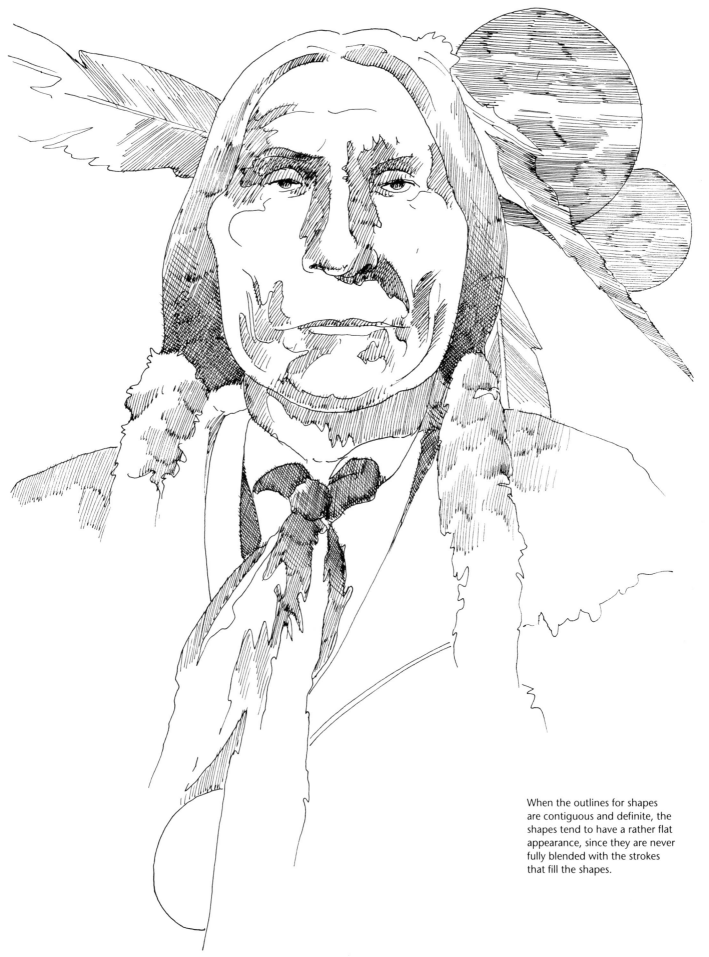

When the outlines for shapes
are contiguous and definite, the
shapes tend to have a rather flat
appearance, since they are never
fully blended with the strokes
that fill the shapes.

CANADA GOOSE: A STEP-BY-STEP DEMONSTRATION

In order to concentrate on the techniques of the pen without getting distracted by other drawing problems, use an image outline—a very light gray line defining shapes that does not interfere with the ink work.

Alternatives to working with the light gray outline of shapes, which is traced or sketched from a reference photograph, include working directly with the pen, in which case draw with a sketching technique, laying in ink outlines of the major shapes and using a rather spontaneous stroke to set up the values; or, establish small shapes of the different values with pencil, creating a very thorough system of outlined shapes to work with. Set up the pen work in carefully constructed systems of dots or lines and try to do a subtle rendering with different values and blending.

The materials you need for the outline method include a 3x0 or 00 pen and a reference photo. If you are working with pencil, use a 3H or 4H lead and a soft eraser. Stick with one pen size to exercise your ability to vary the widths of lines. Use a photo as a reference for the tonalities you are attempting to render. In the case of photorealistic rendering, it is very important to have a good point of reference for your ink work.

Preliminary Work

When drawing from a photograph, be sure to choose one that has clarity of shapes, as you will begin with outlines of the major shapes in pencil to form a guide for inking. Remember that the major shapes include gray, middle gray, and dark shapes.

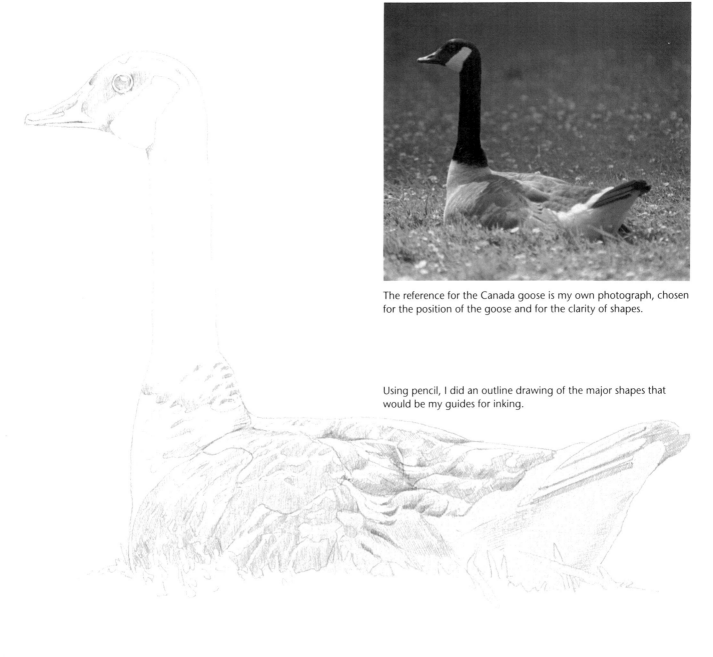

The reference for the Canada goose is my own photograph, chosen for the position of the goose and for the clarity of shapes.

Using pencil, I did an outline drawing of the major shapes that would be my guides for inking.

STAGE 1:

Set Up the Darkest Shapes As a Guide

With the Canada goose the obvious starting places are the head and neck of the bird. The second safest area is the tail. In both cases, however, resist making any more than one layer of lines in these initial stages. Set up the shapes before creating significant value differences among them. At this point you just want to enter the drawing, get the dark shapes established, and maintain a sense of organization with the strokes.

One of the few ways to make an existing pen-and-ink shape look lighter is to make everything around it darker. If you have already made the surrounding shapes too dark, there is no possibility of making such an adjustment. In the goose's case, there are some very subtle dark gray values around the eye ring and cheek. If you plow into the drawing with cold black values from the beginning, odds are you overlook these subtleties at first and have no way to counteract the mistake later.

The safest place to start inking is the head and neck of the goose. On the head I have left some shapes untouched until later, since they will be dark gray and can easily be obscured as the drawing progresses.

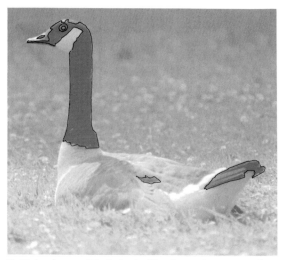

Outlining in pencil includes looking for major groups of shapes, such as dark shapes.

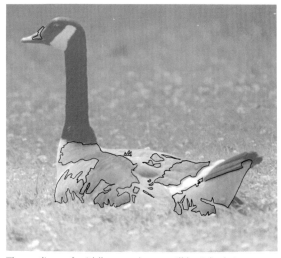

The outlines of middle-gray shapes will be inked at a stage different from the outlines of dark shapes.

Fill the Dark Shapes with One Kind of Stroke

When setting up the drawing's first shapes, it's particularly important that you keep those shapes uniform in appearance. It's the uniformity that enables you to identify them as a group of shapes all performing the same function. Usually the shapes inked first are shadows in the image or simply dark-colored shapes. For example, the feathers on the goose's back all have their own shapes and small white edges, but they are also part of the larger shape of the goose's body and of the cast shadow across the back. If the individual feather shapes each have strokes running in different directions, they don't look as though they are lying together in the same plane. By hatching all the first shapes in one direction, the drawing looks as if it has a fine layer of gray wash laid down over the darkest shapes.

In the case of the feathers, the edges of the shapes should include small white rims on the feathers' back edges. These help maintain an illusion of layers and rows. Uniformity in line direction helps keep track of such details. Losing track of the edges of the first shapes you ink leads to inaccurate shapes as the drawing progresses.

Make Sure the Strokes Are Working As Values

In subtle areas such as the lighter parts of the goose, small, close lines are more effective as value than lines that are widely spaced. Use small pen points (6x0, 4x0, or 3x0) and work for tight, consistent patterns of strokes. One of the visual adjustments you have to make with the pen is accepting that any value, no matter how light, must have some kind of black mark in it. All other values must then be adjusted accordingly. Also, stand back from the drawing and see what the value looks like. From a distance it will surprise you with its subtlety.

With a shape as large and consistent as the goose's neck, there is a temptation to fill it in with long strokes. You have many more options for control and blending if you fill the shape up with small clusters of line.

Keep Small, Interior Shapes in Sight

To prevent small shapes from getting lost in subsequent large dark strokes, very carefully reinforce the small shapes first. By starting with very small pen strokes, you can adjust the shapes in stages as the composition gets darker and more complex.

General view of goose with first major shapes. All of the first strokes in the drawing are consistent in type and direction.

The consistency of the vertical clusters of hatched lines enables me to work in the general direction of the neck's edges and to see the individual clusters of feathers on the back. Too much variety in line direction at this stage confuses the identity of small shapes.

For example, the goose's eye ring is very subtle. As you add strokes to the head area, you will need to reinforce the eye ring with more strokes; otherwise, you will lose its roundness and its value as the darkness of the head shape encroaches on it, eventually obscuring it.

The goose's tail has very dark divisions between the layers of feathers. This area is less subtle than the eye ring, but without a clear pencil path to follow for the shadows between the feathers, these small dark lines can start to curve or to swell, distorting the feathers and their positions. Ink these before you start inking the larger feather shapes of the tail. Think of small lines like this as shapes and hatch them as such. Avoid drawing a solid line that cannot be integrated into the larger shapes later.

The feathers on the goose's back are very subtle. They look defined, but actually they are merely suggested in shape and in position. They tend to melt into a general shape at the chest and to disappear into the shadows on the back. The edges that are actually visible should be established, but avoid the trap of faking rows of feathers when the shapes aren't there. There are times when a pattern such as the layers of feathers can be "faked" just enough to help give the impression, but don't overdo it. Work as much as possible with what you can actually see, and you will produce the effect of soft feathers in sunlight and in the cast shadow from the neck. If all the feather shapes are set up first, including their white edge, the cast shadow can then be inked as one shape and the shapes within that shadow will darken in the right proportion to the sunlit feathers. The white edges on the back feathers will keep them visible when you put more strokes over them for the larger cast shadow. You don't have to make individual value adjustments to the white edges within the shadow if they are set up early.

Make Strokes Touch the Edges of a Shape

Ragged edges will start distorting shapes and eventually the small rivers of white edges that form on such shapes as the goose's back feathers will start to meander. Since they are defining the contour of the goose's back and sides, as well as the layers of feathers, these meandering lines look as though they are misplaced or, like the goose's back, have a strange shape.

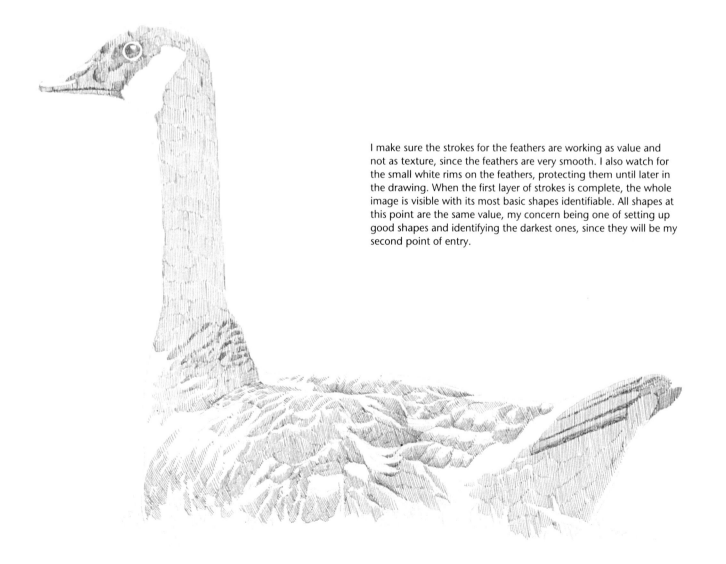

I make sure the strokes for the feathers are working as value and not as texture, since the feathers are very smooth. I also watch for the small white rims on the feathers, protecting them until later in the drawing. When the first layer of strokes is complete, the whole image is visible with its most basic shapes identifiable. All shapes at this point are the same value, my concern being one of setting up good shapes and identifying the darkest ones, since they will be my second point of entry.

STAGE 2:

Develop Middle Values from the Dark Shapes

The neck, head, and tail feather shapes are the natural place to begin this second series of strokes in the goose drawing. Start here with the next darkest shapes, such as the bill, the cast shadow on the back, and under the tail.

Keep the Area of Emphasis in Mind

The goose's head and neck are rather logically the points of emphasis, if they are rendered consistently with the photo. It is possible, however, that a background could be developed that would overshadow the bird.

Your composition will typically have an area that is emphasized, usually by size, by strong contrast, and by sharp edges. Once the overall values of the drawing are established, start developing the major area of emphasis so that it stays a little ahead of the rest of the drawing's development. You can always bring the rest of the drawing up to greater intensity if you desire, but you can't compete with a background that is already so intense that the major subject can only match it.

Use Distinct Edges to Create Areas of Focus

Edges are one of the most effective devices for creating emphasis, depth, and order in the drawing. Edges that are unintentionally imprecise impede the shape's sense of depth and modeling, but if every edge in the drawing is precise, it will prevent areas of values flowing into one another. This not only impedes the visual path through the drawing, but it stylizes the drawing into more design than rendering.

If you want to integrate the subject with the background, or if you want to create a visual flow of values throughout the

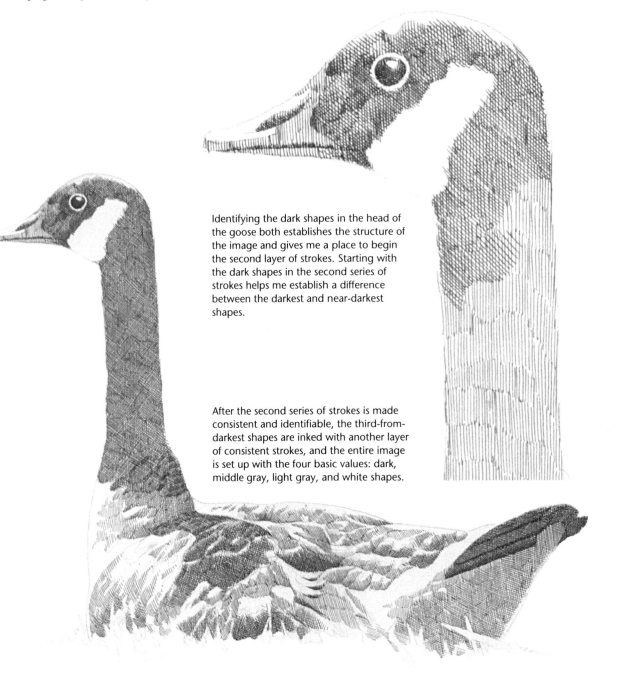

Identifying the dark shapes in the head of the goose both establishes the structure of the image and gives me a place to begin the second layer of strokes. Starting with the dark shapes in the second series of strokes helps me establish a difference between the darkest and near-darkest shapes.

After the second series of strokes is made consistent and identifiable, the third-from-darkest shapes are inked with another layer of consistent strokes, and the entire image is set up with the four basic values: dark, middle gray, light gray, and white shapes.

Once the four basic values are established, the darkest areas are darkened even more to establish their dominance. It helps to keep an eye on the area of emphasis as you work, using distinct edges and contrasting values to help create a point of focus. Integrate the cheek patch into the black of the goose's head by working the black strokes into the negatively defined patch with an irregularity that prevents the patch from looking like a bandage just stuck on.

composition, you might want to leave some edges indistinct or even "lost." This will lead the viewer toward the area of emphasis, allowing dark shapes to connect or negative shapes to open into one another.

Blend values by avoiding definite edges between two adjacent shapes. The feathers on the goose's chest melt into the grayness of the cast shadow, enhancing the sunlit effect on the bird. The potential need to blend shapes is another reason not to establish their edges and values too soon.

When you correct the edges, work away from the edge rather than toward it, making the shape's value look as if it extends to the edge rather than sitting as a dark rim on the shape. For example, the cheek patch can appear "stuck on" rather than integrated with the head shape. Avoid this by creating an imprecise edge, "feathering" the black head shape into the white cheek patch.

The dark but subtle shapes on the head also blend together, sculpting the shapes rather than pasting them together.

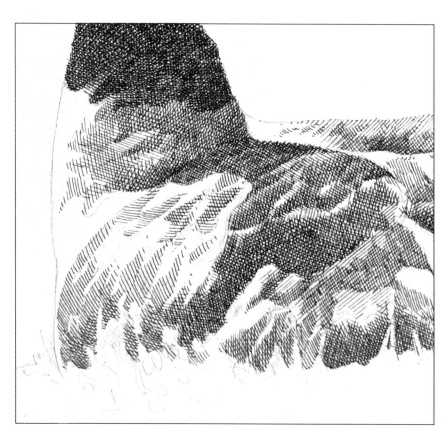

Groups of shapes, such as the shadows on the back of the goose, are consolidated into more identifiable large shapes with additional strokes. Small areas, such as the lower body set against the negative grass shapes, are darkened to give roundness to the body and set it back from the grass blades. Modeling the clusters of feathers on the back with shadows makes them look fluffier.

STAGE 3:

Develop Light Areas

In reality, there are few pure negative spaces in a
subject, but in pen-and-ink rendering, extremes are
necessary in order to create a scale of values from
white to black. It's safest to be conservative and leave
uninked any space that is questionable. If you
compare the photograph of the goose on page 114
with the finished drawing on page 129, you'll see that
the edge of the goose's chest, the space between the
back and the tail, the grass shapes, and the highlight
in the eye in the drawing have all been accentuated.

The highlights on the goose's bill, within the eye,
and on top of the head are negative spaces that should
be preserved until the last stages of inking. They
create the lighting effect in the drawing. Likewise,
the cheek patch should be among the last shapes to
receive any gray value under the chin.

The negative shape of the grass is an arbitrary
design solution that solves a variety of problems. It
situates the goose in an environment without having
to define the grass blades with line. It also helps the
grass values open into the lower part of the page.

Some white shapes, such as the
white eye ring, the highlights on
the head, and the white cheek
patch, are usually inked too
soon and get dark as the
surrounding values encroach
upon them. These types of
shapes can be protected simply
by keeping them in focus as you
add strokes.

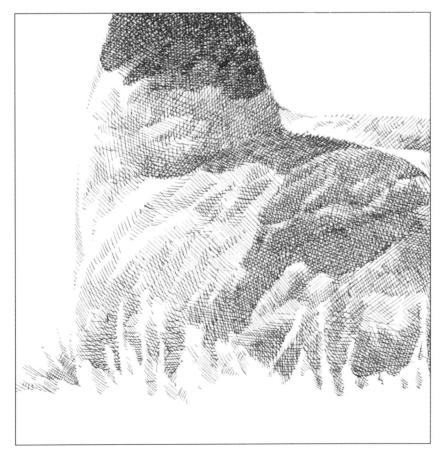

When most of the shapes and edges are
well developed, add such details as the
small suggested edges on the chest. Use
small hatched lines, which are softer and
blend better than continuous outline
strokes.

Consolidate Fragmented Groups of Shapes

Eventually, the many directions of line within specific areas of the drawing need some unity. As the drawing progresses, several levels of development among the shapes begins to emerge. There are the small interior shapes, shadow shapes, the local color shapes, and the texture shapes. Some of the edges may be too sharp, some of the tonalities may not be blended within one shape, the area of emphasis might be weak, or certain shapes may be inaccurate. The problem is often solved by consolidating shapes. This can be accomplished by giving the whole group of shapes a common tonality with an additional sweep of strokes, treating them as if they were one shape.

The shapes within the cast shadow on the goose's back need to look like they are part of one large shadow shape. The same is true for the neck and the tail. Likewise, the small, indistinct feather shapes on the sides and on the back near the tail are the kind of shapes that need a consolidating layer of "color" to pull them together.

Sometimes, the consolidation is needed to create texture. If the goose's neck seems lumpy or rough, it can be smoothed out with a layer of consistent line. The shadow under the tail may need an additional layer of line to smooth out any sculpting effects of inconsistent line.

This consolidation process is one of the most important aspects of fine tuning an ink rendering, but it's also dangerous to the drawing. A failure to realize what the process is supposed to do can lead to overworking the drawing and making it too dark.

The underside of the tail before modeling shows the shadow under the tail to be a little flat. Note how the white space separates shapes, rather than blending them. The feathers of the tail also need definition.

A ridge of shadow near the back edge of the tail makes the figure look rounder. Leave enough lighter value near the outside of the shape to imply a reflected highlight. The black spaces between the feathers of the tail are made blacker to give the dark part of the tail more definition. Linework is added to the white space to blend the shapes.

The very last stages of drawing the goose include ink work in the eye ring, putting a shadow on the underside of the cheek patch, and working some tonality into the highlight on the top of the head. The neck is darkened even more, but this time the front edge is left slightly lighter to imply a light source and to prevent the large neck shape from looking like a flat bar.

STAGE 4:

Final Adjustments: Check the Contrast

If you decide to make value adjustments for darkness, start with areas that are either very small and controllable or areas that are not too critical. When you use a bigger point, go slowly and carefully at first. It's easy to underestimate the effect, and you could suddenly find that you have a critical area of the drawing twice as dark as you intended. For example, if you are working on a portrait, the end of the nose is not the place to introduce a larger pen size. The effects can be immediately disastrous.

If the goose drawing lacks punch, I can always safely add a little more darkness to the head and neck. If the body of the goose seems flat, I can add a little value at the bottom edges between the goose and the grass. If the back seems too dark at the top, I can either add a little value to the cast shadow on the back or I can create a background value against the back.

Edges

In the goose drawing, the lines that separate the tail feathers might seem to be dense or the white edges of the back feathers might need a little more delineation. The feathers on the back and sides of the goose are prime examples of inappropriately distinct edges. The back feels more like it's armored and less like a soft composition of feathers.

Sometimes correction in this final stage can be achieved with an electric eraser. If you have done some scratching over the tonal area, you can sometimes go over it with an electric eraser and obscure the scratch marks. Be careful that you don't scour the paper and create a hole in the paper surface. If this happens, attach a patch of paper and redraw the area to be corrected. Also, once you've scratched or erased over the paper surface, the next pen applications must be very small and light-handed, because there is always the danger of the paper's increased porousness making the line bleed into a larger mark than you intended. Once this process starts, you're in trouble, so proceed very cautiously. Avoid repairing a drawing with correction fluid, as it will not go unnoticed.

Your attention to edges can make the drawing more accurate. At this stage of the drawing, sometimes a very small change can make a major difference in the appeal of the subject. For example, the eye shape of the goose might not feel quite as round as it should. The edge of nostril shape in the bill might need a little more sculpting. Or the edge of the cast shadow on the back might not be clean enough to look like a shadow rather than a gray patch on the back.

Clean Up the Drawing

Don't erase too soon. There are times when you get impatient and want to erase the pencil just to get some feeling of completion, but if this is premature, you can erase significant shape outlines that are never recaptured. As it is in so many phases of this medium, there is virtue in caution and patience. Don't cut off any advantages you have until you are certain you don't need them.

In the final stages of the drawing erase any residual pencil lines that are apparent. Use a soft eraser, such as Staedtler Mars plastic eraser, Koh-I-Noor 286-J soft vinyl eraser, or Berol E-601 plastic eraser, and avoid scrubbing the drawing, particularly where there is a heavy layer of ink. This tends to polish the ink and give it a different surface from the rest of the drawing. Some coated papers will get shiny surfaces where you erase them.

One of the surprises that comes with erasing is a lightening of some values where the pencil residue has created a grayness under the ink. In most cases, this is a relief, as it allows you to recapture a lighter value. This value change can be significant in areas such as the feather shapes on the goose's back. It is sometimes a relief to find that the white edges of the feathers will come out lighter in value than you anticipated. The same might be true for the highlight in the eye or the eye ring shape.

The final drawing includes slight adjustments to small dark shapes for emphasis, such as the edges of feather clusters and the spots between the negative grass blades. Sometimes it helps to reduce the emphasis on edges, such as the boundaries between the feather groups on the upper part of the back and down toward the tail. Compare the original goose image to your drawing for contrast and to see which shapes need to be consolidated, particularly across the back and on the sides.

COLOR AND THE TECHNICAL PEN

The Ancestor, 24" x 32", is rendered solely in acrylic inks, but it combines a variety of inking techniques. The background is airbrushed; the webs, wings, and leggings are painted in with a brush; the scales and body details are crosshatched in with a pen; and the border is a combination of pen and brush work.

Color has been introduced to the technical pen's palette only recently. Initially, there were no pigments fine enough to work in the pens. The alternative was dyes that would stay in solution and flow. Since dyes are not permanent colors, they had limited use in such archival work as fine art. Watercolors were also used, but even then all pigments weren't acceptable, and the ones that were would thicken with time. One solution was to use the technical pen's black line in conjunction with a color application, such as a background wash or color pencil. Sepia washes were common additions to seventeenth- and eighteenth-century Dutch, Italian, and French reed-pen drawings.

Today, the technical-pen artist has a solution to permanent color in the pen itself. Acrylic pigments are now ground fine enough to provide a permanent, waterproof color that will flow in even the smallest penpoints. This chapter introduces you to the more traditional applications of dyes and watercolor and finishes with specifics on how to use the acrylic colors in the pen.

Watercolor, dyes, and acrylics are the common color media for pen and ink and all are transparent (some airbrush acrylic inks are opaque) and water-soluble. Their appearance is similar, but they are handled differently. Acrylics dry quickly and cannot be reactivated once they have dried. Unless worked while wet, they leave obvious edges where the washes stop and start. Watercolors, however, can be reactivated, even picked up to some degree while they are wet, facilitating blending and modeling of shapes inside and outside the pen-and-ink work. Dyes are favored for their trouble-free performance in the pens and for their very intense color.

Brooks Pearce, *Sea Birds*. This pen-and-ink drawing mixes ink and other media so well that there is virtually no way to tell the media apart.

In *The Long Furrow*, 30" x 40", I used frisket over the main image, watercolored the background behind the horses and the driver, pulled up the frisket, and did the ink drawing. I then used another frisket layer to create the second small border and painted the small figures in at the top by hand. Collection of Dr. Dale and Bridget Kincheloe, Hot Springs, Arkansas.

If the color is going to be a strong defining factor in the composition, or if it should sweep behind the subjects, apply color before inking. Starting with large colored areas first also prevents you from investing hours of work in a drawing only to ruin it with color. I put color on after the ink work in situations where I want small areas of color to work within the inked shapes or when I see a need for some color assistance to a composition.

APPLYING LIQUID COLOR AROUND AN INK DRAWING

When you want a wash of color that looks as if it passes behind the subjects in a composition, use a frisket film to mask off the pen drawing so the color wash can be applied over the whole drawing surface. Apply the color early so there is less chance of wasted pen work should the color not work out.

The frisket film is placed over the pencil drawing or, if you've made your color decision late, over the ink drawing, and cuts are made around the edges of the image area you want to protect from color during the brushwork (avoid cutting the drawing surface, which can disrupt the ink work or create an embossed look around the edges). Standard hardware for cutting the frisket is an X-Acto knife or, if the cuts are particularly intricate, a Ulano swivel knife. Rub the frisket down securely at the edges of the areas to be inked. For color on or against borders, I usually apply

John Lively, 12" x 15" (left). This example of color application without masking was painted with watercolor. After the image was inked, I used a clean brush to wet the areas I wanted to paint and then applied the paint wet-on-wet in the predampened areas. The India ink and the prewetting set up a barrier to the newly applied paint as long as the application is slow, precise, and not excessively wet.

In *Pretty Lynne*, 20" x 30" (below), spot color was applied to the jockey for rendering purposes, and a color wash and frisket were used in the rectangular area. Collection of Ms. Cathy Griswold, Tulsa, Oklahoma.

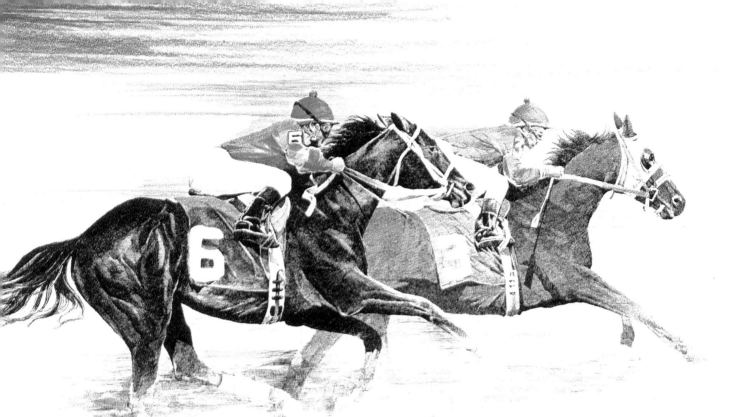

Prismacolor pencils were used to add color to the original India ink drawing of *Gainin'*, 20" x 30". Collection of Mr. Don Schnipper, Hot Springs, Arkansas.

transparent tape because I can lay it down in long straight strips and don't have to do any cutting at all.

Once the frisket is securely in place, follow traditional watercolor wet-on-wet technique: wet the areas you plan to color, then apply paint. This allows you to pick up excess color or to move and blend the colors as you go. Don't be overzealous with the water, or eventually the color will leak under the edges of the frisket and stain the ink drawing.

In cases of simpler color application, where consistency of tone is not important or where the intricacy of the color is not too great, I don't bother with a frisket. I simply wet the edges of the areas to be colored, running a brush along edges of the inked shapes. Then I put the color wet-on-wet into those areas, working them up against the drawing's inked lines. As long as the application is not too heavy, the ink marks form a natural barrier to the color's migration over the edges.

Even when color is simply a design element, such as a moon or sun shape, I prefer watercolor because it is transparent, easy to apply, and can be moved around to some degree. I have used acrylic when I needed a flat and solid color or when I needed to lighten a color element already too muddy with watercolor. I rarely use

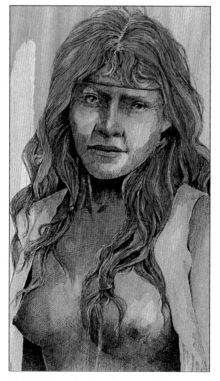

India ink drawings can be created on top of a color background, as in *Indian Girl*, 16" x 20". You can also use a brush to move some of the watercolor around in the image once the ink drawing is complete. Collection of Ms. Maria Aspell, Hot Springs, Arkansas.

gouache with pen and ink, except when I want the brilliance and the opacity of the color to make a shape stand out. The opacity of gouache also enables you to correct watercolor that has not worked to your satisfaction.

DRAWING OVER A COLOR BACKGROUND

To apply color first as a background, either mask off the borders and lay the watercolor wash over the entire paper surface, or choose one area of the paper and apply watercolor arbitrarily amid specific white spaces. This treatment doesn't affect the way the pen reacts to the paper. Also, the application doesn't have to be wet-on-wet, but it does have to be thin enough not to build up pigment on the surface, which will clog the pen or distort the line width it puts down.

Wait until paper is bone dry before drawing on it. Then draw with the pen directly on top of the color. Sometimes after the ink drawing is in place, I enhance areas of the drawing with additional color.

Color application doesn't have to be ink or paint. It is possible to use a variety of mixed media with ink, including markers, pastels, and color pencils. Pastels and pencils should be applied after the ink work because they will clog the pens.

USING COLOR INK IN THE TECHNICAL PEN

Color ink strokes can enhance the look of traditional black ink pen drawings. If a drawing is first done with India ink in a technical pen, and then color is applied with a technical pen, the effect is somewhat muted. This combination of techniques is a good way for someone used to working only in black and white to enter the realm of color. By continuing to use the same tools in each instance, you can concentrate on the color concerns and not on the problems of learning a new tool, such as a brush.

Another and more complex approach is constructing the drawing entirely with color inks in the technical pens, using black very little or not at all. These drawings are much more like traditional renderings with the added complexity of such painterly problems as mixing complements for dark values, using warm and cool colors to good effect, creating a palette from a limited number of colors, and seeing color as values.

Pen Selection

With color inks, I use more of the larger pen sizes (2x0 up to #0) than I do with straight black-and-white work. The colors tend to have less contrast and take longer to build up, so they require larger applications. Such pen sizes as #0, #1, or #2 help with the lighter values. Also, with lighter colors there is more opportunity to fill in solid values or to scribble without the glaring problem of

Dragon and the Knot, 16" x 20", presents a good way for the pen artist to get acquainted with color. I did a black line drawing and then used technical pens to fill in the spaces with acrylic inks. Using small spaces and strong black line image enables the beginner to avoid being overwhelmed by all the complexities of color. Collection of Koh-I-Noor Rapidograph, Bloomsbury, New Jersey.

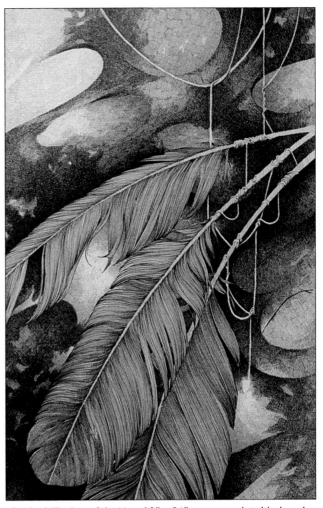

I finished *The Best of the Nest*, 18" x 24", as a complete black-and-white pen drawing and then decided to add acrylic colors with the technical pen. Collection of St. Joseph's Regional Health Center, Hot Springs, Arkansas.

an obvious line texture. I like a 4x0 penpoint for refined stages of some color work. In general, I limit my pen selection to 4x0, 3x0, 2x0 and #0. The number of pens I have at any one time depends on the palette, but generally I keep on hand a pen of each of the above sizes for each of the major colors I am using.

Inks and Color Selection

Until recently, the only color inks fine enough to work in the technical pens were dye-based inks, such as Dr. Martin's Dyes, Winsor & Newton Dyes, and Pelikan Inks. None were truly permanent and some were not waterproof. Theoretically, you can use watercolor in the pens, but the watercolors should be very dilute, and the pens must be cleaned regularly.

Acrylic inks are now ground fine enough to work well in technical pens. My experience is limited to Rotring Artist Colors, but Winsor & Newton Designers Liquid Acrylics and Pelikan Drawing Ink "Z" (also acrylic) have good reputations. Rotring Artist Colors come in sets of twelve colors, but the white and black pigments are too thick for the pens, limiting you to ten colors. The palette is heavily weighted toward the blues and reds, with two different yellows, a green, and a brown (see chart on p. 139).

The most common colors in my palette are the following: red, orange, yellow-gold, blue, blue-green, and purple. I fill some pens with brown and some with mixtures of yellow that work as flesh colors.

I don't mix many colors in the pen cartridges, preferring to do most of the mixing by combining lines of different colors right on the drawing. I think this limits my palette, and in future practice, I will probably give in to premixing colors before putting them into the pens.

Surfaces

The same paper surfaces used for black-and-white drawings can be used for color drawings. You may want to use a watercolor board if extensive color washes will be added to the pen work. The technical pens work best if the surface is fairly smooth and hard, like that of a cold-pressed illustration board.

BLACK-AND-WHITE TECHNIQUE VERSUS COLOR TECHNIQUE

As with black-and-white, color technique involves crafting good strokes, understanding image construction with pens, and working with volumes, textures, and values. You must still establish a good preliminary drawing with the intended shapes and their edges indicated in pencil. With color, however, there are more options for subtle differences in shapes, which might require more detailed penciling of edges where very subtle color changes are necessary.

The development of shapes and textures is still primarily a function of pen strokes, but value and color are functions of color choices and density of application.

Unlike black-and-white drawings, color drawings are largely built around local colors of the shapes. The local colors are applied over the dark values of shadow and texture shapes that have already been drawn. This creates a consistency between the shadows and the local color, unifying the shape.

Choosing Color for the First Strokes

This book doesn't cover color theory, but any successful drawing with color in technical pens is based on an understanding of color dynamics.

The stages of development with a color drawing are similar to black-and-white work, but the issues of contrast and definition of edges are not as crucial. In color, a more subtle distinction between

The Last Tree, 20" x 30", is the result of a completely painterly approach to the technical pen. Acrylic inks were used to cover the drawing surface entirely with color. The color was used to work with lost edges to integrate subject and background.

In *Sister Werner*, 30" x 40", consistency of color from one image to the next was difficult to maintain, because coloring with pens is a cumulative process. Each set of strokes and each color have to follow a similar pattern and density or the color will change significantly. Since rendering depends on adjusting by adding strokes, there is a danger of misdirecting the color. Controlling skin tones is particularly difficult with acrylic inks, as the pen strokes work by contrast. When the contrast is too striking, very dark skin tones result. Collection of St. Joseph's Regional Health Center, Hot Springs, Arkansas.

shapes, where edges might be blended, is possible. Color differences themselves will reveal the different shapes and their textures. Start with a pencil drawing for guidance, then make the first series of ink strokes in shadow areas with a dark value of the shape's real color.

One way to define shadows of a local color, or real color of an object, is to use some of its complement, or opposite, which creates a neutral. Thus, if the local color of flesh, for example, is essentially orange, you could define shadows on it using blue.

In the latter stages of a drawing, when the layers of ink have accumulated, the darker complement tends to compound in value faster than the lighter local color. A clustering effect occurs where the darker strokes coincide. When a color of light value, such as orange, overlaps in crosshatching, its accumulated value is still relatively light. But a color with a dark value, such as blue, compounds into a very dark cluster and makes the pattern look pitted. Since darker values tend to cluster within the shadow areas of a drawing, the additional colors I use are ones similar to the local color of the major shapes. I add the complement later as a single set of strokes so it can't overlap and cluster.

Mixing Colors

Creating the palette on the paper surface— mixing colors as lines on the paper—rather than premixing the inks is exciting and leads to unexpected effects. If, however, there are specific colors you are after, you would be wise to experiment and premix the inks before putting them in the pen. Be sure to test premixed colors before applying them, and mix enough for the work at hand—recreating a color can be difficult.

Colors can be mixed optically on the paper by actually overlapping them, such as a blue line over a yellow one to get green, or by simply laying the blue and yellow lines next to one another so that at a distance the two colors seem to mix. Crosshatching relies on the former and stippling on the latter technique. Lighter and darker values of a color, such as green, are developed by wider spacing of lines so more white paper shows through or adding more of the lighter color, such as yellow, to make the green lighter. It doesn't take much imagination to see how many variables this introduces into the process and how quickly it can get out of control— plan carefully before you start inking. Creating dark values is easier than creating light ones, just as with black ink.

This pencil version of *First Light* (left) shows how much preliminary drawing is done to prepare for color.

This detail from *First Light* (below) shows how closely I adhered to the nuances of the pencil when I began inking.

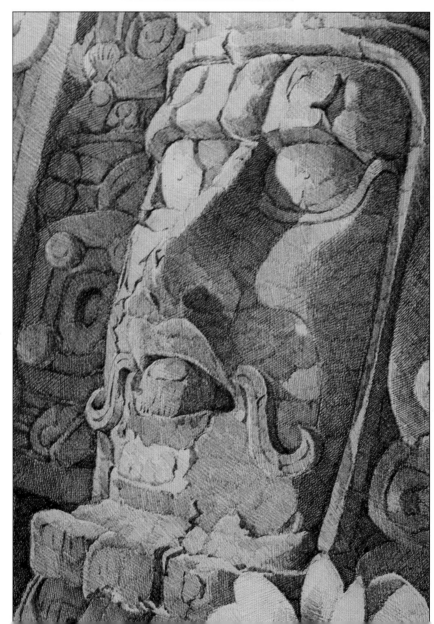

Working with Color Temperatures

Among color's most significant differences from black and white are the effects of color temperature, or warmth and coolness. Broadly speaking, warm colors are yellows, oranges, and reds, while cool colors are greens, blues, and violets. Color temperature is relative, though; there are "cool" reds and "warm" violets, for instance. A drawing that is predominately cool, perhaps a moonlit water scene, has a less active emotional appeal than a warm drawing, such as a yellow-orange beach scene. Cool is typically more remote and distant, while hot is considered close and immediate. Your choice of color temperatures can make a considerable difference in the drawing's sense of depth, as the warmer colors push forward and the cooler ones recede. These effects, compounded with the effects of color complements, add significant dimensions to the drawing process that are not experienced in black-and-white art.

Adjusting color temperatures for consistency in the drawing, for contrast and depth, and for color accuracy causes me to work much longer and to add much more line than I do with a black-and-white drawing. A whole shape can be altered rather dramatically with one layer of strokes that are warmer than the color already on the shape.

Achieving the Intended Color

An important factor in working with color inks is that the color you see in the bottle is not the same as the color that appears on your paper. The white spaces of the paper, between the strokes, automatically cut the intensity with a 50 percent tint. To replicate the color in the bottle requires solid color application, usually with a brush, and that kind of application changes the texture of the drawing; it's like applying solid black ink on a drawing whose texture is crosshatching or stippling.

The colors are transparent, so they work like glazes or watercolor. They continue to affect every color that follows. This cumulative effect means that as successive layers are added, the drawing's colors will shift, usually without your permission.

Building Contrast

With color ink, unlike black-and-white, contrast may develop slowly, depending on the hue. Generally, the only way to adjust values in pen drawings is to make them darker. As a value deepens, the shapes adjacent to it seem lighter. The darkening

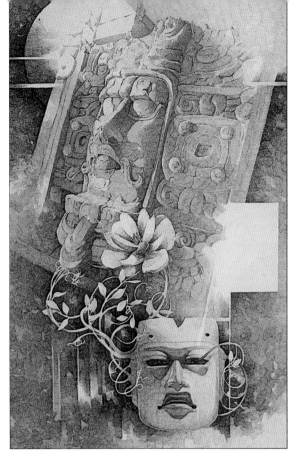

The finished version of *First Light*, 20" x 30" (left), shows the overall effects of depth and color. The piece is monochromatic except for the area with the mask.

A detail from the finished version of *First Light* (below) shows how depth is created by the contrast of values and color temperatures. The warm yellows and oranges stand out against the blues of the drawing. I used some black to help deepen the values further.

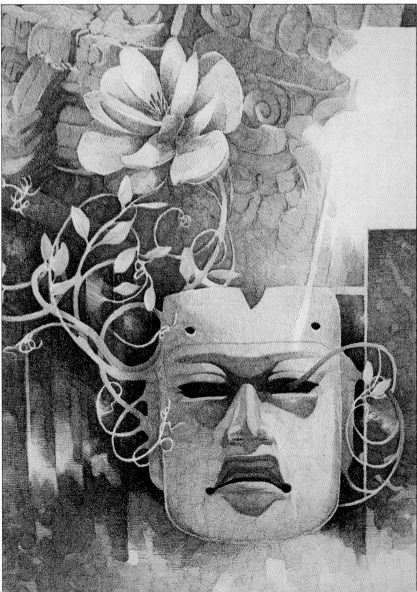

process can be one of adding more of the same color if that color is an inherently dark value such as blue or green (compounding a color of light value, such as yellow, will make it appear lighter). Another way of darkening values is to add other colors to the existing color, usually a complement. The danger here is changing the color itself as well as the value.

Since the values created by black strokes are easier to judge than color values, you can create a correspondence between the two by making a color wheel (see opposite page) and photographing it in black-and-white. You will then see the colors converted to grays, and you can thereby learn to recognize their inherent values.

Using Black

Avoid using black in a color drawing, particularly in the early stages. Once you start adding it to the surface, the colors start to muddy. If you must use black, limit it to small discrete areas.

Using the White Spaces

Color encourages the pen artist to fill in negative shapes, because a color of light value isn't as likely as black lines to give the overall composition a flat feeling or to compromise the contrast between adjacent shapes. But be careful—you will probably want to preserve some white spaces.

The acrylic color as it looks in the bottle is considerably different from the tint created by crosshatching with the pen. This difference tends to make the drawings look pastel or weak unless the drawing's contrast and color saturation are deliberately increased.

This detail from *Broken Promise*, 26" x 32", shows that the color application needed to be very even to create the green mapleleaf surface. Green acrylic inks tend to be on the blue side, so yellow was added to build up the green. Black was deliberately used in this piece to create the murky gray background. Collection of St. Joseph's Regional Health Center, Hot Springs, Arkansas.

EXERCISES

The first exercise tells how to create values.

The second exercise describes the creation of a color wheel (see opposite page). The color wheel describes the primary (red, blue, and yellow) and secondary (orange, green, and purple) colors (secondaries were mixed from proportions of primary colors indicated on the outermost ring). The value ranges of the primary colors, based on single, double, and triple layers of strokes, are shown, as well as mixtures of secondary colors made from single layers of primaries. The middle ring shows how, for example, a layer of red strokes plus a layer of yellow strokes produces orange.

The third exercise describes an experiment in adjusting a particular color's temperature with the addition of warmer and cooler colors.

Creating Values

1. Square off five blocks and create a dark to white scale using one color in the stroke you're most interested in.

2. Using the same number of values, create a gray scale with one color, adjusting its values with black to coincide with a black-and-white gray scale.

3. Create a gray scale with one color and then adjust the values with its complement.

Mixing Colors

1. Make a basic color wheel by dividing a six-inch circle into six wedges of 60 degrees each. Starting with the top wedge, fill in alternate wedges by crosshatching or stippling with red, blue, and yellow. Each wedge between these primary colors will be comprised of an equal combination of the two colors on each side. For example, the wedge between red and yellow will be a mixture of both to create orange. These combinations are the secondary colors orange (red and yellow), green (blue and yellow) and purple (blue and red).

2. Experiment with premixing the colors of the color wheel and crosshatching them in position on the wheel. Keep a careful record of the mixture formulas as you do this.

Creating Color Temperatures

Choose a color—say, red—and crosshatch or stipple it into three squares. Experiment with adjusting temperature by adding a warm color, such as yellow, to the square on the right and adding a cool color, such as blue, to the square on the left.

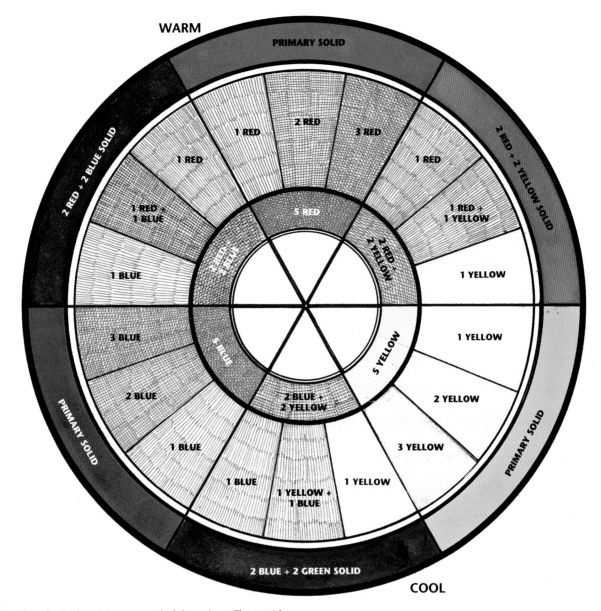

WARM

PRIMARY SOLID

2 RED + 2 YELLOW SOLID

2 RED + 2 BLUE SOLID

2 RED

1 RED

3 RED

1 RED

1 RED

5 RED

1 RED + 1 BLUE

1 RED + 1 YELLOW

2 RED + 2 YELLOW

1 BLUE

1 YELLOW

1 YELLOW

3 BLUE

2 BLUE

1 YELLOW

5 YELLOW

5 BLUE

2 BLUE + 2 YELLOW

2 YELLOW

1 BLUE

3 YELLOW

1 YELLOW

1 BLUE

1 YELLOW + 1 BLUE

PRIMARY SOLID

PRIMARY SOLID

2 BLUE + 2 GREEN SOLID

COOL

The color wheel (above) is composed of three rings. The outside ring shows primary and secondary colors in a solid application of acrylic ink. Each solid color is then shown in the middle ring in three different densities, which are created by layering lines of color. An even denser version of each color is shown on the innermost ring. The numbers appearing with the names of colors refer to the number of layers needed to produce the varied densities.

The color bar (below) shows the various colors available in the Rotring Artist Colors set. The black and white pigments are not appropriate for the technical pen, but can be added in brush applications.

RED PURPLE BLUE GREEN YELLOW-GOLD LEMON-YELLOW ORANGE BLUE-VIOLET TURQUOISE BROWN WHITE BLACK

OKLAHOMA LOUISE: A STEP-BY-STEP DEMONSTRATION

This demonstration, *Oklahoma Louise*, 20" × 30", is based on an 8" × 10" color photograph. It provides a good example of typical problems you can solve with color in the technical pen. The skin tones, the lighting, the textures, and the large area of black make this an interesting challenge.

I started this exercise by examining the photograph carefully. The blackness and dominance of the hat posed the question to me of whether I should use black ink or try to create a black by combining complementary colors. I wondered how to draw attention to the face as well as the largeness of the hat. I was attracted to the prominence of the hat's cast shadow across the face; I wanted it dark but did not want it to obscure the eyes.

Important considerations would include getting the right skin tones, maintaining the smooth texture of the face, and modeling the cheekbones, chin, and nose. I was also concerned about the accuracy of the color in the clothing, particularly the lavender of the scarf. Faded denim is so distinctive that the color needed to be just right. The caramel jacket lapel, and the subtle yellow in the scarf pattern, concerned me since I

was building the color in layers.

To carry out this demonstration yourself, set out one 3x0 or 4x0 pen for each Rotring Artist Color. Don't premix the inks.

STAGE 1:
USING LOCAL COLOR
TO SET UP DARKS

I started the color drawing of Oklahoma Louise with the cast shadow from the hat brim, the mouth and smile lines, the eyes, and the clothing folds. For the shadow cast by the hat on the face, I began with 6x0 blue lines, since blue is the complement of the orange flesh tones, and I wanted to darken the area of the shadow. I did the same with the smile lines and the eyes. For the clothing, I limited myself to the small dark recesses around the jacket folds. I planned to keep the negative spaces in the eyes even though the cast shadow was over them.

Once this first layer of shadow shapes was set up, I began with the local colors of those shapes, starting with the orange of the face. Eventually I established the basic colors for all the main shapes in the drawing while continuing to develop the

shadows. If the local color began to overwhelm the shadows I would add more complement to the shadow to keep it prominent. The blue in the hat shadow began to cluster where the lines crossed several times, giving the shadow a pitted texture that is inconsistent with the texture of the girl's smooth skin. The point size of the pen was small enough that the clusters never really became obtrusive, but to avoid this the next time, I would start with a dark orange for the shadow and then add the complement late in the development of the piece, so there would be fewer layers of blue lines necessary.

In spite of the obvious volume and dark value of the hat, I did not start with it. When a shape is this prominent, I like to have more feeling about how the overall drawing is developing before I make such a major commitment to color. I knew what the texture would be, and decided that I needed the strength of black line for this volume.

The hair at this stage was simply set up for shapes. I developed the small shadows that are prominent between the tresses of hair and isolated the small highlight shapes

This detail (right) of cast shadow over the eyes shows how I began by establishing a good pencil composition to work over. The first lines were drawn in the shadow areas to help define the overall image. I picked a light blue color for the cast shadow of the hat brim because of blue's complementary relationship to skin tones. It worked, but not as well as I would have liked. This drawing would have worked better if I had started with a weaker contrast to the skin tones, such as a red-brown combination.

to be developed later with more color. I also developed the specific shapes in the eyes and the mouth, the nostrils, and the patterns in the garments. These first stages were aimed at getting all the shapes in the right places and approximately the right color. For example, the scarves' various patterns are filled without any regard for modeling or final color. The lavender scarf is set up for the shadows that indicate its folds and translucence. The development of texture and color comes later as the kerchief and face take on color. No background is involved at this stage.

STAGE 2:
DEVELOPING CONTRAST, HUE, AND TEMPERATURE

The local colors of the garments are built up from successive layers of the same color. For example, the local color of the denim jacket is blue, so I started with a blue for the shadows and built them up in two or three layers before I took that color into the bigger shape of the lapel.

In this drawing, there are a lot of colors, many of them very strong. My major concern was achieving the subtle orchid of the scarf, the bright yellows of the kerchief, and the right shadow color of the red under the chin.

In the face, I was extremely careful to preserve the white highlights. They are particularly critical because the flesh tones are inherently light values, giving me little margin between them and the highlights.

In the area of the mouth, I avoided making the corners and the recesses behind the teeth too black. This gives an artificial impression of the actual spaces around the mouth and hardens its expression.

By the time I had the basic colors of the clothing set up and the primary flesh tones established, I was ready to start filling in the hat shape. I wanted this texture to be very smooth and felt-like, so I was particularly careful about the consistency of the pen strokes. As you can see, I applied one layer at a time, sweeping all the way over the hat before starting another layer. I chose the directions of the strokes to give me maximum uniformity and contrast. I realized that even though the hat was very dark, the underside of the brim against the face and shoulder must be even darker, so I worked those areas for maximum contrast before any other areas of the hat.

Eventually I started adjusting the shadows for color temperature in order to affect their feeling of distance. I made the shadow under the hat brim even bluer than it already was with some purple tones. The purpose here was to push that part of the face back under the hat brim. I added reds to the end of the nose to bring it forward in contrast to the blues.

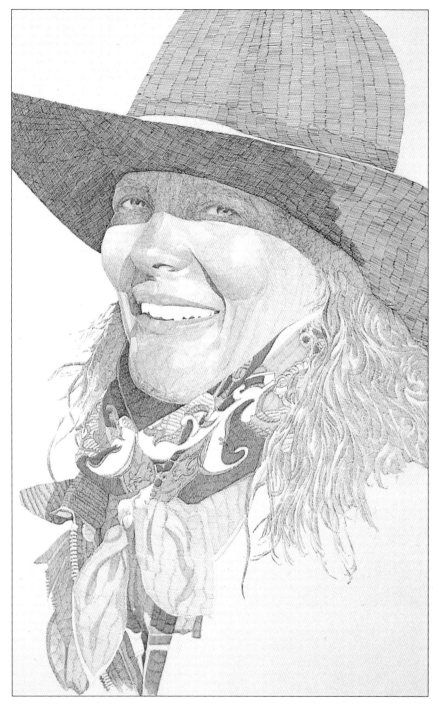

After applying the blue, I began crosshatching in the skin tones of the face, taking great care to preserve the white highlights on the nose, cheeks, and chin. Without highlights, you are forced to darken the skin tones to model the features. With highlights, a very light skin tone is enough to set up contrasts on the skin. I added color in stages, working on large color groups one at a time; for example, the reds of the scarf were all put in at the same time, and the skin tones of the face were developed all at once. However, it's easy to lose track of the layers you are applying for any one color. When you discover some small shape that was left out, you have to attempt to recreate the sequence you used to create the color initially.

In setting up the hat shape, I attended more to texture than tonality. I knew I could add lots of line, because the hat is so dark, but I also knew that I could not correct an uneven texture if the successive layers of strokes were not absolutely consistent.

STAGE 3:
MAKING OVERALL
ADJUSTMENTS

I was tempted to change colors when the red of the kerchief seemed to remain pink. Eventually the red began to accumulate to the right intensity. I had similar difficulty with the yellow-brown colors.

Eventually, I made some adjustments to create warmer or cooler versions of colors throughout the drawing. To warm the blue shadows in the jacket, I used a warm complement, such as orange; to cool it, I used rose. It could also have been warmed up with a similar color, such as blue-green, or cooled with a color more on the purple side.

I added some purple in the cast shadow across the face in order to cool it and push it back from the nose and chin.

I also made considerable adjustments to the hair color, using the negative spaces I had saved for warm yellow highlights, making the hair look raked by the sun's rays.

At this stage it was tempting to add black in order to hasten the development of contrast. Black, however, not only muddies the color, but reduces the opportunity to adjust actual hues with other colors. Black also dominates color strokes and gives a rough texture to shapes. If you look closely at the cast shadow under the hat brim in this drawing, you can see this effect. Creating darks by mixing the complements gives you much more opportunity to control and to adjust the colors as you go.

The background was a last-minute decision based on the need to anchor the subject within the frame and the need for some complementary color against the figure's cheek. This little shot of blue line helped define the lighter cheek and helped bring it forward from the background. A little orchid in the blue background helped integrate the subject with the larger space and gave subtle interest to the sky effect.

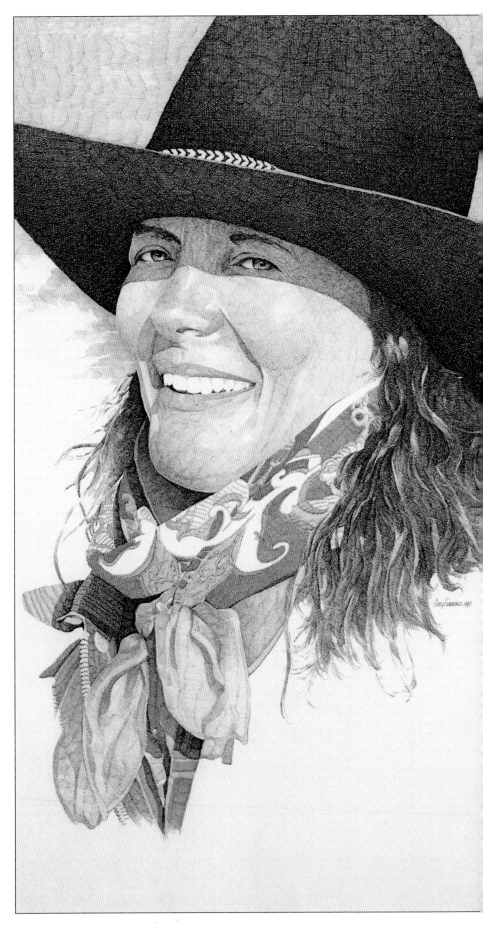

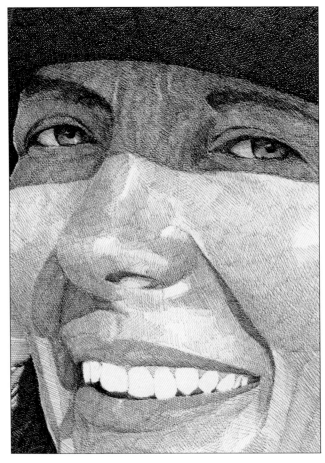

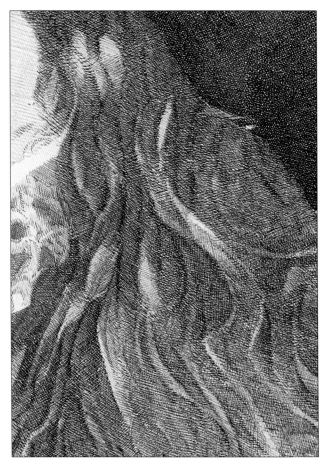

The underlying shapes of the eyes are always critical in a facial study. Since the cast shadow was going to fall over the eyes, I didn't want the shadow strokes to dull the whites of the eyes by compromising their highlights. Once the eye shapes were established, I continued to leave negative shapes in them even though they were in shadow, as this detail shows.

This detail of the hair (above) shows how the negative shapes reserved as highlights were converted to yellow and reddish tones. I was more concerned initially about the underlying shapes than about the color, but I was also sure that in order to add sunlit effects on the highlights, I would need to preserve the negative shapes until late in the drawing. The deep ravines among the tresses needed to be set up early and kept prominent, so I used a deep brown as a version of the local color that would characterize the final version of the hair.

This detail of the lavender scarf (left) and the larger scarf shows the work done toward deepening contrast, adjusting hue, and adjusting color temperatures, all of which take place with any one stroke. This complexity is reason enough to proceed conservatively when introducing changes at the last stages of a drawing. Here, the shadows in the lavender scarf and the reds and yellows of the larger scarf were intensified for contrast.

INDEX

Acrylic inks, 22, 131, 133

Background, 107
 color, 133
Black, 71, 117
 color and, 138, 142
 in cross hatched drawing, 66
 effects, 65
 silhouetted images, 67
 in sketching, 96, 97
Blending, 84, 116
Border, 108
Boxes, pointillism, 64, 71, 82
Broken parts, technical pen, 21
Bubbles, pointillism, 64, 71

Cartridge design, 14
Circles, pointillism, 64, 71
Clogging, technical pen, 20-21
Color
 ink, 21, 22, 131, 134-35, 137
 local, 141
 mixing, 135, 138
 temperature, 137, 138
 warm/cool, 142
Color technique
 background, 133
 vs. black-and-white, 135-38
 color selection and, 134-35
 demonstration, 140-43
 exercises, 138
 with frisket, 132-33
 pen selection and, 134
Composition, 69-83, 105-8, 110
Consolidation, 127
Continuous lines, 42, 43, 44, 70, 114
Contrast, 107, 128
 color, 137-38
Crosshatched lines, 55, 56, 70, 75, 114
 black, 66

Dark shapes, 114, 121, 122, 124
Doodling, 99
Dots, 63, 71, 82, 87, 117
Dripping, technical pen, 20
Dye-based inks, 21, 22, 131

Edges, 115, 123, 124, 125, 128
Emphasis, 107, 124
Engraving effect, 45, 70
Erasing, 129

Frisket, 132-33

Geometric patterns, 45, 70
Gestural drawing, 90-103
Gray scales, 84
Grays, 112

Halftone negative, 13
Hatched line cluster, 70, 79
 effects with, 49, 50, 51
 layered parallel, 52, 70
 radiating, 54, 70, 79
 reticulated, 53, 70

Henson, William, 69

Illustration board, 23
India ink, 21-22
Inks, 21-22, 131, 134-35, 137
Irregular-weave patterns, 58, 71

Jess, Robin, 63
Joern, Dennis, 57

Leaking, technical pen, 20
Loops and scales, 62, 71
Loose drawing techniques, 26, 27, 87-103
Lorenz, Al, 31

Mattis, Bob, 32
Merging lines, 60, 61, 71
Middle values, 115-16, 124

Negative silhouette effect, 72
Negative space, 95, 126

Ohanian, Nancy, 50
Outlines, 31, 32, 33
 broken, 117, 118
 loose, 87, 88, 89
 tight, 117, 118, 120

Paper, 22
Parallel line, layered, 52, 70
Patterns, 35
Penciled border, 108
Pencil drawing, 108-10
 transferring, 110-11
Pen drawing techniques
 composition, 69-83, 105-8, 110
 demonstration, 120-29
 elements of, 31-37
 loose, 26, 27, 87-103
 rules for, 113-19
 tight, 26, 27, 105-29
 See also Color techniques; Pen strokes
Penpoint
 materials, 14
 sizes, 11-13, 96, 113, 114
Pen strokes
 basic, 41-67, 70-71
 combinations, 69
 common errors, 38-39
 edges and, 115, 123
 exercises, 84
 initial, 114
 purpose of, 112-13
 selecting, 28
 simultaneous effects with, 30
 uniform, 114-15
Photocopying, 110
Pigment inks, 21, 22, 131
Pointillism
 circles/bubbles/boxes, 64, 71, 82
 dots, 63, 71, 82, 117
Precision, of pencil drawing, 108
Projectors, 23, 111

Radiating lines, 60, 61, 71, 79

Scales and loops, 62, 71
Scott, Ralph, 42
Scribbling technique, 80
 loops of lines, 47, 70
 random, 46, 70
 reticulated, 48, 70
Shankman, Gene, 44

Shapes
 consolidating, 117
 dark, 114, 121, 122, 124
 in pencil drawing, 108-10
 small, 113, 122-23
 as values, 122
Silhouetted images, 67
Sketching field, 102
 loose techniques, 87, 90-103
Skin tones, 141
Skipping, technical pen, 20
Snagging, technical pen, 21
Stippling. See Pointillism
Surfaces, 22-23
Symmetrical-weave patterns, 57, 70

Taylor, Karen, 33
Technical pens
 brands of, 8, 14-15
 cartridge design, 14
 cleaning, 17-20
 for color inks, 134-35
 common problems with, 20-21
 equipment, 21-23, 102
 filling/refilling, 15-16
 limitations of medium, 9
 point materials, 14
 point sizes, 11-13, 96, 113, 114
Television, sketching from, 102
Textures, 36, 51
Tight drawing techniques, 26, 27, 105-29
Tonalities, 34
Transfer paper, 110
Transferring
 drawing after, 111
 methods of, 110-11

Values, 116, 125, 129
 color, 138
 grays, 112
 in loose sketching, 98
 middle, 115-16, 124
 in pencil drawing, 109, 110
 shapes as, 122
Vignette, 111
Visual memory, 102
Visual note taking, 90

Wave lines, 58, 71
Weave patterns
 irregular, 58, 71
 symmetrical, 57, 70
White spaces, 116, 126, 138
Woody, Curtis, 67

Zigzag lines, 58, 71